THE AFRICAN ARTISAN

Education and the Informal Sector in Kenya

The African Artisan

Education and the Informal Sector in Kenya

Kenneth King

Lecturer in Education, Centre of African Studies,
Edinburgh University

HEINEMANN
LONDON · NAIROBI · IBADAN · LUSAKA

TEACHERS COLLEGE PRESS
TEACHERS COLLEGE, COLUMBIA UNIVERSITY
NEW YORK

Heinemann Educational Books Ltd
48 Charles Street London W1X 8AH
P.M.B. 5205 Ibadan P.O. Box 45314 Nairobi
P.O. Box 3966 Lusaka

EDINBURGH MELBOURNE TORONTO
AUCKLAND SINGAPORE HONG KONG
KUALA LUMPUR NEW DELHI KINGSTON

ISBN 0 435 97380 0

©Kenneth King 1977
First published 1977

Published in the United States of America 1977
by Teachers College Press
Teachers College, Columbia University, 1234 Amsterdam Avenue
New York, NY 10027

Printed in Great Britain by
Biddles Ltd, Guildford, Surrey

Contents

Illustrations

Acknowledgements

My main thanks are due to Kenya's Ministries of Labour and of Education, many of whose officials have encouraged me to proceed with this study, and have helped me from time to time during three successive periods of work in the field. I am particularly grateful to the officers of the Directorate of Industrial Training for the interest they have taken in this work, and for several valuable discussions of issues that are central to its main themes.

There are several friends who have been most liberal in their help with this project; it would not have been possible to complete the work satisfactorily without their insights and assistance, both in Kenya and Britain: Neville Chittick, Helen Morrison, Michael Macharia, Abi and Eric Krystall, John Nene Ihugo, Grace Hunter, Colin Leys, Josephat Kimani, Philip Macharia, Per Kongstad, George Green, Ephraim Gavihi, and John Clayden. There are many others naturally who have in various ways encouraged me to complete the study.

Field work was carried out in Kenya during the British summers of 1972, 1973 and 1974 and I am grateful to the Centre of African Studies, Edinburgh University, for a Hayter Travel Grant for the first of these visits, and to the Economic and Social Research Committee of the Ministry of Overseas Development for support in the later field work visits and for assistance towards writing them up in this present form. Of course, the opinions expressed in this study are the author's own, and in no way represent the Centre of African Studies or the Ministry of Overseas Development.

Introduction

This is really a study of unofficial Kenya; that is, of the very large number of adults and young people whose jobs are not enumerated in government statistics, and whose skills are not catalogued in any manpower plan.

In the early 1970s some development economists began to refer to certain of these uncounted jobs (in petty production and petty services) as the 'informal sector' of the economy. And at almost the same time in the sphere of educational planning, a number of observers introduced the concept of 'non-formal' and 'informal' education to refer to types of learning that seemed to go on outside the formal provision of the Ministry of Education. One thing we examine accordingly is whether the economists and educationists are talking about the same people. Or rather, as these concepts have so far been used in only a very general way to describe alternative policies for employment or learning, we attempt to flesh out the people of the informal sector, and describe the actual processes of skill acquisition amongst them.

We concentrate on the productive and manufacturing side of this informal sector and do not include the host of other uncounted people who offer cheap services to Kenyans. Informally skilled manpower cannot, however, be understood from an exclusively contemporary survey. Nor can technological development in the informal sector. We offer therefore a version of the history of the informal sector, and discuss the origins and spread of that intermediate technology associated with it.

If the majority of Kenya's African artisans today have been produced silently—without a formal policy and without a formal institution—it is nevertheless also true that for sixty years of colonial rule and twelve years thereafter, the production of skilled African manpower has been consistently emphasised. In Kenya, as in many other African states, the attempt to create artisans in a formal institutional context often seems to have turned out very differently from what was planned. It is for this reason essential to trace informal skill development against a background of very forceful intervention by the state in the production of skilled labour.

School and skill appear to have drifted apart in Africa—as witness the

disillusion with school voiced by so many of the international and specialised agencies. We would argue that the terms of this disenchantment have been too starkly portrayed by observers, and that there is instead a need for sober reflection on the precise outcomes of schooling at the village, district and city levels. Much of the current terminology on the crisis and irrelevance of the school seems too clumsy when viewed from the individual village or the informal urban workplace.

Studies of small-scale industry in Africa have tended to concentrate on what was small compared to European, American, Lebanese or Indian enterprise in the continent. However, much of this small-scale sector is relatively large, and often privileged, by comparison with the informal, or micro-enterprise which is our focus here. Policy-makers need perhaps a different set of tools to relate to this sector.

This is not itself a policy document but a piece of description and analysis. It was, nevertheless, fertilised by thinking about certain projects and innovations associated with the following bodies: Kenya's Ministry of Labour, and within that, the Directorate of Industrial Training; the Ministry of Education, and particularly, the Technical Education Division; the Ministry of Co-operatives and Social Services, and especially its programme of Village Polytechnics; the Rural Industrial Development Project and its four associated Centres.

CHAPTER I

Education and Training: International Trends and Local Reaction

This chapter is concerned with the emergence of a local educational style on the one hand, and the broad direction of international policy-making on the other. A contrast is developed between the changing educational priorities of those groupings outside Africa (such as the UN specialised agencies, country donors, and private foundations) and the growth of a local mode of educational decision-making in a particular country, Kenya. The complexity of this local style is illustrated by a case study of technical education and training.

As far as the external literature on education is concerned, it is worth noting at the outset that there appears to be a firm consensus on the *critical* state of African educational systems in the 1970s. As a consequence, the advice being given by external agencies to local education officials today seems to be running almost counter to the mood that marked the immediate post-independence years. Nor is the Ministry of Education in African countries the only section of government to hear of the need for changed priorities. Also, in Agriculture, Economic Planning and elsewhere, there seems quite suddenly to have been a switch from some of the advice and some of the schemes aided externally during the Development Decade. The high-yield crops of the Green Revolution are no longer recommended with the enthusiasm that they once were a few years ago; on technical grounds there are complications, not least the spiralling price of the essential fertilisers, and on social and political grounds, some commentators now believe that the Green Revolution speeds up a process of rural stratification, with the rich farmers getting dramatically

An earlier version of the first part of this chapter was given at the Seminar in honour of Basil Davidson, November 1974, Centre of African Studies, Edinburgh University.

richer, and the poor farmers having to exchange smallholding for wage labour.[1]

Similarly in Economic Planning Ministries, the tide of international advice is no longer flowing quite so strongly towards the building up of industrial estates where local manufacture could save the foreign exchange costs of consumer goods. Instead, there has been a very widespread critique of much of this imported technology, and an interest in exploring alternative technologies that could have a wider impact in Africa than the cluster of high-cost factories in the miniature industrial estate of the capital city.[2] This attack on the impact of western technology in Africa has been associated with a wide-ranging critique of the role of the multinational corporations in developing countries. In fact, many of the allegations against the multinationals have parallels, as we shall see, with what is now condemned about the export of the European school to Africa. They are said to transfer to Africa consumer preferences for goods identical to those made in the West; there is little or no attempt at adapting the product to local conditions, since the internationally respected 'brand image' of a product is more important than substantial local content. And many of the products are only aimed at a fraction of the population in any case.

These sorts of considerations have led a number of outside observers and analysts to examine the possibility of promoting local or intermediate technology. There has, accordingly, been a diversion of interest from the relatively highly paid workers in the modern sector of the economy to the thousands who carry on skilled work of various kinds quite removed from the sophisticated technology of industrial estates. International bodies, such as the ILO and World Bank, have very recently focussed attention on this large body of employed and self-employed informal operators, and have begun to advise governments on how most effectively its employment and skill potential can be linked to a larger development strategy.[3]

In all these fields — education, agriculture and economic planning — it is not so much the rights and wrongs of the current advice that we are concerned with; it is rather an anxiety about the speed with which advice changes. In particular, when advice is frequently linked to the availability of capital aid for new programmes, it is of great importance to distinguish international planning priorities from the local processes of educational decision-making; there is otherwise the danger that a country may agree to adopt particular programmes that now seem relevant to the international bodies, even though not much thought may be given as to how the new initiatives from outside fit into the structure of local education and training structures. The obligation, therefore, of expatriate educational planners and advisers is to pay considerable attention to the direction and dynamic of local educational processes before suggesting further innovative programmes.

Accordingly, this analysis will tend to proceed on two levels. In the first part of the chapter, an attempt will be made to periodise the general literature on African educational development that has been produced by commissions, advisory committees, the agencies of the United Nations and other groupings. Naturally some of the reports and memoranda have been remarkably insightful, and have had the effect of charting whole new areas of research into education. Occasionally, however, there is the danger—perhaps particularly as the majority of analysts are still non-African—that a new trend or emphasis marked out by a high level conference can take on almost a life of its own, quite separate from the particularity of African conditions. The new insight or strategy may rather quickly become the orthodoxy of other conferences, appear in learned articles and become adopted by donor agencies. Indeed, to the historian reflecting on the literature alone it may seem as if Africa has at different periods been noted for its 'adapted education', 'Jeanes schools', 'mass education', 'functional literacy' etc., etc. And yet research at the level of the educational institutions themselves might still reveal very little that corresponded directly to the great themes of the conference literature.

In order, therefore, to tap something of the direction of educational change at the field level, it will be necessary in the second part of the chapter to examine more narrowly some of the key features of the education and training system. In particular, it should be possible to fill in the recent background of those elements which now figure so conspicuously in the advisory literature; employment creation, educational innovation, technology and equity. The process should demonstrate something of the spirit of local educational decision-making whose priorities are often in rather marked contrast to those of the international bodies concerned with educational planning in developing countries.

INTERNATIONAL TRENDS

Disenchantment with African education

To any student of the literature, one of the most striking features of the early 1970s has been the speed with which opinion has consolidated on the failure of formal schooling in Africa.[4] We shall sketch some of the antecedents to this a little later, but it is necessary first to examine the varieties of pessimism about formal education. It must be remembered that in this area many of the analysts are not themselves African; nevertheless, their main concern is by no means that African school systems should be abandoned to their imminent fate, but that measures should be taken fundamentally to reform or transform them in a number of ways.

3

(a) *The non-formal option*

This very popular notion is derived principally from the conviction that formal schooling cannot even deliver those very limited goods expected of it by Ministries of Education. The message of its more influential proponents, particularly to the poorer countries of the Third World, is that formal education will merely consume an increasing proportion of their resources with little to show for it. Indeed, they would argue that there is in fact even less to show than the figures allege. Thus, for example, a primary school age enrolment ratio from ministry statistics may suggest that 40 per cent of the age group are in school. However, a more careful analysis will consider the impact on the figures of over-age pupils, repeating classes, wastage, regional disparity and will ask how many of the 40 per cent leave school actually possessing the essential primary skills. This type of analysis can have the effect of slashing the apparently quite promising ministry figures to a fraction of what was claimed.

> The conclusion to be drawn . . . is that in a country with an overall primary school participation rate of, say, 50 per cent, the chances are that in some of the poorer rural areas as many as 90 per cent or more of all young people (especially girls) are reaching maturity without knowing how to read or write.[5]

The deflation of official statistics is designed to drive home the point that despite the heady expansion at independence, the often vast outlays of money on teachers, and the local forms of self-help, African countries are not getting a fair return for their sacrifice. They should, therefore, it is suggested, consider whether what most children are failing effectively to get through the schools can be provided by *alternative* methods. Some of the main avenues being explored are enumerated below.

1. *A skill to live by.* This the conventional primary school notoriously fails to provide. Children enter too early, or drop out too soon. And anyway the expense of the traditional primary school is heavy enough without contemplating schemes for effective vocationalisation. Hence, the interest of the nonformal enthusiasts has been directed towards indigenous apprenticeship systems, on-the-job training, and particularly to innovative methods of acquiring skill in institutions that are *not* too institutionalised. A good deal of the emphasis is on local and traditional methods and forms of training. Paradoxically this has meant a reawakening of interest in those institutions such as Koranic schools, Coptic Church schools, tribal lore acquisition (as amongst pastoral peoples) which were often regarded in earlier decades as major obstacles to modernisation.

2. *Basic communication skills.* Here, too, the nonformal educator would claim that the ordinary rural primary school has been weighed and found wanting. It is so caught up with certification (very often in

English or French) for the few that it fails in its obligations to the majority. Instead of the extended sequential system of seven or more years in primary school, nonformal proponents believe that the very notion of a complete primary cycle could be dropped in favour of much shorter tailor-made units. The more successful adult literacy campaigns would testify to the fact that communication skills can be picked up in much less orthodox ways than seven years of continuous classroom attendance.

3. *Community orientation.* It is alleged also that primary schools as they presently operate, tap almost nothing of the knowledge that exists in the community around them. The assumption is that only a teacher can teach, and that *a fortiori* a qualified and certified teacher must be more effective than an unqualified one. This view disqualifies most members of the community from contributing to the school as resource people, reservoirs of local history, craftsmen and in other roles. Lacking any local flavour or community participation, primary schools operate as merely a network of more or less effective examination centres, each releasing two or three fortunate children a year into the next level of the national grid. Accordingly, new structures need to be worked out which can be put to more effective use by all members of the community. Nonformal educators have been scanning the continent for places where institutions appear to have been designed in this spirit.

A substantial part of this critique is by no means novel, but goes back almost as early as the first western schools in Africa. What *is* new is first, the attempt to draw together the many unco-ordinated initiatives of government departments, voluntary agencies and local bodies *outside* the formal school system and to suggest that the spirit and style of some of these could provide the germ of a new approach. Secondly, nonformal education seems to be fundamentally concerned with the issue of equity in African states. The clients for which nonformal education is being designed are ultimately the majority of low-income peasants and workers — what the ILO have termed the 'working poor'. And the learning environment is being deliberately recast with them in mind, since the traditional school system has, for all its expense, left them quite untouched, or roughly discarded them after a brief and pointless spell in the lowest classes. One strand therefore in nonformal education planning is derived from a strong distaste for what is seen as galloping elitism in many African societies. The formal education machine is viewed as being intimately connected with this process. And consequently it is felt that the interests of the majority of poorer parents will be better served through different forms of education and training. The thinking on nonformal education is still very tentative; so that it is not clear from the literature what sort of interaction there might be eventually between formal and nonformal systems. There is the

danger, however, that nonformal could be interpreted and locally condemned for sounding like a special, inferior provision for the rural and urban poor.

(b) *Reform of the formal school from within*

Apart from the planners concerned with devising new modes of out-of-school education, there has in addition been a good deal of thought given to reforming the system from within. The spectrum of bodies involved has been quite wide, including donor organisations, the UN agencies and church groupings and some manpower planners. In many cases they are the same bodies that assisted Africa to expand the system they would now change. Their anxiety flows from the same features as the nonformal educators: the apparent inequity of function, the inappropriateness of what little is learnt, and the problematic linkage of school to job.[6] Unlike them, however, they see some possible room for manoeuvre. Some of their most characteristic concerns at the moment are to regulate the overheated school machinery by a number of controls, enumerated below.

1. *Certificate escalation.* Much more rapidly than in an industrialised country, the relentless pressure to expand formal education in Africa raises the qualifications necessary to land a job in the modern sector. Indeed, it seems as if in some areas almost twice as much schooling is required to get the same job in 1975 as was needed in 1955 or 1960. Would-be manipulators of this situation desire to break this spiral upwards, and look for ways in which schools can have the insidious pressure of the labour market taken off them. Ideally they would like to shift some of the selection function from the schools to the shoulders of the main employers. They would also want selection for jobs to be got over sooner rather than later, since it is this which keeps students for years longer in the system than there will be jobs afterwards to justify.[7]

2. *The relevance question.* Another area suggested for manoeuvre is that very large numbers of those not finally selected for jobs or higher education leave school with no marketable skill whatsoever. This has been true of the primary leaver for some time, but increasingly applies to the products of the expanding secondary school systems. To meet the situation, a wide variety of suggestions have been made. Sometimes a new phrase is coined such as work-oriented courses or diversification of secondary schools, but the area in general remains one in which recommendations come in thick and fast from every convention or committee in the 1970s as in earlier decades. There is the same hiatus today between advocacy and practice. However, a slightly different emphasis is sometimes apparent in the proposals for schools to prepare their leavers for self-employment and petty entrepreneurship. This arises naturally from the now widespread recognition that the schools

produce more aspirants than there are wage and salary jobs in the economy. But, as we shall see later, the demand that schools produce cadres of enterprising self-employed involves a good deal more than a few manipulations with the syllabus.

3. *The examination as the judo-trick.* As well as being concerned with certification and the labour market, reformers today have identified the examination as the main reason for the internal defects of the schools. From it are seen to stem cramming, irrelevancy, repeating of classes, poor teaching, and inequitable access to higher education.[8] Its backwash affects many classes earlier than the examination year. And, as a recent ILO report affirms, it is with it that reform must begin: 'It is only after the root cause of the disease affecting the present function of the schools (i.e. the existing examination structure) has been eliminated that a change in the content of education begins to make sense'.[9] Analysts are anxious, for instance, to see if by switching from the traditional achievement tests to various forms of aptitude testing the role of rote learning could be diminished, and the backwash through the schools reduced. This could also, they feel, have implications for innovation in teaching, and free students from the deadening effects of preparing for and repeating several times the same artificial content. In turn, students might be better fitted for entering self-employment.

4. *Quotas for equity.* A key motive with the reformers as with the nonformal advisers is how education systems can be prevented from intensifying what is seen as a growing inequity between group and group, region and region, town and country. At present, certain areas in most African countries are felt to get far more than their 'fair share' of secondary or university places, by reason of the headstart they had in western education, or the surplus from cash crop agriculture that could over the years be ploughed into school buildings and school fees. To control such imbalances, it is suggested that expedients like quota systems could be introduced, and that planning units in Ministries of Education could monitor — possibly with outside assistance — where new schools or streams should become government-aided.

5. *Basic education versus high level manpower.* A number of the most recent international conferences (e.g. UNESCO-UNICEF basic education conference, Nairobi, August 1974) have stressed the priority of the basic education cycle. Again, the argument has to do fundamentally with elitism; and many outside planners and experts conceive that overinvestment has taken place in secondary and higher education for the few as opposed to insuring a really secure grounding for the majority. Indeed, basic educationists would argue that where there are still pockets, districts, states and even whole countries in which primary participation has not yet reached 30 per cent of the school age group, it is plainly inequitable to continue the obsession with high level manpower.[10]

These, then, are some of the themes on the reform and the nonformal aspects of African education. They are common to a whole range of advisory literature, much of it rather influential. But before turning to consider what has been and is likely to be the impact of this all-embracing critique in Africa itself, it may be useful briefly to examine its antecedents. And, without wishing to overemphasise the historical perspective, it is worth at least bearing in mind that all the senior men and women in Education and related ministries have probably a view of education influenced to some extent by their own colonial schooling of the 1940s and 1950s. These are the people ultimately responsible if there is to be any edging of education out of its present path.

Headless Pyramids, or the 'Beware of India' phase (1920s and 1930s)

Although it is difficult to generalise on education in tropical Africa at this period—since the commodity was in a few parts of West Africa a hundred years older by then than most of East and Central Africa—many of its education systems resembled small flat plateaux with perhaps a single tall tree on them for the few more determined climbers. In the late thirties, for instance, there was not one *complete* secondary school course in the whole of East and Central Africa preparing for university or professional studies. At the pinnacle instead was Makerere College, Uganda, in which students followed either school certificate or vocational courses. In its fifteen years of existence up to 1937, it had turned out four hundred students at these low levels. Reflecting on the situation, Arthur Mayhew, secretary of the British Advisory Committee on Education noted with just a hint of anxiety:

> There is a tendency which, although natural, is capable of perversion, to guard against a surplus production of graduates which may stimulate unrest and discontent.[11]

This natural tendency, which marked the advisory literature of the period, was derived from administering India. Indeed, the development (or lack of development) in African education from at least the 1910s and 1920s must be partly understood in terms of Britain being desperate to avoid reproducing in Africa what it saw as the disastrous progress of education in India. In fact, as Indianisation continued apace in the early decades of the twentieth century, often the very personnel charged with the new education departments of Africa were British colonial servants who had just left a world of multiplying 'colleges', falling standards, and degrees which could be commenced at fifteen or sixteen years of age. This continuity of personnel at the advisory and policy-making level is worth noting not only at this stage; it would happen again a decade or two later when, in turn, the Africanisation of colonial departments of agriculture, education, labour and social welfare would produce significant numbers of recruits for the relevant

UN agencies and the overseas development bodies of France and Britain.

At any rate, the cautious policy that marked most plans for secondary and higher education through the thirties and into the forties was not only the result of a concern for *quality*; it was perhaps as much a fear of the correlation between higher education and political unrest which again India had amply proved. The combination of factors produced attenuated and rather expensive little education systems in many African territories. Mayhew, for instance, worked out that in the Gold Coast in the late thirties the cost per pupil in government and mission primary schools was £7.20 and £4.35 respectively, compared to an average of £0.50 in India, while in aided secondary schools the figure was £33.35 in the Gold Coast as opposed to £2.70 in India. His own justification for the policy is valuable as a contrast to later advisory literature:

> This high cost per head is a necessary result of our African policy, born of bitter experience in India; a policy of caution and firm foundations, advancing gradually from a few selected and well-equipped centres in slowly widening circles, secondary education being restricted with reference to local demand and the more urgent claims of primary education.[12]

In the same spirit of extreme caution, in the years after the second world war, slender tops to the school pyramids were constructed, and these were crowned here and there by meticulously built little university colleges. High cost, 'A' level entry, few students, many European staff, *and* a research function. In all respects it was the opposite of what had gone on at a similar formative period of Indian higher education.[13] As far as secondary and higher education are concerned, therefore, there was a rather close correspondence between official policy and what actually appeared on the ground.

Relevant education for the masses

When we turn to the advisory literature on this side, the correspondences are a good deal less marked. There is, first of all, no shortage of really excellent blueprints on integrated rural education, linked to community development, agriculture, adult literacy and the growth of the rural economy. The classic landmarks are perhaps the Colonial Office's *Memorandum on the Education of African Communities* (1935); *Mass Education in African Society* (1944); and *African Education: a study of educational policy and practice in British Tropical Africa* (a joint product in 1953 of the Nuffield Foundation and the Colonial Office). As almost twenty years separates the first from the last of these, there are naturally differences of emphasis. The earliest uses concepts almost identical to those that would appear in the

nonformal literature of the 1970s; its call for the integration of school education with the wider informal offerings of the other government departments came at a time when Africa's school systems were still tiny, and lay becalmed after the Depression. The analysis assumed that the stagnation or even absence of educational development in so many areas was itself almost proof that conventional primary schooling could not produce rural development. The alternative — community education — that was being urged through a re-integration of the existing resources implied that it could more effectively prepare the ground for any eventual higher education than could the few rather isolated primary schools. What little education existed was already expensive enough, as has been pointed out above, without contemplating much more. Or at least not until the community as a whole had developed economically to a point where it could afford it. Thus the model of colonial self-sufficiency was being adhered to, eked out by community education.

> Injustice may be done to the peoples of Africa by introducing educational improvements and refinements in accordance with Western standards which make excessive demands on the limited resources of a territory and by creating an education super-structure which African communities at the present stage of their development are unable to bear.[14]

In view of the emphasis on financial self-sufficiency it is worth noting that at this period almost the only *working* examples of community education were the two or three better known Jeanes Schools in Kenya, Nyasaland and Northern Rhodesia; and they had only been made possible through the funds of the Carnegie Corporation of New York — one of the first instances of nonformal education's reliance on aid from outside Africa.

By the time the Colonial Office next made recommendations about mass education — in 1944 — the mood had changed significantly.[15] War service for Africans had involved adult and nonformal education on a scale unprecedented in the history of any of the colonies. Reporting the same year, the Asquith Commission on Higher Education in the Colonies had suggested a major break in colonial self-sufficiency in education: university colleges no longer needed to wait for integrated rural development in the colonies to produce the necessary surplus, but could receive grants direct from the new Colonial Development and Welfare funds.[16] (It could of course be argued that this was only channelling back to the colonies a part of the surplus extracted from the rural areas in the first place by marketing boards, monocrop plantations etc.)[17]

The correspondence between Report and practice was very close for higher education, and for a time the omens looked favourable also for a

really massive implementation of the mass education proposals. Unlike the situation of some of those international bodies advocating nonformal education today, the 1944 Report was produced for the body that ultimately controlled policy in the colonies. The Colonial Office had not necessarily wished to implement much of its advisory committee's prewar recommendations; but now in the aftermath of the Second World War, there seemed a great deal to recommend the nonformal education package which they had published. For one thing, mass education was no longer needed to *stimulate* vast stagnant territories, as in the framework of the earlier 1935 Report; it was, they felt, desperately required to direct and make responsible an African consciousness that was only too obviously awake towards the end of the war.

> So marked is the change that a mass consciousness seems to have developed that actually exaggerates the responsibility of groups or individuals, especially those in authority. . . . Such a change of attitude is, no doubt, related to changes in the distribution of social and political prestige and to changes in the conception of what power can do particularly in recent times by the application of scientific knowledge. The explosive temper which may result from such a change can only be controlled and guided by wisely directed mass education with particular stress on the development of social and civic responsibility.[18]

As it was the adults who had been exposed to active service abroad or worked in the various wartime support organisations, it was correspondingly adult education that was needed. The Colonial Office committee were clear that it was not mere literacy that was required. Anticipating UNESCO's adoption of 'functional' literacy by some twenty years, they insisted that literacy should be related to 'people's needs and interests, and it should assist in stimulating their desire to improve and control the conditions in which they live'. Paradoxically, also, it should be selective, and concentrate initially, like the 'progressive farmer' policies of agricultural departments, on those areas and districts that were likely to be most responsive.[19]

There has been no comprehensive research undertaken on the various literacy campaigns that followed on from this Colonial Office initiative, and which were to be given international encouragement by the formation of UNESCO and its continuing interest in Fundamental Education. Here and there, for instance in the Gold Coast, the mass education campaigns flared up well in the early stages, when they found co-operation from other sections of government and caught the enthusiasm of voluntary workers.[20] Once the heady days were passed, the difficulty was where to find a place for this awkward child (literacy) in the already well-established departmental hierarchy of government. To judge from its own literature, mass education appeared to have some

concern with health, labour, agriculture, education and commerce. It did not seem to have experts of its own in these fields, and yet wanted to integrate for its own purposes the competencies of other Departments. On the other hand, the Literacy Division usually had more enthusiasm than finance, and consequently often lacked the status and authority necessary to implement its ideal of mass community education. In a number of countries, the Division was consequently tossed backwards and forwards between other departments such as Education, Labour and Co-operatives which were never quite sure where it belonged.[21] Meanwhile out in the field, the fullblooded conception of developmental mass education was often reduced to bare literacy through lack of funds, materials and trained workers. And by the time the International Commission on the Development of Education were reporting in 1972 that four out of ten primary school age children in Africa were still not in school,[22] it seemed as if the infrastructure for mass literacy in several countries had nevertheless almost disappeared. Only the celebration of International Literacy Day remained.

The era of identity of advice and practice

Part of the reason for the relative decline in literacy interest was that from the early 1950s the formal school machinery was gathering speed. Thousands of illiterate parents clearly believed that they should invest in education for their children instead of for themselves. And as the 1960s grew near with the expectation of independence, it became obvious that for all the colonial talk of 'education for citizenship' and civic responsibility in the post-war years, the educational superstructure was totally inadequate. Quite suddenly the gradualism of the early advisory literature was abandoned, and for a brief decade overseas planners and educators urged the expansion of the top layers of the pyramid, as fast as was compatible with standards. Eric Ashby for instance could state with pride in the Report of the Commission on Post-School Certificate and Higher Education in Nigeria that 'our proposals remain massive, expensive and unconventional'.[23] As the African ministers of education plotted their targets for universal primary, and substantial percentages for secondary and higher education, their figures were affirmed by a new group of expatriate manpower planners.[24] These concentrated their attention predominantly on middle and high level manpower, and the shortfalls for the necessary cadres were translated directly into so many secondary and university graduates.

In Africa itself governments, politicians and communities acted in the faith that education equalled development, while outside a good number of economists tried to prove it. Within a decade a whole literature on returns to educational investment was generated. Even in

the field of literacy, the mood was infectious, and UNESCO decided to try and measure scientifically the positive correlation between literacy and development.[25] Although there was, outside, a good deal of attention paid to creating a science of educational planning, metropolitan governments and the USA did not wait for the outcome of the human capital debate to send out their volunteers, teachers, lecturers and advisers to help man the expanded system.

External disenchantment

And then just as suddenly, the era of optimism and assimilation of African systems to European was over as far as the international literature was concerned. This had been caused by an awareness of spiralling costs, educated unemployment, and the continuing insatiable demand for secondary and higher education—apart from the other factors outlined at the beginning of this account. Many of these items were quite predictable from the Indian experience, had that not slipped out of sight for a decade. However, this mood of disillusion may be traced more or less precisely to late 1967 and 1968. Admittedly, anxiety had been shown in the very early 1960s by Callaway and others over the phenomenon of primary school leaver unemployment,[26] but this had seemed part of the colonial legacy of restricting secondary school places. It could perhaps be reduced by tremendous efforts to build secondary schools. When, four years later, reports began to be written again, this time about the employment difficulties of secondary school leavers, it looked as if there might be deeper structural issues involved.

The disaffection with formal education was not restricted to African data and experience. It reflected a much wider mood of disillusion in the West, particularly in America. Much of this was concerned specifically with the American school system in the post-Kennedy era, but already in 1967 Illich and Reimer had begun to add a third world dimension to the debate through the influence of the Cuernavaca Centre in Mexico.[27] At the international agency level in October 1967, the debate was widened very substantially at the International Conference on the World Crisis in Education. The conference of 150 education policy makers affirmed the general outlines of a document by Philip Coombs, Director of the Unesco International Institute of Educational Planning, and this appeared in 1968 in book form—*The World Educational Crisis.*[28]

A unitary position appeared to have been established, in which the African education crisis was not really unique, but just a version of a world malaise afflicting formal schooling institutions. The essentially monolithic nature of the crisis was given further affirmation by the influential Faure Report, *Learning To Be: the World of Education Today and Tomorrow* (1972).[29] And naturally by this time, policy

13

makers were beginning to throw up remedies, the most popular of which were that education should begin to be seen as 'lifelong', 'recurrent' or 'continuing'. All of these suggested in some way that reorganising access to learning, so that it was no longer only age-specific (children and adolescents) and no longer only associated with schools, would reduce the harmful effects of formal education.

It was in this context that proposals for nonformal education in Africa were made first in 1972, 1973 and 1974.[30] Since African attempts to build up a complete metropolitan education system were, it was argued, ill-conceived and ultimately impossible to achieve, they should concentrate their attention on building lifelong educational systems out of nonformal components linked where appropriate to more formal items. In Coombs' words from his *New Paths to Learning*.

> Actually a 'lifelong education system' is not something that each country must create *de novo*. Every country, even the poorest, already has the beginnings of such a system — various formal and nonformal components (as limited, fragmented and ill-fitting as some of these components may be) and a strong and ubiquitous informal learning process.[31]

There is by now a fairly clear consensus amongst outside agencies, from the World Bank, UNESCO, ILO to individual private foundations and country donor organisations, that some radical rethinking and restructuring of formal education has to take place.[32] In face of this unanimity abroad, the key question must be what is the reaction, if any, of the men on the spot. The Chairman of UNESCO's Faure report, *Learning To Be* has stated confidently that 'they [Third World countries] *have now become aware* that these models (often obsolete, even for the people by and for whom they were devised) are adapted neither to their needs nor to their problems'[33] (my emphasis). It is accordingly to a more local assessment of these models that we may now move.

LOCAL REACTION

In turning from the analysis of African education in the general literature of the agencies most concerned overseas, it is possibly advisable to examine the local structure from the perspective of a single country. Despite certain similarities, the independent African countries already have education systems at rather different stages of expansion — not to mention the African states which have not yet achieved their independence. Kenya is chosen here, since the data is readily available, although it should be noted that Kenya is one of the most education conscious states. To this extent, along with parts of Nigeria, Ghana and

the Ivory Coast, its analysis may anticipate certain developments and innovations which have not yet occurred in some of the poorer countries.

A number of the main structural features of the education and training system will be analysed so that the particularity of the Kenya situation can be perceived, and the potential for innovation assessed. Those areas to be considered include the dualistic structure of formal schooling, schools and skills, the issue of technology, the colonial legacy and innovation, and of these, particular attention will be given to the issue of schools and skills.

The colonial legacy

There has been a good deal of discussion about the pernicious effect of the 'colonial model' of education in independent Africa, as if a whole foreign system had managed to reproduce itself faithfully in inappropriate conditions overseas. It would be truer to say that for Kenya at any rate there has in the colonial and post-colonial period been a good deal of discrimination over what parts of the British model should be followed. The British colonial government, after all, had only allowed a truncated form of its metropolitan system to appear in Kenya, and some of its imports to Kenya on the technical side, as we shall see, had no counterpart in Britain at all. With this proviso, we may nevertheless say that there are several levels at which we may meaningfully talk of a colonial legacy. It is common today to concentrate on curricular and institutional aspects when discussing the legacy. Such current concerns of many of the expatriate advisers miss the point that the colonial government bequeathed to independent Kenya an educational system whose most important features were racial and numerical restriction. Consequently a reaction to this legacy was the immediate obligation at the time of independence to unscramble the double narrowness of the colonial era. Equally, however, the terms of the initial reaction to what was objectionable in colonial education necessarily produced many of the most intractable problems for contemporary education.

The racial legacy
The bitterest message for long stretches of the colonial era was that Africans as a group were thought sufficiently different from Europeans not to merit the same access to knowledge. This racial message was particularly prevalent in Kenya, many of whose European community firmly believed that it would always be a white man's country. Africans were to have a different future from Europeans; so there was no point constructing a school system for them that would encourage in them similar aspirations to the Europeans. Faced with a rigid racial stratification of schooling, the only defence against apartheid education

15

lay in demanding the same curriculum as white children received. In Britain's white settler territories such as Kenya, where the government was anxious to evolve special African curricula 'suited' to their mentality, Africans and some of their staunchest white defenders in the United Kingdom fought for identity of provision: if Snow-white and the Seven Dwarfs was good enough for white children, then it would do fine for Kenyans also!

At independence it was easy enough to unscramble the racial formula, and throw the European and Indian schools open to the better-off Africans. Ten years after Independence, this cluster of schools still retained something of their elite tradition through their pattern of recruitment, but it never looked as if the Kenyans would turn them into 'public' schools on the English model with feeder preparatory schools. They took their students after the same national primary examination as all other secondary schools used, and although their fees were still higher than these, there were indications in the early 1970s that fees would be brought into line with the other state secondaries.

Colonial barriers and employment

The racial school issue was not the only significant part of the colonial legacy; it affects very few people today. Much more important was that the colonial government had a very effective examination hurdle low down in the primary cycle, which meant that 65 to 75 per cent of all standard four children never went on to the last four years of primary education. In the late 1950s and early 1960s, this took roughly one hundred thousand children out of educational circulation each year, and naturally guaranteed jobs to the ones who remained till the end of primary. With the approach of independence, there seemed no way to justify this forcible deschooling. The examination was removed and the wave of previously discarded children moved steadily upwards, to reach the end of primary school just after independence. Where primary leavers had been about ten to twenty thousand in the last years of colonialism, by the mere expendient of lifting a colonial barrier, that figure was shortly 140 000 and ten years after independence a quarter of a million. The primary school leaver crisis thus emerged, just after Kenya's independence,[34] as part of an inevitable reaction to the legacy of colonial restriction.

Returning to our earlier discussion of certification escalation, we could say that by postponing the crucial selection in this way for three years (from Standard IV to Standard VII), the primary school certificate was rendered worthless. The basic cycle was made three years longer, the cost of the exercise probably doubled, and a good deal more English had been taught. But as we shall see, the English medium in the upper primary does not necessarily in the longer term give the average primary seven leaver any edge over his primary four colonial

counterpart. It only really affects the small group selected for secondary schools.

Self-help: a local planning style
The highly developed phenomenon of self-help in Kenya is partly the result of the colonial legacy. The colonial government was very suspicious of any initiative in education that was not linked to mission or local authority patronage, and in particular had banned the 300 to 400 independent schools of the Kikuyu people at the outbreak of the Emergency. Early efforts of communities to provide themselves with secondary schools had usually been deflected by government towards elementary or primary school building. As a consequence it was politically impossible at Independence for the new African government to frown on community self-help in the provision of secondary schools. Of course communities were not only reacting to the legacy of colonial restriction, but were also drawing on indigenous traditions of self-help.[35]

Soon the new government began to apply to the secondary school sector the same principle that had already become widespread in primary education since Independence. This had meant at the primary level that once a local community had provided the capital costs of a school and had shown it was a going concern, there was a very good chance of its recurrent costs being met by the local government. Of course when it came to the secondary level, government takeover of the burgeoning self-help (*harambee*) secondary schools could not be automatic, because of the much greater recurrent costs involved. But even if it could only afford to take over, say, thirty unaided form one classes each year, at least the possibility was always there for the remaining three or four hundred. And this made many *harambee* school committees anxious to design their new ventures to a high standard, and if possible hire one or two expatriate staff. It made the *harambee* school stick as closely to the government model as it could afford, in the hope that it could pre-empt the Ministry's choice of new schools to be maintained. By the early 1970s, this meant that government no longer built secondary schools, or even planned where they should be built. It merely reacted to a host of local political pressures in deciding which existing self-help schools should be taken over. Also by the 1970s the self-help movement which was the engine of primary and secondary school development turned to the promotion of post-secondary technical and technological institutes. As the plans and fund-raising for some fifteen of these got under way in 1972, the same principle of pre-emptive development was at work, and the same relatively high cost, high specification model of a technical college was aimed at. Of course this whole recent drive towards technical education is very much at variance with the scholastic academic legacy despairingly alleged of so many African school systems. It will be noted

later, however, that technical education deviates very markedly from many outside observers' notions of the African prejudice against manual and technical work.

For the moment, we may say that the colonial imported system did not have only one impact either in the colonial period or since independence. As colonial policy on education itself was by no means static, reactions have changed accordingly in the colony, and continue to alter now in the second decade of independence. It needs to be pointed out also, in this connection, that the local styles of educational decision-making which have emerged in different African states are not composed of decisions to accept or reject the colonial import; they are a much more subtle blend of these along with an indigenous, and often traditional ingredient. In effect the metropolitan model had a filter placed on it both by its exporters and by those for whom it was imported. To this extent, the local policy makers do not see the education system as quite the artificial construct that many outsiders imagine.

Dualistic structure of formal schooling

It was mentioned earlier that one of the demands at the international advisory level is for the development of diversified secondary school systems, with a whole new layer devoted to relevant and more vocational biases. In Kenya, for instance, it was often regretted by observers that *harambee* secondary schools did not strike out on their own, to search for more appropriate solutions to post-primary education. It has to be remembered, however, that, unlike metropolitan countries with their lycée/grammar/direct grant or academy streams and schools rather rigidly divided from their non-certificate counterparts, Kenya, along with many other African countries, has basically only a *monolithic* secondary system. By co-opting the self-help movement gradually and thus maintaining its standards, the emergence of the backstreet private venture school has been considerably retarded. In addition, in a situation where only a small portion of the quarter of a million primary students have the fees or good fortune to get into *any* sort of secondary school (academic, technical or *harambee*), no very great status divisions should be expected within the secondary population.

The great divide in Kenya is not by school type, but between primary and secondary. Since this has some important implications for innovation in the primary school, as well as for post-primary employment options, it may be worthwhile examining this division more closely. The style of life in the two institutions has a great deal to do with the aspirations of their respective graduates. The main terms of the contrast is presented in a chart.

	PRIMARY	SECONDARY
Language	English, not taken root	Competence in English
Fee	No fees in St. I to IV K£2 to K£3 per annum in St. V to VII	K£20 to K£50 depending on govt. or *harambee,* day or boarding
Boarding	Almost non-existent	Very prevalent
Staff	Entirely Kenyan and 50 per cent unqualified	Significant expatriate element; still many unqualified in *harambee* secondary
Equipment and Compound	Great variations in desks, classroom size, teachers' houses, often overcrowding	Standard class sizes, desks and laboratory; provision of stone-built teachers' houses
Repeating Classes	Widespread throughout all but urban primary schools	No repeating
Dropouts	Still very considerable as well as dropping in	Scarcely significant between Forms I and IV though some *harambee* leavers after Form II

It is often alleged that the primary school is somehow removed from the way of life of the village, as a remote and foreign institution. It seems that this is really quite untrue. In fact, the primary school is a very close reflection of the village's state of development. Depending on the village's prosperity it is built of mud, timber or stone. The pupils have a uniform of a simple shift, or a shirt and shorts. Except in the better urban schools, there are no sandals under individual desks, but often even in the top classes two or three lots of bare feet clustered round each makeshift desk. The compound and the teachers' houses, where they are provided, merge into the surrounding village; and there are no cars outside their doors. As in the village, there is no electricity for the teachers or the classes. There is no food at lunchtime; so children who walk too far may eat their first real meal rather late. Most children, though they use English officially as the medium of instruction in higher classes, have never talked to any teacher who uses it as a first language. Schooling is not, of course, compulsory, but few children take the primary course in the minimum of seven years. Experience has shown that success in secondary school selection can often only come after repeating classes and retaking the final examination two or three times. Thus it may sometimes take ten or eleven years instead of seven for a child to realise whether he or she is going on to secondary education.

By contrast, the successful secondary entrant moves physically away

from the village to a world where there are real uniforms, stone buildings in a large compound, some expatriate teachers and regulation-sized classes. Some children receive shoes for the first time, and instead of the single meal' a day, there are two main meals for boarders, in addition to breakfast and other snacks. By virtue of passing his entrance, the child can escape from household chores—particularly heavy for primary school girls—and become someone whose vacations even are respected by most parents who revere study. While the unsuccessful primary leaver's English ability gradually slips away from him; secondary school affirms English competence and creates a group of graduates who are separated at least linguistically from most school children and most adults. Also, once safely into secondary, there is almost no danger of being removed from it until four years are up, and the next hurdle of 'O' level presents itself. It is quite understandable therefore that boys and girls who are in this sense the aristocracy of the school population should think of themselves as 'big people', and that even boys in technical and vocational schools should see themselves being prepared for careers of directing and supervising others rather than having a direct practical orientation for their own work.

Dualism and Unemployment

The implications of this dualism of school type are important both for employment and unemployment. Firstly, it means that we have to be clear what is suggested by the 'problem of primary school leaver unemployment'. When, for instance, Kenya's Education Commission, reporting in the first year of Independence, discovered the 'new phenomenon' of primary school leavers with no opportunity for further education or jobs, it was naturally very concerned.[36] They were after all looking at the first wave of pupils who had no longer been halted by the Standard Four examination; and these were therefore arriving at the top of primary school with the *same aspirations* as the elite group who had just a year earlier been protected by that same colonial filter. They could not be expected immediately to accept that the primary school leaver had ceased to be anything special. And so naturally they flocked to town, and came to the attention of the contemporary analysts. Here, for instance, is René Dumont (in 1962):

> They [the Republic of Congo (Brazzaville), Gabon and Southern Cameroon] are thereby filling up the village, later the town streets with jobless and idle youths.
>
> Before long, these young people end up in the shanty towns of the capitals and become social parasites. Their days are spent writing requests for jobs. . . . Some of them, in Douala for example, join the underground.[37]

This view of the primary school leaver as a layabout-cum-political threat possibly had a grain of truth for that period when the newly

released primary school bulge was first stopped short by the lack of jobs and further education. But by the time ten cohorts of primary school leavers had had the same experience in tens and hundreds of thousands during the 1960s, this early image of primary leavers had become an unjust caricature. As we shall see later, once the primary-school leaver in Kenya has tried his luck one, two or three times on the national lottery of the secondary entrance examination, he does not wait around, but seeks out some form of local or urban self-employment directly. [38]

By an extension of the same principle, the secondary-school leaver may be expected to take a good deal longer to reconcile himself to taking up even the humblest forms of self-employment. It was noticed in Kenya as early as 1968 that the 14 000-odd form-four leavers were having a good deal more trouble getting satisfactory jobs than the 4 000 who had left the same form in the year of Independence. By 1974 predictably the 40 000-odd fourth-form leavers found things a bit more difficult still. It is doubtful, however, if they can set aside so lightly the rather special status that secondary school attendance conferred on them. Indeed, there is some limited evidence to suggest that secondary leavers are prepared to mark time for several years—perhaps taking a temporary job, following a vocational course, or taking some further examinations as private candidates. [39]

When we come to consider the impact of the two types of schools upon technical skills and productive employment, we shall find that the very different 'styles' or 'messages' of primary and secondary schools have some further significance.

Schools and Skills—a Case Study of Local Interaction

The subject of 'schools and skills' is perhaps one of the most crucial areas in the eyes of the outside funds and agencies concerned with African education; it is for that reason all the more vital that the *local* priorities and attitudes towards technical skills be uncovered first, before suggesting further innovative programmes for skilled manpower. There has in fact been no shortage of suggested schemes in the field of manual, vocational or technical education—indeed such recommendations form a strong continuous thread from the 1970s back to beginnings of education in Kenya. The common denominator of almost all this advice on vocational education has been the assumption that it has to be communicated in a formal institutional setting. There was accordingly a disinclination to look beyond the bounds of the school, and a failure to notice that the condition of technical education and training *inside* the school system was quite substantially affected by what sort of skill acquisition was available outside.

It is critical therefore to outline briefly the emergence of these two forms of skill (in-school and out-of-school) over the last few decades if a

21

proper appreciation of technical education and training today is to be reached. As will be seen, in-school and out-of-school skill training have not always been the same as they now are. They have, however, usually interacted with each other, and it is this process of interaction which is of particular importance in the 1970s as planners wrestle with the problem of what skills the school can appropriately provide.

THE DEVELOPMENT OF FORMAL AND INFORMAL SECTOR SKILLS

Stage I: The school as a factory (1911-1934) versus the Indian mode of skill acquisition

Although it has been frequently maintained that Africans successfully resisted the imposition of manual and vocational biases in their schools, there is no doubt that in Kenya for a considerable period all the main mission and government primary schools were vocational. This was not a question of a little technical or agricultural emphasis here and there in the school curriculum — there was simply no way of acquiring schooling that was not narrowly vocational. Pupils were indentured as they entered primary school (that is after their four years of what was then called elementary school); most of their school day was organised around productive labour in the particular vocation to which they had been legally bound, and there was an opportunity to pick up the academic subjects in night school. Most pupils were indentured to follow the basic trades of masonry and carpentry, although in some missions it was possible to follow a course for hospital dressers, teachers and catechists. As the government grants in aid were primarily allocated for the artisan apprenticeships, no school could attract substantial grants unless it technicalised itself.[40]

Several points need to be made about this relatively early system, a number of which have immediate relevance to the present.

1. There is no sense in which this productive labour system in the best primary schools was a part of some metropolitan model. At this period the schools of England and Scotland were certainly not engaged in productive labour. Indeed a master who moved from manual instruction in Scottish elementary schools to, say, the Scottish mission schools in Kenya at this time left a system where he taught carpentry for two or three periods a week to each class for one where he directed building and production squads all day.[41]
2. Apprenticeship and indenture, which was, of course, industry-based in the United Kingdom, found its way into the school system in Kenya. It was assumed that skills *had* to be produced through

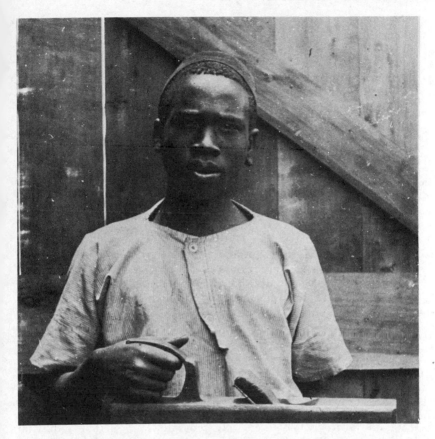

Fig. 1. Jomo Kenyatta, one of Kenya's earliest formal sector apprentices, pictured here during his indenture in the technical department of the Church of Scotland Mission.

apprenticeship, and lacking the industrial and trade union structure in Kenya, the school tried to substitute for the firm. As a result the first two years of the indenture were carried on in school, and even then the pupils did not leave for jobs, but continued for their next three years of apprenticeship in a central government school — the Native Industrial Training Depot (NITD). Thus, even at that early period, it was accepted that industry — such as it was — would not be able or would not wish to produce a 'real' African apprentice.

3. The decision to manipulate the school system to produce African artisans stemmed from the larger politics of East Africa at the time. It was not that there was a shortage of available skilled manpower, but rather that white settlers wished to substitute what they hoped would be cheaper African artisans for the Indians who monopolised almost all

skilled positions in the country. Many white settlers were in a parlous financial state—particularly during the 1920s and early 1930s—and although they were campaigning against giving the franchise to the Indians, some could scarcely afford to employ an Indian skilled man (*fundi*).

4. Paradoxically, although there was a considerable political interest in substituting Africans for Indians in the Kenya economy, the Indian monopoly of skilled positions in the Railways, Harbours, Power and Lighting, as well as in building and contracting and private industry continued right up to Independence in 1963. Africans did begin to emerge from the NITD in the late twenties, and a few went on to the great estates as the settlers had hoped. Others aimed at the technical corporations like the Railways where conditions of service were very advanced by the standards of the time, or the Public Works Department (PWD). It was noted by the authorities quite early on that these NITD people, for all the rigours of their training, had really quite fixed ideas about the sort of job they should accept. In fact, it was not surprising that the school-based apprentices in Kenya should have aspirations radically different from UK apprentices of the same period. The British apprentice did not consider himself at all privileged; he was often following in a family tradition, and approximately a third of his age group would likewise be entering apprenticeship. But when this five-year UK model was transferred to Kenya, it was organised around that tiny school-going elite who clearly were in some sense special. Moreover, unlike Britain, it was introduced right at the top of the educational pyramid—in the best government and mission schools, and in the follow-up Depot at Kabete.

So quite apart from the fact that the Kenya apprentices learnt their trade in formal schools, entirely separate from actual industrial conditions, the particular trade they followed did not by any means determine their own career, as it very likely would in Britain. Practising to be a mason or carpenter for five years *appeared* to be the main curriculum, but often this curricular message was overlaid by the awareness of being at the top of the school-going section of the community. Consequently, very few got stuck in a lifetime's service in, say, the building trades, or on a settler estate. Because of their relatively privileged position in their own communities, they were able to turn to business on their own account and to the retail trade, acquiring land in many cases. Those who went into the Railways or the PWD would certainly not have been ordinary experienced joiners or masons twenty years later, but would probably have been on the supervisory side.

Even in this quite early period, also, it appeared that the five-year apprenticeship system was not producing the kind of skilled man required by the settlers or by the smaller-scale Indian firms in the towns. As early as 1930, what would later be called the 'mismatching' of school

and job was being noted by the Director of Education.

> The employment of ex-apprentices on farms is not an unqualified success. The farmer appears to have two needs. The first is a handyman which we do not undertake to produce. *If the African training is to be successful in the long run, he must be successful because he is a skilled tradesman and not a poor 'jack of all trades'.* The second requirement of the settler is a man to do a piece of work which will occupy a month or so. This is a real difficulty. The boy who leaves the Native Industrial Training Depot wants and looks for permanent work.[42] [My emphasis]

It could already be said in the mid-thirties that the system designed by the government to lessen reliance upon the Indian skilled class had not succeeded in its main purpose. Instead of turning out an adaptable group of skilled craft-level workers, it seemed to be increasingly used as a stepping stone towards the security of the largest corporations. This configuration was to continue in the next decades, and formal technical training was to become more and more remote from the needs of the majority of small enterprises in Kenya.

5. During this time when the formal school was being unsuccessfully entrusted with producing a new layer of African artisans, there was a singular lack of interest in methods of Indian skill acquisition. Occasionally, the Education Department would bemoan the lack of manual training in the segregated Indian schools in Kenya, but there was little reflection on the *methods* of Indian training outside the schools despite their effectiveness in destroying both African *and* European competition. Of course, a good deal of the Indian skilled class came to East Africa with long family traditions of working in tin, glass, wood, iron and other more specialised occupations. These families were responsible for introducing to Kenya a technology intermediate between that of the large colonial corporations and the traditional crafts of the various African communities. They imported silently, but on a grand scale, a very significant range of low level products, and a style of manufacture in which improvisation with tools and materials was a key feature. A contemporary writer picked on some of these features of adaptability and informality back in the early 1930s, at a time when the government's formally produced African tradesmen were already encountering difficulty in getting employment of the sort they desired.

> If an Indian can do nothing else, he can drive a lorry: whether he learns beforehand or on the way to the police test-station is perhaps doubtful. He can certainly get movement from a car which to anyone else appears an animated scrap-heap. On the road he is always travelling at full throttle; when stopped by an overheated engine he will draw water from the boiling radiator and make tea. He can apparently repair most things with a piece of string, and will run tyres till they look like firehose gone ragged. An Indian shopkeeper faced

with competition cuts prices till only he knows where he makes the profit; he will sell whisky at a price per bottle lower than the wholesale pro rata case price — he sells the deal box separately, and makes his profit on that.[43]

It was also during the 1930s that this mode of improvisation began to reproduce itself in the first African employees of the Indian craft workers. Such employees were at the opposite pole to their counterparts in formal trade training; they would almost certainly have no schooling at all — like so many of the Indians they worked for. They therefore learnt the various technical processes entirely on the job, and gradually as the Indians relaxed their closed craft mentality, whole items began to be produced completely by African labour. This will be referred to in more detail in several of the technical chapters that follow. But the result was that from the whole range of Indian small enterprise (garages, blacksmithing, tinsmithing, tailoring, furniture and building, to mention only a few) there began to emerge Africans who had slowly acquired elements of Indian skill. In all likelihood, such Africans were the first generation in their families to engage in craft activity. They established themselves shortly on their own in the African areas of Nairobi and Mombasa, making independently what they had previously made in employment, while others went back to their town or village and used their newly acquired skills there. It seems, for example, as if in many areas the first permanent stone buildings were erected in such villages through the skills of these ex-employees of the Indian builders.
6. With the emergence of these rough and ready skilled operators, there began to grow up also from the 1930s a variety of ways in which their skill could be passed on to village or town mates who were interested. Often for a sheep or a goat, amongst the Kikuyu, a skilled man would agree to teach somebody else, and then as time went on a sum of money took the place of the gift. It seems to have been then as now a rather flexible system. The learner was not bound to stay with the master for any specific time, but could leave just as soon as he felt he had acquired sufficient skill. As far as can be ascertained this informal training was not based on any traditional model in any of Kenya's communities. A detailed account of its workings will be entered into a little later; at this stage it is mentioned simply to point up the contrast between the formal and informal modes of skill acquisition. In both sectors, for example, trainees would seem to be getting skills in, say, masonry and carpentry. The difference was that those training in the Indian mode would be rather likely to remain carpenters or masons either in employment or self-employment, and some of them in turn might well become skill models for other younger men. The formal sector trainee — despite the apparently much more rigorous exposure to trade training — could well have abandoned the actual practice of the trade after an interval of a few years.

7. In addition to the school-based system and the Indian mode, which rapidly indigenised itself, into a local monetised system, there was a third category which can also be called a variety of the Indian mode. This was a procedure which became widespread in many of the Indian and European industries. It involved taking on unskilled and, usually, unschooled workers as casual labour (*kibarua*), and then over the years letting them sort themselves out into the more or less productive. Increasingly, the better workers would work close to an Indian *fundi* and then be taken on to permanent terms, while the others would remain as casual labour. Given the availability of Indian skilled labour (these could be imported direct to Kenya from India as late as the 1950s), it was perhaps inevitable that a phalanx of skilled Indians should establish themselves in most enterprises, and that beneath them all the more or less semi-skilled jobs should be done by Africans. As long, therefore, as there was no embargo on using Indians, firms found that really there was no training problem. Indians knew it already, and the others could be recruited as day labourers and pick up what was necessary on the job. We shall see later that a problem only presented itself in this area at Independence, when the skill monopoly of the Indians became a political embarrassment. It was thought for a time that there would be the most enormous gaps if, for instance, the non-citizen Indians had to be replaced at all rapidly, and that, as a consequence there would have to be major programmes mounted in the formal sector of education to produce substitutes.

This notion was affirmed by manpower planners in the period just after Independence who tended to assume that a replacement craftsman or technician had to have so many years of formal education, followed by so many further years of formal craft or technical training.[44] In fact, however, as the non-citizen element began to withdraw, their places were quietly taken by Africans who had originally been taken on at the factory gate as casual labourers. It became clear that the African workers had not really been an undifferentiated semi-skilled mass, but that a good number had successfully acquired substantial skills informally. As will be seen in a later chapter, the satisfaction of many employers with such informally skilled workers made for difficulties of absorption for the more highly schooled and certified products of the formal educational system.

Since the main lines of demarcation between the formal and informal modes of acquiring skill had become apparent as early as the mid 1930s, it will not be necessary to treat the subsequent stages in much more than outline.

Stage II: Trade Schools and Primary Schools, 1935-1963

The emergence of Trade Schools

The indenturing of primary school students to follow certain trades was

dropped in the early thirties when Kenya was still gripped by the world recession. Perhaps almost a thousand students had completed the full five years and graduated from the Training Depot at Kabete, near Nairobi. But, possibly for some of the reasons mentioned above, government, the white settlers and local industry were not so clear as they once were about the desperate need to undercut the Indians. The settlers, for their part, found the ex-apprentices unsuitable because they were insufficiently versatile. They were not at all acceptable to Indian local industry which was used to training workers on the job. The apprentices themselves wished to be taken on in the largest private firms and in the government's technical departments. In this event, it possibly did not any longer seem worth skewing the whole upper primary school system towards technical work when the operation was rather expensive and had really relatively little impact on the larger economy outside.

Once primary schools had been relieved of the task of indenturing artisans and of attempting to give them *fulltime* training, this operation was left to the post-primary level at the Kabete Depot, and the latter changed its function to being the first of the trade-and-technical schools. By the late 1940s and early fifties, it had been joined by five similar post-primary schools. This group of specifically trade schools continued the Kabete tradition of engaging in a very sizeable amount of productive labour. The students went in squads round the country building school blocks, or made prodigious quantities of school furniture when they were based in their schools. The value of the work completed by this particular form of cheap labour could be anywhere between £10 000 and £100 000 in a single year.[45] Undoubtedly, the fact that such schools engaged in *productive labour* on a scale without parallel anywhere in Independent Kenya (or in many other African countries) did mean that some students got sufficient work experience to launch out on their own shortly after leaving. They were still, however, not particularly acceptable to the bulk of Kenyan industry during the 1940s and 1950s, which, as we have said, preferred to recruit much lower down the educational pyramid, and let skills be acquired on the job.

Faced with criticism of the school-based apprentices, the Education Department tended to react by schemes for further upgrading or more certification. Thus the trade-and-technical schools formalised a link with the City and Guilds examining body in London, and they gradually lengthened their courses and added more theory. The more this was done, however, the narrower the band of employers that could take them on.

There were very few official voices raised to oppose this search for the elusive 'model apprentice' with his higher and higher qualifications, or to notice the almost total divorce between the trade schools and the

majority of smaller Indian and European firms that used less sophisticated technology and different training methods from the large technical departments of government. Indeed, almost the only major insight into the malfunctioning of the watered-down UK apprenticeship export to Kenya came from the famous East Africa Royal Commission of 1953-55. Just as it had challenged the closed system of the White Highlands, and other white monopolies, so it also wanted labour training to be marked by openness and diversity. Its judgement may be quoted at some length, particularly as, in this matter, it was not heeded in the slightest.

> It may be doubted whether, at this stage in the industrial development of East Africa, there is much scope for the further extension of systematic schemes of apprenticeship or for a slavish adherence to a type of apprenticeship which is peculiarly European. Historically the apprenticeship system in Europe was introduced to preserve the exercise of a craft which already existed and, by restrictions on entry, to maintain the economic position of those who already practised this craft. *It was not primarily designed to increase the supply of skilled labour.* In East Africa, where among the African industrial population there are practically no established crafts to protect, it may well be that the dominant need is for a more flexible system of training rather than a close imitation of a system which evolved under quite different circumstances.[46]

Vocationalising the late colonial primary school, 1935-1963
There was, of course, a 'more flexible system of training' already operating informally, and this we shall return to in a moment. Meanwhile, in the upper primary schools (called 'intermediate' during the late forties up to Independence) agriculture, handcraft and domestic science were still important, and these were greatly aided by the examination; the official position was that a child could not gain his primary leaving certificate unless he had passed in one of these subjects. It will be noticed that this use of the examination as a lever is precisely what is so frequently recommended by primary school reformers in the 1970s. At that earlier period, the colonial government — apart from its Education Department — was prepared to give such vocational training their support. They had become convinced after the war that there had to be some sort of revolution in agricultural practice and produce in the African Reserves. Agricultural Education Officers were appointed here and there, and worked to make school gardens and individual plots a demonstration of the new orthodoxy on terracing, contouring and soil preservation. One of the more sensational outgrowths of this vocationalisation was the experimental ranch of 2 000 acres attached to the pastoral Maasai's intermediate school in 1950.[47] And there were other areas where the enthusiasm of a headmaster and a vigorous inspectorate produced quite remarkable results. Like the Maasai

experiment there were attempts to develop positive local linkages with the surrounding economy; a clear example would be the soapstone carvings — now a tourist industry — which played an important part in the intermediate schools of what is now Kisii District.

Although these schools had moved a long way from when, prior to 1934 the indentured students had spent the entire day on their trade, there was still a solid section of each day devoted to non-academic work. They were still in fact a long way away from what passes as vocational bias in many African primary and secondary schools today. At first glance agriculture and trades appeared to be structurally integrated into school experience at this level; in reality this was not the case at all. There was a direct clash between the selective function of these schools and the vocational message they strove to supply. This was particularly true of the 1940s and early 1950s when the colonial barrier at Standard IV ensured that the intermediate schools (Standard V to VIII) comprised only 2 to 10 per cent of the total primary school population. They had been rigorously selected in the fourth class, and thus apart from the miniscule number of students in senior secondary schools they were at the top of the education pyramid. This meant that the vocational emphasis was being offered primarily to that select group who could without any difficulty at that time find a secure job in the civil service or private sector of the economy. Protected by the expulsion of 60 to 80 per cent of primary children at class four, the intermediate school leavers in general had absolutely no need to practise those 'relevant' subjects which had been so carefully inspected and examined. Only a handful of those who dropped out or were unable to complete the four-year course began to practise their trade as a last resort. And this had certainly not been the intention of the Education Department.

The examination had been an effective lever, as far as ensuring some competence in vocational subjects was concerned, but its influence had been outweighed by the stronger lever of selection at Standard IV. This severed any need for a link between vocational schooling and a job.

The example of this colonial examination lever has been deliberately mentioned to point up the danger of generalising about vocational schooling prior to Independence. Often it has been alleged that trade training was a failure because of 'African resistance'.[48] This is much too vague a term to be helpful, and in the particular case just mentioned is really not applicable. Political resistance there certainly was in some situations where it looked as if the school farm or ranch was going to involve yet more alienation of African land than had already been lost to white settlers in Kenya. But in the majority of cases, *both then and now*, it is necessary to examine in some detail the wider structure of those schools that are said to be vocationalised, if the likely impact is to be assessed.

Continued Expansion of Informal Sector

As the school-based system proceeded to greater and greater degrees of formalisation towards the end of the colonial period, the flexible, open-access training available in the informal modes continued to provide most of the basic skills used in the rural and urban areas. Information on its existence and development has principally to be derived from oral interviews, since the official labour statistics did not register this layer of the population. But there is also the negative evidence from the schools. The intermediate and trade schools kept trying unsuccessfully to produce an artisan type which was being turned out by other methods out-of-school.

It is important, during this period of the late 1940s and 1950s, to distinguish this local brand of almost unseen informal training, from the various initiatives in out-of-school education that began to make their appearance in significant numbers. Some of these were the practical working out of the interest in mass education that we remarked on in the advisory literature earlier in part one. And it was certainly true of Kenya that they were strongly tinged with political motivation. In fact, community development and adult literacy schemes were ushered in during the Mau Mau Emergency, and some initiatives were clearly designed to immunise surrounding tribes against the revolt that seemed to be spreading outwards from Kikuyu country. Informal education purveyed at this time appeared more as rehabilitation of dissidents and vagrants than as a wide campaign to deal with the illiterate and disadvantaged. Towards the end of the 1950s, community development workers began to organise rather low level courses in artisan and homecraft skills, but this does not seem particularly to have affected the larger informal apprenticeship system.

Stage III: Detechnicalisation and Retechnicalisation at Independence

These are rather clumsy but useful shorthand for processes which took place during what we called the era of identity or assimilation, when external planners urged the dramatic expansion of formal education systems — particularly at the higher level. They may be used to demonstrate the role of local planning as it affected the more technical side of the school and training systems. We have shown that, apart from the separate trade and technical schools, formal vocational instruction had only been offered to a group in the intermediate schools whose future employment had been secured by rigorous selection, and who consequently did not need to make use of their practical knowledge. As Independence approached, local communities strove to build up their own intermediate streams, and pressure began to grow to remove what was seen as the colonial device of scrapping 80 per cent of primary

children at the class (or Standard) IV level. Once this barrier had gone down, the hundred thousand children who had previously been discarded each year began to press upwards through the remainder of the primary system. Within three years, there were almost 400 000 in that portion of the school which selection had earlier restricted to 40 000. The numbers alone put an immediate obstacle in the way of providing compulsory, examinable vocational instruction in the higher primary classes. So, rather than attempt provision for a few, the Kenya Education Commission recommended the withdrawal of agriculture as a separate and distinct subject. On the trade training side, the practical examination was abandoned and the importance of the subject entrusted to exhortation.

> Not all teachers can readily supply this emphasis, but we hope that training colleges will not only give it their attention during the training of new teachers, but will also explain to all their students the widespread importance of manual dexterity in all aspects of life in Kenya today.[49]

Through out-of-school provision

Within two years of Independence, Kenya's version of the Primary School Leaver Crisis had struck. We have already mentioned the aspirations of these first batches of leavers from the Standard IV bulge. But what also became rapidly clear to concerned bodies between 1965-67 was that these leavers had no marketable skill at all. They no longer even received that exposure to manual work that their predecessors had got but had not used. In response therefore to this situation, a series of initiatives were taken to offer skill opportunities to the primary school leavers. Most had a strong vocational bias. The earliest of these post-Independence ventures was the *National Youth Service* — a two-year programme that linked a little general education with productive labour and gave short intensive vocational instruction in one of four basic skills — carpentry, masonry, motor vehicle and electrical. The mode of the Youth Service is rather formal, and its narrower vocational aim is preparation for a Government grade three trade test. So far the Service has been relatively successful in placing its graduates in employment in the public and private sectors of the economy.[50]

A significant role was also seized by the voluntary agencies in this area of skill provision to primary leavers. In fact it should be noted that a large number of innovative projects have been launched particularly by religious bodies — both missions and the indigenous churches. As missions and church bodies shed their very demanding obligations to formal education that they had carried through the colonial period, a number of countries, including Kenya, found that with the secularisation of formal education, the voluntary agencies were able to move into

less formal provision, often pioneering in very important areas. Indeed, many of the schemes so much admired by the enthusiasts of informal education are ones which have been sponsored by religious organisation.

The most notable example in Kenya is the *Village Polytechnics,* which grew out of the National Christian Council of Kenya's working document: *After School What?* [51] In contrast to the National Youth Service — with its boarding accommodation, country-wide recruitment and formal provision of basic courses aimed at employment, the Village Polytechnic architects were anxious to avoid institutionalisation. They wanted small, flexible, intensely local structures, which could reflect a particular community's needs at the post-primary skill level. They were adamant that provision should not mean the same four old courses that every vocational institution felt it necessary to offer: carpentry, masonry, electrical work and motor vehicle repair. Instead, ideally, the polytechnic should respond to local needs whatever they were, and also take the lead in offering skills that might make a difference to the quality of life in the countryside. It should not, its designers felt, encourage students to aspire to wage earning positions in towns, but prepare them individually or communally to exploit the income opportunities of the rural areas. Finally it should be low cost, non-boarding and steer clear of certification.

From this brief outline, it can be seen that the village polytechnic movement (in 1974 there were some sixty polytechnics) might be a useful illustration of some of the nonformal thinking that was discussed at the beginning of this chapter. And it certainly has had the attention of a number of the overseas agencies most concerned with out-of-school innovations. Its aims and philosophy looked impeccable, particularly from the viewpoint of those groups disenchanted with formal education and anxious to identify viable alternatives. There has accordingly been a great deal of interest in whether the village polytechnic has been able to work out its philosophy in practice. [52] Many of the students have been asked about their aspirations, and others have been followed up after leaving to see whether they were in fact staying in the rural areas, or slipping towards urban wage employment after all.

Results of such survey work are by no means conclusive yet, but concern has been expressed at the trend towards formalisation in many of the polytechnics. Course provision has by no means been as varied and innovative as was hoped. In fact, carpentry and masonry have figured prominently, and these and other courses have been linked to taking the government trade tests. There has also been student pressure in some areas to make the polytechnics more school-like, through requests for uniform, boarding facilities and more academic content. And despite a sizeable group who have entered local self-employment, there remains substantial interest in entering formal wage employment.

It could perhaps be said that the polytechnics have suffered from being examined in isolation from the wider opportunities for skills in a particular area. They have been seen too often as being at the opposite pole to the formal school and the formal technical institute. Whereas it would be truer to say that they are only about midway along a spectrum from formal school to the completely informal apprenticeship we have described. When the size of the completely informal apprenticeship is once appreciated, it is not difficult to see how would-be innovative ventures get co-opted into the formal mainstream. Compared with the *ad hoc* arrangements that characterise informal training, the village polytechnic has, after all, paid teachers, some permanent structures, and links to finance and consultation in Nairobi. It is not perhaps surprising then that they do get used by some students as if they were formal training institutes.

Some of the heart-searching about whether village polytechnics were going to be true to their ideal could have been avoided if *all* the *existing* avenues to skill in the rural areas had been noticed, and the village polytechnic contribution had then been fitted into this wider band of training opportunities. In the event, it was too readily assumed that, as primary schools from 1963 no longer offered any significant manual instruction, the primary-school leaver (and his adult community) would embrace the polytechnic movement as the only real alternative to secondary-school entrance. Since a wide range of low level skill instruction already existed informally, it was not remarkable that parental and student interest focussed on further secondary school provision and on the formalisation of village polytechnics where they existed.

We shall attempt in a later chapter to elaborate upon the skill spectrum that obtains in many rural areas, and discuss the interaction of its various components. Here the point is merely being made that training initiatives at the immediate post-primary level need to be looked on as part of a continuum, from formal to informal. Along such a spectrum, the various provisions for skill acquisition can be marked off, and it would need to be noted that many of the most obvious skill offerings on the Kenya post-primary scene are much closer to the formal than the informal end of this spectrum. Bearing in mind that many of the following cluster round the formal end, we list a number of them here to indicate a progression from formality to informality.

FORMAL

Approved Schools
Technical Schools
Kenya National Youth Service
Christian Industrial Training Centres, at Mombasa and Nairobi

YMCA Craft Training; YWCA Vocational Training; Limuru Boys
 Centre
Private technical 'academies'
Government Youth Centres
Village Polytechnics
Rural Training Centres (Christian-sponsored)
Indigenous apprenticeship (individual arrangement with experienced
 artisan)
On-the-job skill acquisition in rural or urban African or Indian
 company

INFORMAL

A number of these formal institutions, although effective with those
they enrol, have such small groups of students passing through that they
cannot make any very major dent in that huge body of primary leavers
who do not go on to formal further education. Some of the Christian
Centres have a hundred or less enrolled at any one time. The 13-odd
village polytechnics had only about 400 students in 1971, although
numbers have increased almost tenfold recently with the many new
foundations. The form-one entry to the eight technical secondary
schools has only very recently passed the thousand mark. Admittedly,
the National Youth Service now graduates nearer 2 000 students (boys
and girls) annually. But even if all these sponsored skill programmes
are combined, their annual impact would almost certainly not be more
than 5 000 young people. A few important issues emerge even from
these rather approximate figures.

1. Apart from the last two items in the scale above, technical skill
provision immediately after primary school is in any one year presently
running at not much above 5 000 — which is quite a small proportion of
225 000 leaving Kenya's primary schools in 1974.[53]

2. Nonformal education and training surveys in East Africa have
tended to concentrate on programmes *sponsored* by some agency —
whether a ministry, a voluntary body, or a private foundation. They
have therefore tended to neglect the *most nonformal* acquisition of skills
through on-the-job training and the indigenous apprenticeship.

3. Leaving out these last two categories, it has to be admitted that the
genuine enthusiasm of many bodies to retechnicalise the primary school
leaver during the Independence era has succeeded in touching only a
fraction of the annual cohort.

4. No mass movement has emerged to cater for this level of leaver.
And it has to be remembered that if the numbers seem relatively small,
Kenya is probably, nevertheless, ahead of most African countries in the

diversity of programmes offered. That is to say, if nonformal education (of the sponsored variety) is still small for this age group in Kenya, it is a good deal smaller elsewhere in the continent.

5. It could be suggested that most of the sponsored programmes for skill acquisition communicate a desire for wage employment in the modern sector of the economy. By contrast, the 1960s witnessed a really major move towards self-employment from Kenyan primary school leavers getting their skill in the indigenous unsponsored system.

This last point presents something of a paradox. For although this very widespread move into self-employed craft activity is good news for those agencies that were most concerned earlier about the primary school leaver crisis, it also seems to raise a set of new questions, many of them bearing directly on the relationship between self-employment and the conventional academic school system. The chief of these is simply that very considerable numbers of young people have gained an artisan skill in the last decade, even though their seven to eleven years of schooling were completely devoid of prevocational bias, let alone any practical work experience. We shall be looking later more closely at the style of enterprise amongst these resolutely self-employed youngsters; it is tempting, however, to suggest that there seems very little specifically school ingredient in the training of these petty entrepreneurs.

Before jumping to the conclusion that this is further evidence against the expansion of primary schooling, it should be admitted that we have no very clear notion of what impact even a poor primary education has in Kenya. Too often only the actual subjects in the curriculum are considered, and on this basis, primary education is written off as irrelevant and undevelopmental. And yet the children (*and* young men and women) who leave primary schools have apparently not been completely deadened by years of cramming for the national multiple-choice examination at the end of primary. They have learnt the basic communication skills (even though their English will slip away from them, as maths does in Britain) and they have absorbed some kind of desire to move and improve themselves. Their vague sense of frustration at having failed to continue in the school system does not seem to affect their determination to make good through out-of-school opportunities. Obviously, seven to eleven years of cramming in primary school is not the ideal preparation or 'apprenticeship' for the many who will leave and become self-employed. But given the political reality that the primary school is a national lottery for *all* who would like to gamble on secondary education, there is not much that can be altered in its curriculum for the benefit of the eventually self-employed.

Clearly the perceived purpose of primary education dictates quite largely what can be taught in it. Thus, as the message of the primary school is concerned with employment and mobility, through secondary

school entry, any attempt formally to present a 'realistic' message about self-employment at the same time is likely to be unsuccessful. It is not really therefore a question of manipulating the primary-school leaving examination so that it has less harmful backwash effects throughout the school (as many modern reformers would propose), or so that entrepreneurial skills can in some way be communicated. It is more important to identify the larger function that government and parents see primary school fulfilling, and only then consider what innovations or reforms are compatible with this wider purpose. It has then to be accepted that in the short term at any rate primary schooling is designed as a relatively open access system of competition. The politics of fee-free primary schooling, which since January 1974 operates for the first four classes, affirms this, as do the rather small fees for the remaining three years. The race may eventually be to the swift, but at least everybody has a chance to enter.

From this perspective, one of the most important things about primary schools is their *ordinariness*. As we have stressed earlier, they are popular institutions built to the level the ordinary village can afford. They have the same lack of status and pretension that characterises the informal sector of the economy. And it is not surprising that after admitting defeat in the national examination competition many thousands of primary students can move directly across to earning their livelihood in that sector. There are, of course, important questions to be raised about the nature of that livelihood, and particularly about the impact upon the informal sector of the large companies and their style of operation. But these will be examined in a later chapter.

Formalisation of skill in the secondary school and Harambee Institute
1. *Technical secondary schools in the 1970s.* One last aspect of this process of 'retechnicalisation' needs to be considered, and this concerns the most recent developments in formal technical provision in Kenya. During the early 1970s (and thus at a time when the international literature on African education was at its most pessimistic) there has occurred local interest in technical education on a scale quite unprecedented anywhere on the continent. The most conspicuous part of this has been the planning and fund-raising for institutes or colleges of technology at the level immediately after form four. But even attitudes towards the eight to ten technical secondary schools altered dramatically in 1973/74. Five of these are the same foundations we described as trade and technical schools during the 1940s and 1950s; they have only very gradually increased their numbers, and compared with the eight hundred-odd general secondary schools, they are still a tiny section of the secondary school world. Nevertheless, they have suddenly been exposed to the most intense competition for entry, with hundreds of primary school leavers for each place. Indeed many of the

brightest children in the top primary classes across the country are putting down the names of technical schools as their first choice.*

The reasons for this build-up of interest in technical schooling betray either realism or optimism about the labour market. It may be called a realistic local adjustment if parents and teachers are becoming aware that the job prospects of the conventional, academic secondary leaver are no longer quite what they used to be. Equally, however, if it is going to become the received wisdom that a formal technical education will secure a good position on an otherwise closing job frontier, then there may be disappointment. We examine in some detail in a later chapter just how complex the industrial sector of the economy is, and how very varied are its views on *school-trained* technical personnel.

Here we may simply mention that the formalisation and upgrading of these schools has proceeded apace in the last few years. They now have a full four year secondary course, many of the subjects identical to general secondary, but with carefully assessed practical and theoretical work on the technical side. The specifically craft subjects remain the same (wood, metal, plumbing, electrical, motor vehicle), and the official position remains the same: that these students will become craft apprentices in the UK mould. The only difference is that apprenticeship is begun after form four rather than in the school itself. We have mentioned before that an institution such as apprenticeship which appears like a United Kingdom export, can function in Kenya in an entirely different manner from within its country of origin. In the case of apprentices, firms are *only* allowed to draw them from this tiny group of eight schools, and not from the general run of secondary schools (as they do in Europe). And since in Kenya the only organisations that have been interested at all in taking on apprentices have been government and the largest and most sophisticated subsidiaries of British companies, there has arisen a placement problem even when recruits are drawn from a very restricted group of schools. This raises a very real issue for the formal technical provision: these schools *appear* to be training people in broad craft skills which many thousands of artisans actually practise in Kenya, whereas in fact, the vast majority of skilled men in these basic pursuits (carpentry, building, auto repair, electrical work) continue to be trained by some of the other methods outlined earlier. The implications of this situation for secondary technical schools and for industry are taken up in Chapter III.

2. *Harambee institutes.* It is at this level that the drive towards technicalisation of the formal system has been most marked. The communities that constructed self-help secondary schools in the early

*Each child is allowed three choices of secondary school; the computer then sorts out for each government secondary school the total number of first, second and third choices it has obtained, and ranks these by marks obtained in the primary leaving examination.

and mid sixties had scarcely seen two or three cohorts complete the full course before it was apparent that mere general secondary education did not necessarily guarantee an immediate wage or salary job. Some marketable technical skill was needed, communities felt, to complete the task of the secondary school. It should be noticed in passing that the regional and tribal groupings that began fund-raising in 1971 and 1972 did *not* direct their attention to how the government and *harambee* secondary schools could be technicalised, along the lines of the eight schools that were. Technical diversification of existing secondary schools has been much more a concern of the international bodies such as the World Bank, and the Canadian and Swedish aid agencies. Local community planning by contrast was pre-occupied with post-secondary provision. Moreover the scope of the institutions planned was at the opposite pole from what we noted were the aims and philosophy of the village polytechnics. They were to be expensive, architect designed, boarding institutes whose products would enter wage employment, or if they turned to self-employment it would be more as small contractors than as artisans.[54]

However these institutes have been noted here, not so that they can be analysed or their provision criticised, but rather to point up the significance of the local factor in educational planning. In any case, in 1974, only one of the institutes was fully operational, two were on the point of commencing, and two or three others had designs which are going out to tender. It is clearly premature to suggest that they be turned into something else, when the great majority are not yet on the ground and when large sums of money have been collected towards implementing a particular kind of project. It is hoped, nevertheless, that in the following chapters some of the information on urban and rural skills will help to locate the sort of contribution that can be expected from the Harambee Institutes.

CONCLUSION

This account has attempted to contrast the complexity and particularity of Kenya's educational development with the more general thinking on African education at the international advisory level. Much of the most recent literature generated by the latter has stressed the need for a less formal conception of education in the poorer countries of the world, and for less linear expansion of the inherited colonial systems. One of the main difficulties in this new approach is that it tends to set up In-School-Learning and Out-Of-School-Learning as if they were two quite separate, readily identifiable things. Whereas, as we have tried to show, in Kenya, and in the case of skills in particular, formal and nonformal education form a continuum and not two quite different modes. Indeed

THE AFRICAN ARTISAN

many of the 'nonformal' programmes in Kenya most admired by donor agencies are much closer to the formal end of the spectrum than is appreciated. Their total coverage is also very small at the moment compared with the much less formal system of indigenous apprenticeship.

Furthermore, before some of the existing nonformal initiatives and projects get dignified into an alternative mode of education, it is important to recognise how they interact with or are structurally connected with parts of the formal mainstream. Many outside observers are very interested in what sort of impact the nonformal concept of education can have on the traditional school system; given the strength and buoyancy of the traditional system, however, it makes much more sense to turn the question round, and ask in what sorts of ways would-be nonformal programmes will become co-opted and altered by the general system of education.

Finally, it is important to recognise that there is no such thing as 'the traditional system' of education in a country like Kenya—if that term is used to connote a slavish retention of an outdated and inappropriate colonial model. Students, parents and local planners by no means have a static set of priorities about educational development in Kenya. In fact Kenyan education has shifted some of its emphases a great deal even since Independence; witness the drive towards mastery of technical education. Even at the intensely local and individual level there have been developments in education and training which are a world apart from the academic obsessions so frequently alleged of third-world countries. It is consequently to one of these major local innovations, the widespread system of indigenous apprenticeship, that we now turn.

REFERENCES

1. See, for example, W. Ladejinsky, 'Ironies of India's Green Revolution', *Foreign Affairs*, Vol. 48, No. 4, 1970; and I. Palmer, *How Revolutionary is the Green Revolution?* (published by the Voluntary Committee on Overseas Aid and Development, April 1973).
2. International Labour Office, *Employment, Incomes and Equality* (Geneva, 1972), 180-185.
3. *ibid.*, Ch. 13, 'The Development of the Informal Sector'.
4. D. Najman, *Education in Africa—What Next?* (Deux Mille, Aubenas, France, 1972); P. Coombs, *New Paths to Learning for Rural Children and Youth* (International Council for Educational Development, New York, 1973).
5. Coombs, *op. cit.*, 29.
6. M. Blaug, *Education and the Employment Problem in Developing Countries* (ILO, Geneva, 1973).
7. See, for example, Institute of Development Studies, 'Qualifications and Selection in the Educational Systems of Developing Countries' (Mimeo, IDS, University of Sussex, March 1974); and D. W. Courtney, 'Certification—a Trojan Horse in Africa: a perspective on educational and social change in mainland Tanzania' (Ph.D. dissertation, University of Syracuse, August 1973).

8. L. Emmerij, 'A New Look at some Strategies for Increasing Productive Employment in Africa', *International Labour Review*, ILO, No. 3, 1974, 199-218; also, 'The Examination and Selection System and the Certificate of Primary Education', Technical Paper No. 25 in ILO, *Employment, Incomes and Equality*. See K. King, 'Primary Schools in Kenya', Institute for Development Studies, Discussion Paper No. 130, Nairobi 1972, mimeo.

9. ILO, *op. cit.*, 244.

10. Papers presented to UNESCO-UNICEF Basic Education Conference, Nairobi, 1974, mimeo. Although this chapter is concerned with international trends, it is well known that Julius Nyerere has also espoused a form of basic education in his document, *Education for Self Reliance*. See also, World Bank, *Education Sector Working Paper* (Washington, December 1974).

11. Arthur Mayhew, *Education in the Colonial Empire* (London, 1938), 179.

12. *ibid.*, 195-96.

13. E. Ashby, *Universities: British, Indian, African* (London, 1966), Chs. 3 and 4.

14. Advisory Committee on Education in the Colonies, *Memorandum on the Education of African Communities* (Colonial No. 103, HMSO, 1935), 7.

15. Advisory Committee on Education in the Colonies, *Mass Education in African Society* (Colonial No. 186, HMSO, 1944).

16. Colonial Office, *Report of the Commission on Higher Education in the Colonies* (Cmd. 6647, HMSO, 1944).

17. W. Rodney, *How Europe Underdeveloped Africa* (Tanzania Publishing House, Dar es Salaam, 1972), 264 ff.

18. *Mass Education in African Society*, 7.

19. *ibid.*, 21.

20. See, for instance, Peter du Sautoy, *Community Development in Ghana* (Oxford University Press, London, 1958).

21. R. Prosser, 'The Development and Organisation of Adult Education in Kenya with special reference to African Rural Development, 1945-1970' (Ph.D. dissertation, University of Edinburgh, 1971).

22. UNESCO, International Commission on the Development of Education, *Learning To Be* (UNESCO, Paris, 1972), 54.

23. Nigeria, Federal Ministry of Education, *Investment in Education: The Report of the Commission on Post-School Certificate and Higher Education in Nigeria* (Lagos, 1960), 3.

24. For an evaluation and critique of these manpower plans, see R. Jolly and C. Colclough, 'African Manpower Plans: an Evaluation', *International Labour Review*, 106, Nos. 2 and 3, 1972, reprinted in ILO, *Employment in Africa: some critical issues* (Geneva, 1973), 231-88.

25. For a brief overview, see Pierre Henquet, 'Unesco and the Eradication of Illiteracy or the Metamorphoses of Fundamental Education', *Convergence*, 1, No. 3, September 1968; also M. Blaug, section on 'Adult literacy in poor countries' in his *An Introduction to the Economics of Education* (Penguin, 1970), 247-65.

26. A. Callaway, 'Unemployment among African School Leavers', *Journal of Modern African Studies*, I, 3, September 1963, 351-71. See also J. R. Sheffield (Ed.), *Education, Employment and Rural Development* (Nairobi, 1967).

27. See I. Illich, *Deschooling Society* (London, 1971), vi, vii. Also R. Dore, 'The Cuernavaca Critique of School', Institute of Development Studies, Discussion Paper No. 12, University of Sussex.

28. P. Coombs, *The World Educational Crisis: A Systems Analysis* (Oxford University Press, New York, 1968).

29. UNESCO, *Learning To Be*, see reference 22 above.

30. J. Sheffield and Victor Diejomaoh, *Non-Formal Education in African Development* (African-American Institute, New York, 1972); P. Coombs with Roy Prosser and Manzoor Ahmed, *New Paths to Learning;* and P. Coombs with Manzoor Ahmed,

Attacking Rural Poverty. How nonformal education can help (John Hopkins, Baltimore, 1974).

31. Coombs, *New Paths,* 13.

32. See for example, Ministry of Overseas Development, *Education in Developing Countries: A Review of Current Problems and of British Aid* (HMSO, London 1970): World Bank, *Education: Sector Working Paper* (September 1971, New York): UNESCO/UNICEF Co-operation Programme, Seminar on 'Basic Education in Eastern Africa', Discussion Paper (August 1974, mimeo).

33. UNESCO, *Learning To Be,* xix, xx.

34. See primary school statistics in Republic of Kenya, *Ministry of Education Annual Report 1968* (Government Printer, Nairobi, 1969), 80.

35. For the wider background of self-help in Kenya, see J. Anderson, *The Struggle for the School* (Longman, 1970), chs. 8 and 9; for fascinating detail of the self-help process, see his *Organisation and Financing of Self-help Education in Kenya* UNESCO, IIEP, Paris, 1973).

36. Government of Kenya, *Kenya Education Commission Report, Part I* (Nairobi, 1964), 137.

37. René Dumont, *False Start in Africa* (London, 1968 edition), 73.

38. A valuable overview of the primary school leaver literature is John Anderson's 'The Rationality of the School Leaver: Africa's Teenage Problem', in Centre of African Studies, *Developmental Trends in Kenya* (Edinburgh University, 1972), mimeo.

39. Some of this evidence is contained in K. King (ed.), *Jobless in Kenya* (TransAfrica Publishers, Nairobi, forthcoming 1977).

40. See Colony and Protectorate of Kenya: Education Department, *Report on the Technical Departments of Mission Schools Receiving Grants-in-Aid* (Nairobi, 1925); also K. King, *Pan-Africanism and Education* (Oxford, 1971), ch. iv. For more detail on the development of Kenya's artisan training programmes, see King, 'Productive Labour and the School System: contradictions in the training of artisans in Kenya', *Comparative Education,* X, No. 3, 1974, 181-92.

41. Interview with Rev. R. Macpherson, artisan missionary in Kenya from 1925, presently retired in Dunfermline, Scotland.

42. Kenya Colony, *Education Department Annual Report, 1930* (Nairobi, 1931), 28.

43. H. E. Weller, *Kenya without Prejudice* (London, 1931), 120-21.

44. For an analysis of this notion, C. Colclough, 'Educational Expansion or Change', *Journal of Modern African Studies,* Vol. 12, No. 3, 1974, 459-70.

45. See Kenya, *Education Department Annual Reports,* 1945 to 1960 for details of figures on productive labour.

46. *East Africa Royal Commission 1953-1955 Report* (Cmd. 9475, London, 1955), 149.

47. K. King, 'The Politics of Agricultural Education for Africans in Kenya', in B. A. Ogot (ed.), *Hadith 3* (East African Publishing House, Nairobi, 1971), 153-55.

48. The complexity of the 'resistance' issue is valuably presented in P. J. Foster, 'The Vocational School Fallacy in Development Planning', in M. Blaug, *Economics of Education 1,* ch. 19 (Penguin, London, 1968).

49. *Kenya Education Commission,* 60.

50. A short account of the National Youth Service is contained in Sheffield and Diejomaoh, *op. cit.,* 172-75. For an annotated list of many of the other nonformal initiatives in skill provision, see Dorothy Thomas, *Who Pays for Adult Education in Kenya?* (Board of Adult Education, Nairobi, 1971, mimeo).

51. *After School What?* (Report by the National Christian Council of Kenya, Nairobi, March 1966, mimeo). Essential background analysis of the village polytechnics is contained in J. Anderson, 'The Village Polytechnic Movement', Institute for Development Studies, University of Nairobi, Evaluation Report No. 1, August 1970, mimeo.

52. David Court, 'Dilemmas of Development: the village polytechnic as a shadow system of education in Kenya', Centre of African Studies Seminar, *Developmental Trends in Kenya,* 150-74. See also Sheffield and Diejomaoh, *op. cit.,* 75-86.

53. E. M. Godfrey, 'Technical and Vocational Training in Kenya and the Harambee Institutes of Technology', Institute for Development Studies (Nairobi), Discussion Paper No. 169, has some detailed figures on a number of these provisions of skill.

54. On the Harambee Institutes, see E. M. Godfrey and G. C. M. Mutiso, 'The Political Economy of Self-Help: Kenya's "Harambee" Institutes of Technology', *Canadian Journal of African Studies,* VIII, No. 1, 1974, 109-33; also K. King, 'Some preliminary notes on technological self-help in Kenya', paper in *Developmental Trends in Kenya,* 175-203.

CHAPTER II

Skill Acquisition in the Informal Sector

For some of the reasons mentioned in Chapter I, the informal sector has caught the attention of many international concerns, and is the object of research by the ILO and other bodies in a number of countries. Shortly, therefore, a good deal more data will be available on the personnel and operations within it. At the moment, however, the words 'informal sector' do not presumably convey very much to the general reader, with no direct experience of the Third World, and it may perhaps be useful initially to sketch in some of the dimensions this sector has in Kenya.

From one angle it may be represented perhaps by the image of a man pushing the entire shell of a used car on his little handcart to one of the areas where the metal will be recycled into some household goods. Geographically, it may be taken to refer to whole concentrated sections of Nairobi, for instance, where without demarcation of plot from plot, petty producers are packed tightly on to the slopes of the Nairobi River, or cluster on a piece of open ground at Eastleigh, Kariobangi or Shauri Moyo. On the Gikomba site, along the Nairobi River, the debris from the reworked and gouged-out cars and lorries rises higher and higher, and threatens to overwhelm the diminishing open ground left to the petty mechanics, tinsmiths and woodworkers. In the smaller towns, by contrast, there are no really large unregulated areas where workers may carry on their trade; here and there activity seems to have spilled out into the open, but generally artisans operate out of some kind of premise or fenced off area. And in the villages, again, petty artisan activity tends to be closely associated with a homestead or semi-permanent work area.

The impression of such activity, particularly in the Nairobi concentrations, is one of exceedingly hard work for long hours under the sun or a makeshift shelter. In parts of the Burmah market, near the Nairobi Stadium, the din of metal being beaten and reworked is maintained from dawn till nightfall. There is no hush at the lunch

hour, as there is in Nairobi's formal Industrial Area next door. It is an interesting historical twist that one of the areas of most intensive day-long production along the Nairobi River is still called Grogan, after the notorious early white settler who caricatured and occasionally whipped his labour for their 'inherent' laziness.

The image, then, is of hard work in adverse conditions, on sites that may be required for redevelopment in a few months' time. It is not surprising therefore that the ILO mission that visited Kenya in 1972 were impressed by the dynamism of the informal sector, particularly in Nairobi.[1] Unlike the rather gloomy predictions about employment in large scale business, evidence of employment potential in petty activity declared itself loudly from all these jostling sites. Perhaps the most important impact of the sector was that it now clearly had a *productive* side, or a manufacturing side; it was not restricted to the older petty service image of match-girls, maize-roasters, shoe-shiners and hawkers.

THE SPAN OF INFORMAL SECTOR ACTIVITY

Before coming to examine the implications for education and training of such strenuous activity, it is worth trying to put the productive or craft side of the informal sector into some kind of perspective. This needs to be done particularly in relation to the *'service'* side of the sector. Clearly a very great deal of what shelters under the informal sector umbrella appears to be service activity. Again, naturally this is at its most conspicuous in Nairobi where hundreds of rickety roadside 'Hiltons' provide tea and hot food to the lower paid people of the large scale firms as well as to the informal sector. Many young boys and girls assist these canteen owners. The same is true of food preparation in the small town and rural areas, although there the bars and hotels are licensed registered premises in permanent or semipermanent buildings. This question of premises in urban and rural areas immediately raises a point that we shall need to recur to: *in what does the informality consist?* It seems difficult to consider premises alone as crucial, otherwise the boy who cooks, serves and cleans in a rural hotel for two or three shillings a day is somehow outside the informal sector, while the boy who works in a Nairobi canteen of sticks, stones, cardboard and polythene, teetering on the banks of the Nairobi River, is firmly informal. Nor is it a question of wages or of being enumerated in official labour statistics, since neither boy will have been officially counted, and neither will be receiving anything approaching the rural or urban minimum wage.

We shall come back to the complexity of defining informal again a little later. Still on the service side of the sector, several points need to be made on other issues. First, the service occupations within the informal

sector (whether fetching and carrying, acting as domestic servant in the village or town, washing and guarding cars in the city) should not be seen as rigorously separate from the productive craft activities. In many cases, indeed, service jobs are determined by the youthfulness of the boy who knows that he could not be accepted on a building site or at a factory gate. They are used consequently as a place to mark time in the village or town while waiting to enter other kinds of jobs. Often a boy will wait for a year or two after primary school, moving from small hotel, to small store, to domestic servant, to milkboy, to turnboy, before he even tries to begin some productive course.

The second point to be made concerns girls. Much that will be said later in this chapter about informal education and indigenous apprenticeship does not apply to girls. In both the formal and informal sectors, there are very few productive or craft activities that girls can enter as yet. They are much more likely therefore to get stuck in the service occupations of the informal sector, such as bar girl, servant, village or city prostitute, or in the casual work of tea- and coffee-picking than the boys are in their service sector. There have been a few innovations recently as for instance with the knitting machine which has allowed women to set up on their own in many towns, but this kind of independent craft activity still only affects a handful.

In general, therefore, in examining some of the service occupations of the informal sector, it is important to try for an analysis over time. The rate at which at least the young move through service jobs can then be documented. It seems likely for instance even on present limited evidence that mobility in this sector is more marked than in the craft occupations. Which could mean that the most significant thing to be said about, say, Nairobi's shoe-shiners is that they are likely to stop shoe-shining.

This is not to suggest that the actual occupations in the service side are likely to diminish in importance. Indeed, there is every indication that they will expand and diversify to offer a wider range of cheap services to both rich and poor than they do at the moment. In this event, the present mobility in and out of the service sector might well be reduced. For the moment, however, we may consider some aspects of skilled productive work in the informal sector, as these raise some questions about training.

PRODUCTIVE CRAFTS IN THE INFORMAL SECTOR

We have suggested that this aspect of the urban informal sector is the easiest to admire. Clearly in a city like Nairobi there are several thousands of skilled men (and some women) engaged in such craft practice, and who carry on their trade or business against what seem

considerable odds. The discovery of these thousands of petty producers appeared particularly heartening in Kenya since the primary and secondary leaver problems had been presenting great difficulties to national planners. It was all the more admirable since this productive low-cost world seemed to have thrown itself up without any official encouragement; if anything, indeed, it had been discouraged and harassed by being shunted summarily from site to site. Yet it had survived, and showed every sign of expanding dramatically. How had this come about?

In examining the training component of this productive wing, it is important to distinguish the *informal* sector from that *nonformal* education we were discussing in the last chapter. It was stressed there that nonformal education, as presently referred to in the literature, tends to mean *sponsored* training opportunities, usually offered outside the Ministry of Education. These turn out to be programmes, more or less institutionalised, on which data are readily available, and whose clients can be enumerated. The better known of these are the village polytechnics, the National Youth Service, and skill courses offered by official agencies and voluntary bodies. By contrast, training in the informal sector is not sponsored, and numbers and methods not widely known at all. As there is, however, rather a significant training function attached to much of the productive and skilled areas of the informal sector, it may be useful to gauge something of its dimensions — its internal structure, diffusion potential, attitudes and aspirations of its participants, and its links with the more formal Indian and Western production enterprises. It is perhaps easier to make this analysis concrete if it is linked to the different *products* of the sector.

1. Exclusively informal sector products and skills[2]

Many of the basic commodities necessary to a low income household are *only* produced in the informal sector. These items include the cheapest form of lighting — the tin lamp; the brazier or cooking stove; some kitchen utensils, for cooking and frying; and some containers and measures. Again, in Nairobi, where the cheapest productive activity has outrun available accommodation, these commodities are made almost exclusively out of doors, on open ground or under temporary shelters. The makers are not randomly scattered on the city fringes, but following the existing Nairobi pattern of specialised streets (for cloth, vegetables, auto spare parts, etc.), these informal operators tend to cluster into concentrations of tin, wood and metal workers. The pattern is different in the small town and rural areas where such products are almost invariably associated with some kind of permanent or semi-permanent premise. This accommodation variable is not itself critical in determining differences in production and technology at this low

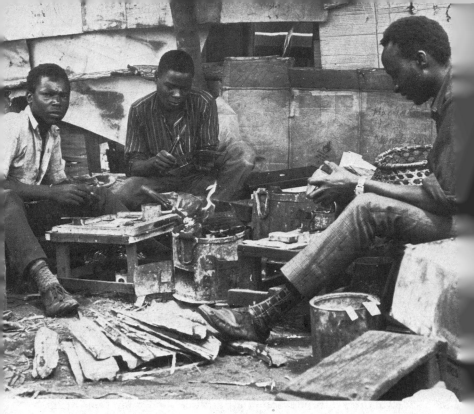

Fig. 2. An urban informal sector workplace. Note the temporary structure of wood and cardboard walls.

level. In fact, in a later chapter, we shall examine for one particular item — the oil lamp — the nature of its manufacture right across Kenya, from the urban wastelands, to the market towns, to the village centres. It will appear that questions of market, distribution, technology and incomes are of rather more importance than the nature of the premises.

As far as training for production is concerned, these particular items are much easier to separate off from the formal education system than many others we shall shortly come to. There is simply no provision for teaching their manufacture in the formal training system, or in the nonformal setting. The skill has to be acquired on the job, at the hands of a local artisan (or *fundi,* in Swahili).

2. Industries and skills common to formal and informal sectors

We enter a much more complex area with these skills since the craft practice can be acquired in a variety of modes, and the skill carried on equally easily in large-scale, small-scale or petty enterprises. The most common of such skills would be: building and contracting skills; automechanic, spray painting, panel beating; metal, blacksmith and

welding; making household furniture; shoemaking, tailoring; driving. As was suggested in Chapter I, the skills required for such activity can be learnt in at least three main modes.

Formally
It is possible to acquire competence in most of the above skills through attending government technical secondary schools — though, as we show in the next chapter, learning by no means assumes subsequent entry to the trade. A little less formally, there are ways to master many of these crafts by entering the National Youth Service, a local village polytechnic, youth centres, and private technical 'colleges'.

Through casual labour to skilled man
The majority of skilled people in Nairobi's industrial area (as in the other large towns) were originally taken on at the gate as casual labourers (*kibarua* men); their skills were learnt exclusively *on the job*, by a process of the more productive casual labourers being attached over the years to the Asian (now African) *fundis*. This method of reproducing skills is central to the Indian firms in Kenya, but common also in the less technologically sophisticated European and all the emerging African firms. Employers tend not to be interested in grades, trade tests or salary linked to formal qualifications. And this, as will be seen in Chapter III, raises a number of difficulties for any attempt by the government to encourage formal technical training, as opposed to acquiring very specific skills of value to particular firms. For the moment, the point is that all the skills listed above can be acquired more or less rapidly on the job.

It is necessary to stress that this is not at present a rather uncommon event, but it is widely and explicitly acknowledged by workers to be a way of becoming skilled. It is not therefore particularly useful to transfer to the Kenya context the standardised western job classifications of unskilled, semi-skilled, skilled and professional, because this static picture distorts the widespread manipulation of the unskilled casual category to attain skilled status.

Indigenous skill acquisition
In addition to the formal and *kibarua* modes of skill attainment, there has emerged over the last thirty to forty years a process whereby an individual can attach himself to a skilled man in a type of informal apprenticeship. It is particularly apparent in these skills and industries which are common to both the formal and informal sectors, but it also embraces those exclusively informal sector skills that were mentioned earlier. As there is a good deal of interest in the varieties of African apprenticeship, and the potential or obstacles they present to rapid employment generation, it is worth examining rather carefully the particular characteristics of Kenya's present style.

In contrast to the formal mode of apprenticeship outlined in the first chapter, the indigenous system operates on almost completely different assumptions. The former is increasingly formalised, being tied to years and qualifications in a very limited number of schools. In addition it is part of rather an elaborate Industrial Training Act, and the apprentices are given considerable attention by the Ministry of Labour, its training officers and training institutions. Wages and conditions are rigorously laid down, and can be enforced.[3]

The indigenous system works on a set of quite different principles.

1. *Fees.* Like the apprenticeship principle in Britain until the early years of this century, trainees pay their masters to accept them, and expect some form of maintenance or subsistence in return. There is, however, a very great variety in what needs to be paid; the premiums may fall anywhere in the range from 100/- Kenya shillings to 600/-, depending on the skill desired. For instance, it is fairly standard in the central area of Kenya to expect to pay 450/- to learn auto repair. But the fee can be reduced or waived altogether if there is some relationship of kin or friendship.

There is no doubt of the readiness of many fathers to pay fees of this order for a 'course'; 450/- is, after all, the same as one year's fees in a government boarding school, and only half what it costs to attend some of the *harambee* boarding schools. Furthermore, it is now relatively well known that one year in secondary school, without the other three, is not worth the expense, whereas most courses in the informal sector are completed in a year.

This system of payment in exchange for skill is not unique to Kenya, but appears elsewhere in the East African territories as well as in Cameroon and Nigeria. There are, however, some fundamental differences in the East and West African modes as will appear shortly. Within the Kenya context, the widespread interest in acquiring a skill for money means that there is sometimes the possibility of the training function displacing the productive element in importance. If it is possible to get nine or ten young boys to pay 300/- to 400/- at the same time to learn car repair, then the income from fees can become as important to the master as the cheap labour. It is easy then to visualise the growth of garage-cum-schools which have begun to spring up here and there in Kenya's central belt.

Obviously when an artisan decides to try combining his garage or workshop with a boarding wing, and begins to advertise for students, he has in a sense crossed into the formal sector. His technical 'college' or 'academy' can be registered with the Ministry of Education, and he may proceed to charge fees of up to 1500/- a year if the student is boarding. In terms of value for money, what students receive from some of these institutions is clearly inferior to straight one-to-one apprenticeship in

the informal sector. These colleges do, however, point to a demand even in the remoter areas of Kenya to get access somehow to a marketable skill. Indeed, the majority of the trainees in such institutions are migrants from up-country Kenya or neighbouring Tanzania. Lacking government technical facilities in their home areas, or relatives with whom they may board in Nairobi, they respond to the advertising of the private technical academies:

> We are among the First Kenya Schools to introduce this system of Education which presently provides technical training opportunities to students in Secondary Schools. What is one's hope nowadays in the Continent of Africa without a technical qualification?[4]

2. *Length of training.* As soon as there is this transition into the formal sector, the fees become much higher, and are related to specific terms and years of study. The courses too make much of being geared towards government trade tests, to be taken at the end of the period. With the smaller fabricator and his one or two trainees, by contrast, the fee is for the length of time it takes the individual student to master the skill — the bright student being expected to serve his time in under a year perhaps, and the slower student up to a year or more. Apprenticeship can be a few months in some of the tinsmith operations, and not much above a year in many of the automotive related trades. This is what principally differentiates the East African system of apprenticeship from the traditional British, or the West African variety. In Dakar, in Senegal, and Lomé in Togo, for example, the apprentice is given over to a master (or *patron*), and will be attached to him without wages for five years and more.[5] Apparently in such a situation, many apprentices still aspire to become masters, and the masters for their part insist that youths *can* become masters as rapidly as their intelligence allows. The reality is, however, different. Apprenticeship in these circumstances is much closer to its original European characteristics of restricting access to journeyman status, and reducing any chance of over-competition amongst those practising the same trade.

In Kenya, on the other hand, whatever else may be alleged of the indigenous apprentice system, it seems hard to picture it as an arena of extended exploitation of cheap labour. Admittedly, apprentices pay premiums, but over the period of a year, a good deal of the 400/- will have been returned to them through daily subsistence and the provision of somewhere to sleep. So far in Kenya there is none of the codification and formality of the West African system, with its written contract, and the elaborate ritual of freeing the apprentice at the end of his indenture. At the moment there seem to be no sanctions that the master can use to hold on to his trainees beyond the time they wish to stay.

Indeed, the most obvious feature of the system is the determination of those under training to move as rapidly as possible to establishing their

own little workshop or industry. Very often the brightest trainees are absorbed within a short time into a co-operative arrangement with their former masters. They may begin to do a little work on a contract business, but as soon as they see how much their master gets from a single job in, say, panel beating, they will either ask to become one of the qualified helpers in the company and share its profits, or will, after accumulating sufficient capital from piece work or contracts, set up on their own. Within a year or two, therefore, it is quite possible for the former trainee to have his own apprentices. Also, many of the older masters seem very aware of the number of people who have gone through their hands, between 1950 and 1970, and are able to identify with some pride precisely where their former pupils are now operating their own businesses. The system in fact seems so open that it scarcely merits the narrow traditional use of the term apprenticeship.

3. *The paradox of the open apprenticeship.* The openness of Kenya's apprenticeship system is perhaps better understood in some historical framework. First, with the exception of blacksmithing, there had in most of the East African hinterland been no long pre-colonial tradition of local craft communities. Second, the major irruption of specialised craft communities to Kenya was associated with the waves of Indian immigration. These Indian craft workers in building, tin, wood, steel, car repair and many other skills, found themselves operating in a much more monopolistic situation in Kenya than they had left at home. And there is little doubt that they did restrict their craft expertise as far as possible to their own community. In doing so, they were acting in a similar fashion to the white settlers who, in their own struggle for survival against Indian and African competition, arrogated to themselves monopolies in land, marketing and the most profitable cash crops (coffee and pyrethrum). Moreover, the skill monopoly of Indian craft groups was further protected even amongst themselves by the rather rigid internal differentiation of the various communities. The result was that it was possible for certain Indian manual workers to accumulate a significant surplus even by the mid 1930s; this could then be ploughed into simple machinery, and by the second or third generation, the family had, in many cases, differentiated into ownership of a small factory, a small precision engineering workshop or a contracting business.

In this process, but particularly after the second world war, the Indians became much less possessive of some of the skills that they had once deliberately guarded from their African employees or fellow workers, who now began to take over the production of a whole range of goods that had originally been made entirely by Indian skilled labour. And it should be noted that these include all the items that we have described above as 'exclusively informal sector' products. We shall look in more detail at the Africanisation of some of these craft processes in

later chapters. Here we are concerned with the effects of the colonial restrictions on land, crops, schools, skill, urban trade, etc. Fundamentally in all these areas it became politically difficult at Independence to stand for a policy of restriction, monopoly and limited access. We have already noticed the impossibility of legislating against self-help schooling, despite the initial concern expressed in 1964 and 1965 by the Kenya Education Commission. Certainly the groups who had managed to get primary or secondary schooling were not able to prevent thousands of others from getting access almost immediately, with the result that any slight educational headstart tended to be eroded. It was the same story with coffee and tea, and, in a different sphere, with licences to carry people in motor vehicles. In the matter of inheriting certain skills from the Indians it was no different. Particularly as the first learners had no ancient prerogative over such and such a skill, but were often the first in their family, clan or tribe to become a welder or panel beater, it was inconceivable that they should act like medieval masters.

In the late colonial period, payment in exchange for skill was a method that a number of Africans had arranged with members of the Indian skilled class. And because of the hostility of the colonial government, it was not uncommon during the late 1950s and early 1960s for Africans who agreed to such an arrangement to sign a lawyer's letter to the effect that they were receiving wages of so many pounds (even though they were getting nothing). This proved, however, not to be a very effective protection against some of the labour inspectors, and once a few Indian firms had been prosecuted and forced to pay several thousand shillings of back pay to their one-time apprentices, there was a general reluctance among Indians to become involved further in fee-paying training. In fact, in a brief survey of the small Indian workshops in one area of Nairobi in 1972, only two or three were found who were prepared to risk becoming skill models in the way that the Africans had meanwhile developed into an accepted pattern on the waste lots nearby. The very hostility of the colonial government, however, meant that the system has not yet really come into the open as in West Africa, even though it expanded very rapidly in the post-colonial period.

A final aspect of this openness concerns the relations of these petty producers with the large scale formal sector of the economy. It could be suggested that the seemingly progressive spread of local skill into areas forbidden or restricted during the colonial period actually benefits the large scale firms, and the elite who work in them and in the public sector. Clearly, the large concentrations of informal spray painters, panel beaters and mechanics across the Nairobi River allow many car and lorry owners to get a relatively good job done at half the price of the large scale car agencies. Africans who patronise these workers do obviously benefit from the intense competition which along with stolen

or second-hand parts keeps the prices low. It is similarly the case that the African and remaining Indian retailers in the formal sector of Nairobi do benefit from the numbers of informal metal workers who compete to sell them their braziers, water cans, rat traps. In fact, in a later chapter, we have a particular case study of the manufacture of bicycle carriers in the informal sector which highlights some of these aspects of dependency.

It is one thing to note this phenomenon, and it is of course rather the fashion to analyse the ways in which the apparent expansion of the informal sector makes for greater dependency, ultimately making the differential between rich and poor even greater. On the other hand, as we mentioned with the current attack on schools in Chapter I, the espousal of the working poor, and the disillusion with the elite has come about so rapidly in the international literature that it runs the risk of neglecting local African opinion. Fifteen years ago probably no Kenyan African possessed an electric welding machine, or a motorised spray paint machine, just as few possessed a form four certificate. Yet, as soon as small numbers did manage to obtain such equipment, they are seen by some analysts as a further aspect of the widening income differentials.

It might of course be preferable for the Nairobi mechanics and spray painters to combine in some sort of closed shop, to keep their prices nearer the going rate in the formal large-scale sector. It seems equally important, however, that this sort of monopoly should not precede the spread of many of Nairobi's cheap services into the rural areas. We shall mention shortly the attraction of doing informal sector apprenticeship in Nairobi; many apprentices are nevertheless aware that the competitiveness of Nairobi and its critical housing shortage will drive them to try out their new craft in some smaller upcountry town. If rural and agricultural development can create conditions that will provide work in crafts that have never been practised there before, this is surely more important than worrying about the possible overproduction of certain skills in Nairobi.

In brief, the present openness of Kenya's indigenous apprenticeship system seems likely to spread rather widely in the rural areas a range of cheap products and a group of versatile artisans.

4. *Character of the trainees.* We suggested in our discussion of the ordinariness of Kenya's primary schools in Chapter I that school leavers have no great difficulty in adjusting their sights to whatever job is available. In this sense they measure up to the conventional picture of the cooling-out of the standard-seven leaver, as they compete to grasp in the 1970s the sort of openings that their protected predecessors despised in the late 1950s: shoe-shiner, shamba-boy, spanner-boy, day-labourer on building sites, tea and coffee picker. We have said that some of these are seen as temporary jobs, to allow them to grow a little older. In other cases what is taken as a temporary job may gradually become

permanent. However, this image of cooling-out does not adequately cover the self-employed petty producers, and those who train to become like them. Many of these see themselves training for a situation where they will be rather better off than those in the lower echelons of, say, government service: indeed in a number of cases, contrary perhaps to expectations, trainees or their masters had come to the informal sector of the economy not because they could not obtain a position in the enumerated sector, but because the jobs they had in the modern sector had insufficient pay and prospects. Often such a distinction is drawn in the literature between the wage-and-salary sector and the unenumerated that it is assumed that *any* job in the former is worth retaining for its security and steady income. The reality in Kenya is that there is a great deal of restless movement in the bottom reaches of the modern sector as people search out an income outside the range of 80/- to 200/- per month. Once they have set up on their own, several claim that they found they make more in a week than they previously made in the month, while avoiding most of the former expenses and overheads. Whatever the reality of their earnings may be, most artisans or their trainees have a fierce determination not to be employed again. As we shall see in a later chapter on machine-making, there are sufficient examples of successful operators in the informal productive world, for it to appear as an alternative route of upward mobility to many who enter.

In most cases, still, would-be trainees are the first generation of their families to take up a particular trade, although in a few skills like woodcarving and blacksmithing there is already some continuity from father to son. Consequently, the commonest pattern is for the young man to approach a friend or an acquaintance of the family who has been following a trade for some time; he is usually a man of the same tribe, but by no means always so in Nairobi. Taken as a group the trainees are largely drawn from the poorer strata of society (though not the poorest). Their parents have not been able to afford secondary school, even though their children might have won a place there. In many cases the result is that younger and more schooled boys are going in order to gain their skill to craftsmen who are frequently illiterate or have had minimal schooling. So rapid, however, is the reproduction of skill in the informal sector that most of the workers are young men.

It is difficult to estimate to what extent this expanding group sees itself as set apart from the industrial mainstream. There is admittedly a tendency for operators within it to stress that only those prepared to work hard and long in dirty conditions need think of entering apprenticeship. As we shall see in the next chapter a number of the owners actually share with their European and Indian counterparts in the modern sector the disdain for the secondary-school boy, seeing him as someone who will be unable to accommodate himself to the work. It

is assumed by all three that his education will have unfitted him for hard labour in exacting conditions, even though, increasingly, poor secondary-school leavers are turning to this type of training. Amongst the majority of secondary school boys, however, it is still regarded as something of a joke to find one of their classmates translated into a self-employed carpenter ('doing what he shouldn't be doing' in popular parlance). However despite the disadvantages of working in Nairobi without access to piped water, electricity or shelter from rain or mud, it seems difficult to conceive of the informal artisans as a race apart. For one thing, while it remains true that the informal sector aims its products principally at the low income African market, some of its wares cannot be distinguished from modern sector artefacts. Cars that have been spray-painted or been panel-beaten in a vacant lot only substantially differ from Indian garage workmanship in price, the informal operators nearly always having initially learnt their skill from the Indians. Similarly, the wardrobes and kitchen furniture that are made under makeshift shelters of polythene duplicate the products of some formal operators. In fact, there are only a handful of items, as we have said, that can be considered informal-sector products exclusively, since scrap materials are widely used by artisans who have moved into permanent premises. Furthermore, the majority of roadside operators aspire to get formal workshop premises, presently in very short supply in Nairobi, and probably do not see themselves as different in kind from those earlier and more successful ones who have managed to rent or buy accommodation already. If the informal areas of Nairobi are inspected carefully, it will be seen that there are constant attempts by the more successful artisans to stake out, and demarcate with bamboo, an area where their equipment and materials can be secure. Many such little tentative plots turn out to be rented from people who work in the modern sector. For these kinds of reasons, whether looked at from the angle of materials, product, premises or personnel, the attempt very rigorously to dichotomise formal from informal appears rather an academic exercise.

As we hinted at the beginning of this chapter, it becomes more and more difficult to put a finger on what essentially constitutes the informality of the informal sector. Not premises. Not wages. Not product. At first sight it looks as if there might be something in the attitude to training that would differentiate formal from informal. This might be summed up in the Kikuyu axiom which is readily produced in the informal sector in any discussion of government trade tests, or formal certification: 'Ti ngirindi irutaga wira, ni mundu'—'It's not the grade that works, it's the man'. It expresses an antipathy to the government trade certification system as something that is not relevant to the small man and his workforce. Petty producers will admit that trade tests are valuable if someone has got connections to enter the large

scale European firms or the Ministry of Works; they can then be used to secure automatic increases in wages depending on the grade of trade test. It can be se.n, incidentally, that this axiom is in line with what many educational reformers would like to see being adopted in the Third World. As we noticed in Chapter I, such reformers despair of the way they think industry automatically raises its recruitment criteria to the certificate level of school leavers, regardless of whether a higher school grade is necessary for the job in hand. Strictly speaking, this is not an accurate generalisation across industry in Kenya, for as we shall see in the next chapter, a considerable part of local industry has needed rather strong government sanctions to make it accept even a handful of formally trained and certified school products.

It has to be admitted in fact that this Kikuyu axiom which seems to express so accurately the spirit of the informal sector is equally applicable to the bulk of Indian enterprise, and a section of western firms also. So it looks as if the informal sector eludes definition on this score as well.

5. *Product technology and urban-rural diffusion.* As far as a separate product technology is concerned, it is not easy to generalise when there is such a range of cheap and expensive goods and services offered in the informal sector. It is interesting to observe that some of those for which there is an insatiable export demand to the smaller towns and rural areas are the originally Indian artefacts, principally charcoal-burning braziers, tin lamps, and metal kitchen bowls and pans. It is common to see the top of country buses leaving Nairobi festooned with braziers and other informal sector products. But this should not be taken to mean that Nairobi exerts a monopoly over such goods. Indeed, even during the last three years, there has been a very marked decentralisation from Nairobi, and the dynamism of new local operators has reduced the need to depend on the capital. There is, however, a difficulty about the promotion of certain goods in the rural areas, for even though many of the informal sector products are now admired by economists for their labour intensity, it should be realised that a good deal of the informal sphere is very much a satellite of the large-scale firms or of some of the products they import at first hand. That is to say, the appropriate technology of the informal sector may be derived from the allegedly inappropriate technology and import patterns of the modern large-scale sector.

To take an example. Kenya's policy on the importation of cars has been frequently criticised for being too *laissez faire,* it being considered inappropriate that so much foreign exchange should go on the purchase of these for the still rather small local and foreign élite. On the other hand, the informal metal-working industry is directly dependent on the detritus from the modern car industry for much of its own dynamism. The vast numbers of motor oil cans collected daily by the service side of

the informal sector from Nairobi petrol stations provide the producers with the most satisfactory supply of cans for the making of the tin lamps. Bought at approximately 5/- or less per hundred from the petrol stations, these cans are converted the same day into lamps that retail at 60-70 cents each depending on the area and style. Additionally, oil and petrol drums and much of the car body is central to the fabrication of the charcoal braziers which retail at 4/- to 6/- for the cheaper versions. Oil drums are also sliced into very effective containers for cattle feed or water. Even the bedmaking industry—which is one of the fastest growing on the carpentry side—is dependent for all its springing on the availability of second-hand tyres, from which the long crisscross strips can be cut. The car, therefore, inappropriate and expensive as it may be, makes a rather important contribution to informal sector products, quite apart from the numbers of mechanics and panel beaters who keep cars, buses and lorries on the road long after they would have been scrapped in the West. Any decision, such as that of Tanzania recently, to restrict radically the import of new cars could well alter patterns of production amongst the various informal ancillary industries. This is not intended as a defence of high cost consumer goods any more than one would try to defend an inappropriate school system on the grounds that it did at least *employ* thousands of teachers. It is, however, worth establishing some of the link between formal and informal before considering any policy questions.

There is a series of problems when it comes to the diffusion of the actual craftsmen into the rural areas. Some of these will only be touched on here, as they will be dealt with in detail in a later chapter, but they do highlight the difficulty of surmounting urban-rural imbalance even in the informal sector. Initially, of course, it has to be admitted that the market for informal sector goods, though vast and still largely untapped, is determined to a considerable extent by the state of agricultural incomes, and can therefore be sluggish in taking up even cheap innovations quite close to Nairobi. The craftsmen who do however decide to practise in their home area (after acquiring the skill perhaps in Nairobi) are naturally attracted by the idea of being one of the few or often the only such in the village or small town. In conversation, however, with some who had taken this step, or who had taken it and then returned to practising in Nairobi, it became clear that there could still be quite substantial difficulties in operating outside the metropolis.

First, there is the task of obtaining scrap materials from Nairobi in sufficient quantity to maintain production. This is particularly critical with the tin and metal based industries, but is naturally much less true of carpentry. The road system is now very adequate to the majority of small trade centres in the middle belt of Kenya at least, but even this is a mixed blessing to the young rural entrepreneur; the very multiplicity of

country buses, and the tendency for most rural families to have some member of their family in the town, means that it is very often easier to buy beds, chests and cooking equipment from amongst the much greater variety of Nairobi and send them up on the bus. The quality is also still very much better in Nairobi than in the smaller market centres.

Secondly, the would-be rural entrepreneur cannot take advantage of the apprentice system to the same extent as his urban counterpart. Especially at the village level he often does not have sufficient work to justify keeping an apprentice, and as it is not customary to sack or send off apprentices for lack of work, they would have to be maintained during periods of slack. By contrast, daily paid labour can be taken on and dropped as the occasion arises. In fact, at the very lowest level of the village carpenter or tinsmith, apprenticeship is often not a feasible proposition. Many of the craftsmen combine their craft with agriculture and only make one-off goods to order. Things are admittedly better in the larger district towns like Nakuru, Murang'a, Thika, Machakos and Kisumu, where apprenticing is much more common. Even so, the result is that many intending apprentices who have Nairobi contacts will prefer to acquire their training there. For one thing, they will learn a much wider range of skills through urban apprenticeship than by attending a master who is restricted by limited rural demand and lack of materials. In the automotive trade, for example, they find it very difficult to get experience of lorry repair, unless they learn in Nairobi, Mombasa and the few other large towns.

Thirdly, a number of artisans give the definite impression that they are much more troubled over licensing in the rural areas than if they were set up on one of the large vacant lots in Nairobi. There, at the moment, the City Council do not attempt to enforce licensing upon whole sections of the carpenters, mechanics and scrap metal workers. But it is almost impossible to avoid it in many rural areas, which is why, as we said earlier, rural petty producers almost always operate out of permanent or semi-permanent premises.

Nevertheless, despite the attractions of Nairobi for migrant apprentices, the informal fabrication sector is very much on the increase in the smaller towns right across Kenya. Unlike the picture of the decay of rural crafts so often drawn for other parts of the Third World, Kenya is witnessing a rather dramatic rise in the level of craft activity in the post-colonial period. It should be added that as long as rents remain as high as they presently are in Nairobi, youths who have learnt informally will continue to try their luck in their own village or town. We shall, however, look very closely at this rural-urban interaction in the chapter on the diffusion of low cost light throughout Kenya.

It should finally be noted in this section on technology, that there is a very marked innovative strain in much of the production in the informal sector, contrary to the usual picture of its doing second-hand things in a

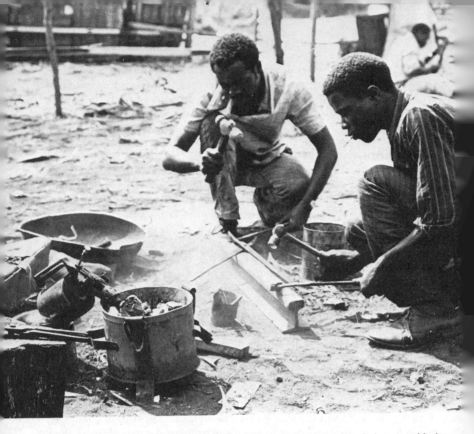

Fig. 3. Improvisation in hand-tools. Tinsmiths in Nairobi shaping their own soldering irons. Note heat from the locally made brazier and the imported blowlamp.

second-rate way. As we shall show with oil lamps and machine-making in the informal sector, a considerable range of variations and improvements have been made in the rather short span that Africans have been involved in their manufacture. In general, there has been product development and design improvement in a whole range of items in the last ten to twenty years, as would be expected. Because of economic necessity, the key characteristic of informal sector technology is its emphasis on *repair* and *improvisation* in the use of scrap and of available tools. This places it in direct contrast with the technology in the capital intensive large-scale sector of the economy, where it is increasingly the case that workers in Kenya as in Britain are taught to replace rather than repair the products of the industrialised nations.

Laudable though this technology of improvisation is for urban and rural artisans, it is still not possible to regard it as unique to what we have been loosely calling the informal sector. We noted in Chapter I that improvisation and adaptability were the mark of the small-scale Indian *fundi* in the colonial period, and it has remained today

characteristic of Indian car repair, and the Indian precision workshops. They continue in the 1970s as earlier to improvise and make on the spot complicated parts and components that would otherwise need to come from abroad. This technology of adaptation, therefore, is much more widespread than the small-scale African work places.

POLICY CONCLUSIONS AND DEFINITIONS

From a policy point of view, there has already been a recognition of the value of the product, the technology and the employment potential of the informal sector. Indeed, in September-October of 1974, the government embarked on a policy of giving limited credit to some of Nairobi's petty producers who did not have permanent workshops.[6] It would seem to be in line with this move if policy were also able to allocate site and service areas where craft communities could gain some security of tenure and provide premises for themselves in time. This would only be to adopt a trend that is already under way amongst the artisans themselves, as they combine to demarcate provisional boundaries.

As far as the present fee-paying element of apprenticeship is concerned, there seems little ground for indignant attempts at eradication, such as marked the late colonial period. It does, of course, mean that apprentices may not be drawn from the most indigent households, just as the earlier British system of apprentice premiums discriminated against the lowest income levels. Similarly, some young people who possibly lack parents or favourable extended family connections cannot afford not to be paid a wage. At the moment this appears to be much more true of the rural areas where money is tighter than of the cities. But even so, the Kenya informal learning system does not mean foregoing real wages for the five to seven year period that was the norm in Britain until relatively recently, and which, from some accounts, still is the norm in cities like Dakar and Lomé in West Africa. It may transgress the letter of the Industrial Training Act, but then, as we show in the next chapter, the Industrial Training Act is not even concerned at the moment with the thousands who acquire skill outside the sponsored official routes.

Over the last twenty to thirty years a system has grown up, almost entirely unnoticed by educationists, which has quietly been producing hundreds of artisans yearly with basic craft skills. Most important, the bulk of the group in their anxiety to be *self-employed* have paid little attention to the system of government trade tests which are decisive in assessing salary in the public sector and the larger firms. They share with the Indian artisans a healthy disregard for paper qualifications and schooling credentials; they are aware that grade tests on certain

occasions can actually be 'purchased', but know for all this that grades are irrelevant in a situation where the hardest worker makes the most money. Like the Indians, they say of a skilled colleague: he's illiterate, unqualified, but equivalent to Government trade test, Grade I. Over against this ungraded sector with its very low training costs (a fraction of the National Youth Service's per capita costs or the Village Poly-technic's), there is a counter ideology spreading throughout the country that there is still a vast reservoir of intermediate and higher level wage-and-salary technical positions waiting to be Africanised. As we mentioned in the last chapter, never until the last few years have there been so many applications for entry into some of the eight secondary technical schools. And to provide institutions for the higher reaches of technical training (sub-university), communities have been competing to tax themselves on a scale unprecedented in the history of African self-help. Both these thrusts are directed to the hope of technical employment (rather than self-employment) whatever their prospectuses may claim to the contrary; and unfortunately not very much attention has been paid to the difficulties already encountered by many technical school graduates in finding a job today. Technical preparation for formal sector employment is in fact rapidly becoming a high cost activity, and the tendency for its products will be, in Kenya as in Zambia and in Nigeria, to have technical 'qualifications' without real industrial or workshop experience.

A case could, however, be made out that there is really a very limited demand in the short term for candidates with these higher technical aspirations. The problem rather is how first to provide all of Kenya with the variety of informal sector skills available to Nairobi. And this, we have suggested, is proceeding apace. And, second, how to produce for both urban and rural areas people of a skill level immediately above that of the present informal sector operator. The latter could conceivably be provided by those whose aspirations for high technical positions become gradually adjusted downwards through unemploy-ment. It is much more likely that as with the Indians in the 1920s and 1930s it will come from hand-tool operators moving upwards into hand-operated machinery. Neither the conditions nor the available machinery are as conducive to this move in the 1970s as they were when the industrialised countries still produced a wide range of extremely cheap hand-operated machines. Nevertheless a small Indian skill reservoir does exist still in Nairobi and Mombasa, and it may prove possible for the precision workshop sector to be Africanised in a way that retains and promotes its methods in Kenya. The people most likely to adopt and spread this next level of machine technology are the more successful informal sector operators, who have in a sense been made in the Indian image. They are not, however, in political and economic terms, the group most able to get the credit necessary to do this. Still,

the need for simple and power-driven machines is already felt very strongly by artisans in the informal sector, and it should perhaps be possible to design a sufficiently sensitive credit or hire-purchase system to take account of their needs.

Again, it has to be stressed that the motivation and aspirations of many in this sector for upward mobility and technological advance continue to make it difficult to separate off the informal sector from the rest of the economy. In fact, the more we have examined the informal mode in this chapter, the more difficult it has been to isolate it from the rest. The difficulty arises in part from the term being first used for the most conspicuous unregulated urban sector of a particular city, Nairobi; whereas, as we have shown, there is very little to distinguish the urban mode of either the service or productive side from that operating elsewhere in the country. The second, and perhaps major difficulty has arisen from a perhaps unconscious use of the term 'informal sector' to mean *African* (at least in the Kenya context) so that attempts at definition are implicitly only concerned with descriptions of the African artisan and service communities. This is really rather unhelpful. It would be more useful to talk of a series of informal modes, and demonstrate how widespread they are throughout the economy. When this is done, it will be noticed that a good deal of the entire economy is informal on some criteria.

Informal education and training

By this criterion, perhaps most of the economy can be judged informal. Preference for on the job and other informal skill acquisition is common to petty rural and urban African concerns, to the majority of larger African and Indian business, and to the European large farm and plantation sector, as well as to the less sophisticated urban European firms.

Technology of improvisation with labour intensity

On this variable also, the informal mode penetrates a very large part of the country's large and small-scale industry. It is particularly characteristic of the Indian sector of the economy, but is conspicuous also in the use of machinery in the large farm and plantation sector. It is of course already well established in the petty and larger African enterprises.

Informal wage structures, determined by productivity not certification

High wage rates associated with level of school certification or trade test are really only common in a part of the public sector and the more

sophisticated subsidiaries of multinational companies. In much of th
rest of the economy wages are arrived at without regard to schooling c
formal trade competence. The indigenous apprentice system has a wag
system irregular by official standards, but then wages much lower tha
official minimum rates are common to many other enterprises. Th
large European (and now also African) farm sector although ofte
regarded as a formal, enumerated sphere, can pay rates to its casua
workers which are often less that the daily casual rate of 5/- amongs
petty producers in the town. Similarly, large scale urban firms can pa
low rates by keeping a substantial number of their work force on casua
terms. Obviously also, the Indian method of taking on casual labou
and gradually paying more to the more productive keeps wage rate
low.

Informal products and services

We have shown that with the exception of a handful of items, there ar
very few products that are exclusive to the lowest stratum of Africar
artisan. And even these were made in the Indian sector of the econom
only a short time ago. Nor can it be made out that various sorts o
illegitimate activity or reliance on stolen goods are somehow a specia
feature of this most petty stratum. *Magendo* business, to use the loca
term, is by no means restricted to this smallest scale of operators.

From this kind of perspective, it appears that informal criteri
permeate a major part of Kenya's economy. There may be good reason;
for examining obstacles such as licensing, harassment and lack o
premises that presently seem to afflict the *bottom* end of the informa
sector, but it is probably not helpful in analysis to regard that bottom
section as somehow a separate entity. Although indigenous apprentice
ship is common in this lowest sphere, it is also found among the more
established African businessmen. Similarly, on-the-job training i;
common both at the bottom of the economy and in many of the higher
reaches of Nairobi's industrial area. Indeed, if the informal modes were
not so deeply entrenched throughout a good part of modern industry, i
would not have proved so difficult to suggest that it accept highly
schooled and certificated apprentices. A good deal more of the relation
between the formal and informal modes of production will become
clear therefore in the next chapter, where we examine the resistance to
the *formally* trained apprentice in what has perhaps too glibly been
called the formal sector of the economy.

REFERENCES

1. International Labour Office, *Employment, Incomes and Equality: a strategy for
 increasing productive employment in Kenya* (Geneva, 1972), Ch. 13 passim.

. For a typology of informal sector activity more concerned with roles, see K. Hart, 'Informal income opportunities and urban employment in Ghana', *Journal of Modern African Studies*, 11, 1 (1973).
. Republic of Kenya, Ministry of Labour, *The National Industrial Training Scheme for the Training of Craft Apprentices* (Nairobi, Government Printer, 1973).
. Brochure of Universal Central Academy, Thika, 1972.
. I am indebted to Alphonse Tay and Olivier Le Brun for discussions of apprenticeship in Togo and Dakar respectively.
. *Daily Nation,* November 17th, 1974.

CHAPTER III

Industrial Training in Kenya: The Formal Sector

We have suggested that the term 'informal sector' has been used rather loosely to refer to a particular African mode of production at the bottom of the economy. It could equally be said that 'formal sector' has been defined rather generously to embrace all the enterprises in a country's modern industrial estates, as well as its public sector, the businesses in its smaller towns and its plantation and large farm sector, if it has such. In all this welter, research has tended to concentrate on the multinationals and their subsidiaries, and particularly on their technology, high profits and the impact of their high wages. And there has been a corresponding lack of interest in trying to place the multi-nationals within the constellation of local firms—both large and small, citizen and non-citizen owned. However, some such exercise is crucial if the formal sector is to be defined more rigorously. This is perhaps particularly appropriate in Kenya where there is such a wide range of foreign and local firms.

This is not however just an academic exercise, but it could raise some rather important implications for technical training and Africanisation, not only in Kenya, but in other countries such as Nigeria where a programme of indigenisation is under way. The present case study from Kenya takes us back to one of the themes in the first chapter where we contrasted international advice with local planning, for over the last five years Kenya has been attempting progressively to implement an Industrial Training Act linked to a levy/grant system of encouraging formal technical training. The model was borrowed substantially from British experience in the 1960s, but unlike the UK version, which was concerned with training at every level from managers down to operatives, Kenya has so far concentrated on skill improvement and

An earlier version of this chapter was presented to the African Studies Association of the UK, 1974, Conference, Liverpool.

formal apprenticeship. However, the vigorous campaign to impress upon the majority of Kenya's large and intermediate firms the need to adopt a particular style of formal technical training has already raised some important issues. Amongst others, it has illustrated

1. the strength of informal modes of skill acquisition
2. internal differentiation within the 'formal sector'
3. widespread employer resistance to formal technical education in school
4. the role of large scale firms in subcontracting to sections of the informal sector.

Since, as we have seen in Chapter I, a key issue with some education planners has been the need to produce a much more *technically* diversified secondary school, it may be useful to examine current employers' reactions to technical school leavers. This view from Nairobi's industrial area may also have relevance to the many communities planning a dramatic expansion of skilled graduates from the *harambee* colleges of technology. Meanwhile for education reformers interested in breaking the spiral of higher and higher certification to attain the same job, there is perhaps some evidence here that in Kenya at any rate by no means all employers have accepted the view that the higher the formal qualification the better the worker.

At Independence, industrial enterprises in Kenya presented a three-fold division of jobs by status, not much less offensive to local eyes than the rigid residential classification of Nairobi into African, Indian and European areas: European managers and engineers; Indian monopoly of technicians and skilled artisans; and Africans in all semi-skilled, unskilled and casual classifications. This pattern had to some extent begun to be breached in the late colonial period by the emergence of Indian management in a growing number of industrial and commercial enterprises, but the composition of the lower two echelons remained substantially the same. Nor was there any radical alteration in the early years of Independence after December 1963; the preoccupation was very much with the Africanisation of the public sector, and there was a desire to avoid a repetition of that insecurity and flight of capital which had characterised the private sector in the immediate pre-independence period. The emphasis was, therefore, not so much to alter the structure of the existing firms, but to encourage the development of African businessmen through small industrial loans. There had admittedly been exhortation in the well-known Sessional Paper No. 10 of 1965 for foreign firms to 'initiate or accelerate training and apprenticeship programmes',[1] but it was hoped that the racial imbalances in industrial employment could be changed without legal sanctions.

It was clear by 1967 with the publication of the white paper on the

Kenyanisation of Personnel in the Private Sector that mere encouragement had failed radically to alter the general employment structure of Nairobi and Mombasa's Industrial Areas, even though a number of individual firms had now for many years been strongly committed to changing the complexion of their intermediate and higher level workforce. The government moved accordingly from persuasion to controls, with the Trade Licensing Act of 1967, the Immigration Act of the same year, with its corollary of a system of work permits. These measures were designed to put certain trade areas and specific products exclusively in the hands of Africans, while work permits could be restricted for particular occupations where it was felt that Africanisation could with justice proceed.

The measures worked quite rapidly in replacing non-citizen Indians with Africans in certain lines of retail trade; in fact such large numbers took advantage of the protection now afforded them that the ensuing competition dramatically reduced the possible profit margin.[2] The situation was much more complex in the majority of firms who had been relying on non-citizen Indians at the supervisory and higher technician levels. Many of the major concerns in the automobile-related industries, construction and engineering were still relying on a solid phalanx of Indian overseers and master craftsmen (*mistris*). In the mid-1960s a typical larger company in the motor trade would have 20 to 30 Indian mechanics, and a host of African auxiliaries or 'spanner-boys' as they are termed in the trade. Similarly in the building trades there would be large concentrations of Indian *mistris*; and one or two of the engineering shops had as many as 70 Indian skilled hands. Naturally enough, the aim was to use the controls to produce the African *mistri* element, who, it was thought at the time, would gradually replace the Indians without very much alteration to the wider structure of these particular industries. This policy clearly involved the training up of acceptable substitutes, and it was at this point that certain assumptions were made which with the benefit of hindsight seem questionable.

THE IMPORTED APPRENTICESHIP MODEL

First, it seemed obvious that for this sort of industry skilled workers could be produced in Kenya as in United Kingdom by an apprenticeship system. A number of companies after all were already committed to such a system and had been using it for a handful of European, Indian and African staff for some years, and the technical wings of Ministries such as Works, and corporations such as East African Railways and Harbours had long had some form of apprenticeship along with their own training establishments. These enterprises naturally found it very difficult to think of training methods different from the British antecedents, and even when apprenticeship schemes

began to spread to other large firms — both local and subsidiaries of British companies — the same was true. This was the more surprising in firms which had such a reliance upon those skilled Indians which apprenticeship of Africans was designed to replace; these cadres of Indians had certainly *not* gained their own considerable skills through the sort of apprentice system now being introduced for Africans. Indeed, there was and is much ignorance in East Africa on Indian systems of skill acquisition. This will be examined later, but for the moment, a system was being articulated by the government for the production of skilled Africans, its principles derived from the practice of the more prosperous British owned or managed companies. In outline, the African skilled worker was to be produced in the following manner.

1. Unlike so many of the illiterate or merely numerate Indian master-craftsmen, the African would be schooled, and in special institutions. Schooling would no longer either be merely primary level as it was for so much of the colonial period, but would involve three or four years of secondary education during which some general work would be combined with both theoretical and practical specialisation. Craft certificates of the City and Guilds of London would be attempted in the last year of school,[3] and would be completed under the sponsorship of their employers. Clearly, the schooling element in making a craftsman or technician has become increasingly important during independence, and to some extent reflects in the technical sphere that same process of certificate escalation that has been much more marked in the general academic streams. But there has been something of a dilemma at the centre of this move. On the one hand, the continual upgrading of the formal education side of a technical trainee has been thought necessary because of the allegedly low status in African eyes of manual work, however skilled. That is to say, that technical streams or technical schools have got to be made *academically* respectable to the pupils. The question is whether this process makes them technically unacceptable to the majority of Nairobi's employers. In this connection it is interesting to note that already, just a year after independence, it was being observed by the Kenya Education Commission that 'the technical and trade schools have not been going well. Out of 487 persons graduating from these schools in 1963, no less than 170 were still without employment, or openings into further education in May 1964.'[4] There was little attempt to examine employers' reluctance at this time to take on the products of these two-year secondary schools; but it was simply assumed that their conversion into four-year secondary institutions would clear up the difficulty. Their graduates were, of course, designed to be the main source, through apprenticeship, of the Indian replacement programme.

2. The second feature of their production would be that once sponsored by Kenya firms, they would be insured a proper training, both on and off the job. They would need to be registered officially with the Ministry of Labour, under its new Industrial Training Act, and would be paid the appropriate wage for the industry in which they worked. Nor was it a 1920s or 1930s version of UK apprenticeship they were being offered, when many trainees would be treated as teaboys or sweated labour depending on the nature of the firm, and when formal theoretical training had to be picked up in the evenings in the boys' own time and at their own expense. Proper on-the-job training premises, run by a training officer, and block release to the Kenya Polytechnic, or the National Industrial Vocational Training Centres (NIVTC) were the norm, and it was particularly noticeable that trainees often demanded release to the Polytechnic with its important sub-university status.

3. The third element was a system of government trade tests, graded from three up to one; these were linked to wage differentials, and thus built an incentive system into skill improvement. Again, this testing component like that of the apprenticeship and of the prevocational technical school was not one that developed out of employer demands; nor had the majority of Indian mechanics and craftsmen ever bothered to obtain such accreditation. They were very popular in the public sector where automatic rises in pay derived from improving one's grade of trade test. But in the private sector employers continued to assess pay on experience and productivity, even though some of the larger enterprises began to follow government practice. In the late 1960s, moreover, it became for a time increasingly difficult to persuade the smaller Indian or European concerns to respect trade tests, once it had become common knowledge in the industrial area that trade tests, like driving tests, could occasionally be had for a price.

EMPLOYERS' ATTITUDES TO APPRENTICES

Despite the irregularities of the testing process, a national scheme did now exist for the training and accreditation of artisans and technicians. The question remained, however, even in the early 1970s, whether industry was prepared to accept the state's definition of artisan training. Just as in the Ministry of Education's upgrading campaigns for unqualified teachers, the only undisputed consequence was that they increased the cost of teachers, so, with this new technician and craft trainee, industry appeared to have a range of reactions, but almost all of them were basically negative. It may serve some purpose therefore to look rather carefully at the dimensions of this hostility, and assess to what extent it may be a temporary phenomenon.

At this point it is necessary to distinguish between the rather small

group of employers who have had any experience of using secondary school apprentices and the much larger group who have probably never hired one, but have very explicit views on why they do not intend to start. And even within the smallish group that has availed itself of apprentices, there seems to be a division between firms that have been more recently established in Kenya and those of longer standing. Such recent arrivals have the advantage of not having to divest themselves of a tradition of employing and stereotyping workers by race; and with the restriction on work permits, they no longer have the option to the same extent of depending on non-Africans. These few examples tend to be international concerns which have developed elaborate training schedules in Europe or America, and they simply apply the whole package of job specifications, progress reports and promotion sequences to Kenya. For them, Africanisation is scarcely an issue; it is merely assumed that one wants to move as rapidly as possible to a position where the operation is entirely in local hands. The few expatriate staff that they still have can be absorbed into other subsidiaries, and have presumably in their short time in the country not entrenched themselves in the manner of some other local managers. With this perspective — the long term one of building for staff loyalty and responsibility — it makes good political sense to recruit at the secondary level, both academic and technical, and to pay high enough wages to attract good candidates. As we shall see, firms can afford to play it this way when their product is assured a near monopoly of the available market, and when the capital intensity of the operation makes it virtually impossible to imitate. There is no difficulty in such firms operating the Kenya apprenticeship model; indeed they sometimes exceed its limits by paying higher trainee wages, and by making a small number of their best trainees, through trips, feel that they are on a par of efficiency with their counterparts in the UK.

The other small group who have some knowledge of trying to use secondary school apprentices are in a rather different position. In most cases, they have been trying to introduce or harness this new component on to an existing framework of skilled Indians and semi-skilled Africans with perhaps considerable experience in the firm. There are probably other categories of industry where things developed differently, but the present evidence is primarily derived from the automobile, construction and engineering sectors of Nairobi's Industrial Area. In these sectors, a number of firms have been accustomed to recruit secondary apprentices for quite some time; some of them have fully appointed training premises and other full time training officers. There is, however, very little connection at all between those they train and those who actually make up their work force. The companies allege that most of the trainees either leave mid-course or quit, as soon as they have served their time, to get higher pay, or to go into quite a different line of work

entirely. As this type of apprentice is the one which the government would like to expand in numbers from the present tiny group of about 100 new contracts annually to several times that figure, it would be well to be clear on their record so far.

RESISTANCE TO SECONDARY SCHOOL EMPLOYEES

First for the stereotype. The more liberal version of this is that the lack of mechanical contraptions (from toys to old motor bicycles) in most African home backgrounds has made these youths ham-fisted, and the secondary school boy having spent an extra four or five years away from 'reality' is that much more removed from the dirt and sweat of much craft and mechanical activity. Even more frequently heard from Indian mechanics and European management is the view that the secondary school boy, whatever his school type, is an abortion; the wrong person in the wrong place. Money-crazed, lazy, big-headed and politically dangerous, he has no loyalty to the firm, and will walk out at a whim. The stereotype perhaps reveals a good deal more about the employers than those they describe.

At one level, and in certain firms, the caricature is self-fulfilling. The employers have had long experience of a very satisfactory arrangement based on Indian skill and African semi-skill; their Africans tended to be kept on very specific tasks, and thus never got such a wide competence that they could market it outside the firm. As the work-permit system began to bite, it became necessary to demonstrate that the firm was taking training seriously; so apprentices were taken on. However, evidence of such readiness to accept and train apprentices was looked on with favour by the government, and made them lenient in the renewal of non-citizen work permits. Something of a political bargain thus emerged in some firms which were not actually committed to Africans replacing Indians, in which it became more important to show willingness to train than to absorb the trainees into the firm. It is not surprising that many Africans sensed something of the employer's real attitude towards them and therefore left prematurely. Others were deliberately, in some cases, exposed to the kind of dirty, hard labour which the stereotype alleged they would resent, and when these trainees began to leave—or were sacked, if they refused to do such things—it confirmed such employers in their prejudices. They could then proceed to explain to the government that they had tried unsuccessfully this time to replace some of their non-citizen staff; they would like to try again with some fresh apprentices next year, but meanwhile would the Kenyanisation Bureau renew the work permits of the following expatriates and Indian non-citizens . . . ?

Such firms are very reluctant to map out possible channels by which

those taken on as apprentices can eventually move upwards into supervisory and foreman positions. In some cases this is due to the fact that the European top technical staff are conscious of the often rather circuitous route by which they themselves reached their expertise, and resent the inquiries by Kenyanisation Bureau about their formal qualifications. A saying can still be heard that a European en route for Kenya used to sail in to the top end of the Suez Canal as a technician and emerge as an engineer. Others may have just recently had their farms bought out in the old White Highlands and have left that amateur occupation to reappear as the technical director of some small local firm.

There are, however, some firms which would in principle like to switch over to African skilled cadres, but the competitiveness of their particular industry makes it much more of a gamble. They feel they cannot afford a period during which they may have teething troubles, while all their closest competitors continue to employ the old system. Paradoxically, too, the dilemma of such a firm has been made more acute with the work-permit system. Instead of merely encouraging the replacement of Africans where there were Indians or whites, it has had the unintended effect of making particular industries like automobile and construction dramatically more competitive. And it may be worth looking at this phenomenon in some detail before returning to the stereotype of the African apprentice.

The permit system certainly succeeded in reducing the actual numbers of non-citizen skilled men in many medium-sized and larger firms. What was not foreseen was that a number of the most highly skilled Indian workers would leave to reappear as technical partners of new Indian owned companies. (A skilled non-citizen did not need a work permit if he was self-employed or directed a company.) This was only possible because the expertise of the *mistri* could be married to the capital now available for reinvestment, once the traditional retail outlets were closed off. It is not, of course, possible to generalise on the large number of car and building firms that arose in the period 1967-1973, but in the significant number it was a case of the leading Indian mechanic in a European automobile firm, or a *mistri* with one of the British civil engineering or building firms linking up with the management expertise and capital of some former big trading concern, to create a new company.

SKILL ACQUISITION IN THE INDIAN SECTOR OF THE ECONOMY

The effect of this very widespread development upon the profit margins of some of the large established British companies and also a few older

Indian concerns was very marked. The new firms operated, for instance, without any of the heavy overheads necessary to firms that paid British overseas salaries with allowances for education in the UK. But more important than this, they produced their skilled labour by a model quite different from that which the government were intent on promoting. Typically a small number of skilled workers had to be hired at the going rate, but the method of adding to the work force was often by selecting upwards out of groups taken on as casual or unskilled men. In a large construction project, for instance, several hundred casuals might be taken on at daily rates, but as the work progressed, a process of differentiation would take place, with the Indian *mistris* selecting out those who showed particular aptitude for block work, plastering, roofing, or woods; such would learn on the job to do particular building operations and their pay would rise accordingly. The result over a two-year building contract will be that while a range of people will have remained on casual rates of, say 9/- a day, others will have moved up to 30/- or more. The focus will be entirely on efficiency and productivity, and not the slightest attention will be paid to those workers who claim rises due to their having already passed trade tests. The system produces rough and ready skilled men who are often largely without very much formal schooling.

But it was a further development of this system which allowed the new Indian companies successfully to outmanoeuvre the established firms in tendering. The relative shortage of *mistris* had made it necessary to pass on certain skills to their best African ex-casuals. It also encouraged a readiness to grant small sub-contracts to some of these more talented, originally day labourers, and this process began to throw up a whole series of petty African contractors.

AFRICAN LABOUR SUB-CONTRACTING IN THE BUILDING INDUSTRY

This does not have to be identified as a philanthropic recognition of the need to encourage African entrepreneurs; it can be explained quite easily as a function of the new competitiveness of the industry, and the readiness of Africans (particularly the Kikuyu) to ask for these small sub-contracts within the major operation. The requests most likely to be heard will come from men who have proved themselves over the last few months or years to the main contractor, and who will already have been given a measure of responsibility in organising a small gang of the firm's casual labourers. For a specified sum of so many thousand shillings they will agree with the main contractor to be allowed to organise any one of a series of possible operations (shuttering, drains, site clearance, concrete block making, door hanging, painting) on the understanding

that the Indian will provide the tools and materials while they provide and pay for their own labour force. They are, therefore, essentially labour sub-contractors; and by availing themselves of this method, it has been found, perhaps not surprisingly, that the work required can be completed very much faster than if the Indian were using his own scarce *mistris* or African chargehands to oversee the site with men from amongst the firm's own labour force.

The system has in fact become so attractive to building contractors that very few, even of the established British firms, can afford to stand aloof from the trend. It does, however, clearly raise some very real difficulties for any simultaneous attempt to promote training and apprenticeship programmes throughout the industry. Because it brings large numbers of men on to the site for whose pay and conditions the main contractor is not immediately responsible, it effectively removes from him much hiring and negotiating with labour. Theoretically the main contractor should concern himself with the wage rates of the labour subcontractors, but in practice a blind eye is turned to the fact that casual labour is now hired at half the rate that the main contractor would have had to pay himself. This means that building sites now increasingly contain workers hired at the unofficial minimum of 5/- to 7/- rather than the official building labourer's rate of 11/- to 12/- per day.

Now, it clearly was not intended that the process set in motion by work permits and restrictions on non-citizen operators should result in the overall fall in the wages of casual labour on some of the main sites, or in the very rapid rundown of the numbers of workers employed directly by the established large firms. But without a careful analysis of the various types of activity that have emerged in these last few years, it is going to be equally difficult to predict the impact of the more forceful training policy that is just being implemented for the industry.

African Firms

Any such forward policy must pay attention to the very complex inter-relations of its three somewhat distinct types of entrepreneurial activity and the patterns of employment which they have adopted. Thus, at the bottom end of the range, it has to accept the fact that African labour contractors have become as central a feature of Nairobi's building scene as the lump system of labour contracting has to London's industry. Even now, African labour contractors run from the petty operator doing his first one-off job for a few thousand shillings right up through a whole range of bigger men to the person who may have a gang of over a thousand men working simultaneously on shuttering on two multi-storey sites. Policy also has to reckon with the rapid emergence of African main contractors, most of them still engaged in building houses, shops

and the occasional petrol station. Many of them will have come up through the Indian system, and may often resemble the Indian *mistri* under whom they may have worked. They will often have had little formal education and be operating in their own growing firms the identical system of on-the-job training of originally casual labour that they themselves experienced. In general this African sector of the building industry is aware that the leverage they have over Indian and European firms who may subcontract to them is that they can use cheap labour more effectively, and can in many cases keep the Labour Officers from interfering over the low wages paid. Indeed, it seems to be officially accepted that cheap labour is the price of producing that class of local entrepreneurs which the government regard as a high political priority. And thus any undue concern about the payment of very low rates can be characterised as an attempt to undercut a budding entrepreneurial class before they have even got steady on their feet.

As far also as some of the training goes in this least capitalised section of the building trades, there is a similar indifference from government. For, as was seen in the last chapter, in addition to the method of selecting out of originally casual labour, the smallest levels of individual operator — whether mason or carpenter — carry on a system of fee-paying apprenticeship for young boys anxious to learn some of these skills. So far from the small employer paying the apprentice as the government model would suggest, it is a question of the apprentice paying the master training fees, and accepting little or nothing in return during his training. The several thousand young people involved in this system of skill acquisition are equally of course directly contravening government regulations about what constitutes apprenticeship; it is, however, extremely unlikely that government would insist upon the letter of the law with these thousands of young people — who in any case are, educationally, disqualified from entering the official style of apprenticeship.

Indian Firms

If the whole *African* contracting scene appears not at all susceptible to government training and upgrading schemes, there seem just as many difficulties in making formal training an integral part of the Indian contracting world. But acceptance of the official training modules is precisely government's intention for this Indian group. Through a system of levying a flat rate of 0.25% on any building contract over 50 000/-, money is presently being centralised to reimburse the training costs of those building firms taking apprentices, while penalising those who do not. This levy/grant scheme has only been working for a few years, and it is too early to be clear about its success. Still it does look as if the majority of the Indian firms have not co-operated and have so far

regarded the levy as a tax rather than an incentive to train. The conventional explanation for this is that the Indians are opposed to training people—particularly Africans. There may be something in this, as we shall see, but enough has been said already to show that the Indians have been pre-eminent in demonstrating specific on-the-job skills to Africans. In fact, their mode of skill acquisition can be said to have indigenised itself at all levels below the most formal contracting; it runs on quite different assumptions from the state version of apprentice training, and particularly opposes the view that trade schools are a necessary preliminary to trade practice. Quite apart from the difficulty of marrying the two systems of training, the new category of Indian contractors run their businesses in ways which will allow them to continue to attract away from the Europeans a major share of public sector tenders. Tendering however has become so competitive that no unnecessary expense can be entertained during the course of the contract. So, in addition to cheapening casual labour, competition has also led in some cases to cheapening of the *mistri* element. Indian migrant workers are occasionally brought over on contract, and even allowing for the money necessary to secure entry permits, they are cheaper than using and holding on to East African Indians. There are probably not in fact more than a hundred such Indian migrants at any one time in Kenya, but their presence does point to the very great difficulty of policing the building industry in any way that will allow cheap reliable short term (and probably exploited) labour to be replaced by a solid, heavily schooled apprentice element. But the greatest obstacle to eventually altering Indian training systems may well be the fundamental insecurity of many sections of citizen and non-citizen Indians in Kenya; apart from the Uganda trauma, this insecurity is continually reinforced by the local stereotype that Indians know they will eventually have to go, and they therefore inevitably operate their businesses in ways which bring the largest short-term profits. It has to be admitted, therefore, that the political climate is not one that would encourage Indian contractors to undertake long-term training initiatives; and it would be regarded as opportunism if they did.

European Firms

So it comes back to the point that the levy/grant system will probably only commend itself to that sort of large European concern that was taking a few apprentices anyway. In some measure, in fact, it is possible to see the levy/grant mechanism as a way of encouraging such firms to continue with a level of training that they were thinking of abandoning. As was mentioned earlier, these firms had been training and subsequently losing such a high proportion of their candidates that they

were already discontented with the value of the exercise. But once they felt the new, very savage competition from the wave of Indian contractors, it became even more difficult to justify continuing these training divisions. Indeed, in the 1971 Report of the Federation of Kenya Employers, the Building and Civil Engineering Industry reported that it 'generally was disappointed at the standard reached' by its 92 apprentices. 'There was also disappointment at the attitude taken by a few boys who had carried out technical courses, as they appeared to be looking for white collar jobs and not wishing to work with their hands.'[5] In this situation the grants system came as a rather timely compromise. Government, for its part, were particularly anxious that this secondary school-leaver category continue to be offered such training openings — and especially so from the late 1960s when a degree of school-leaver unemployment became a political issue. The European firms wished to be relieved of their mounting training costs, which had not so far produced much of value to themselves. Thus a more or less explicit bargain was struck in which, beyond recouping training costs, co-operating firms would find government lenient about certain classes of work permits.

Running through all three levels of the building industry, therefore, is the understanding that apprentices recruited from school are not going to provide the backbone of their skilled manpower. In fact, even the few firms committed to training them are dubious whether the present competitiveness of the building world can afford an adequate training milieu. Any thorough training on the site requires operations that are being repeated in a whole series of floors or houses, and has to afford gradations from very simple to relatively complex. However, within the last few years, through the labour subcontracting system, main contractors have rid themselves of a large number of the replicable and simpler operations, and consequently have left themselves very few areas that can any longer provide appropriate on-the-job training for apprentices. In the building industry, therefore, the training levy actually looks as if it will function in practice rather differently than some of its framers may have intended. In Kenya, as with its forerunner in Britain a decade earlier, it was designed to reduce poaching from the few responsible firms who did train, and give a new training incentive to small firms who might otherwise have found it impossible. When this package was transferred to the radically different structure of industry in Kenya, the original UK guidelines took on a rather different colour. As should be clear by now, the smaller Indian and European firms were certainly not poaching the secondary school apprentices which the large firms thought they lost. They did not like and could not afford this style of trainee, and anyway they had their own system of providing skilled manpower. Secondly, by levying the majority of Indian contractors who did not want such high school

products, the Training Act was in fact running the risk of using the smaller Indian firms to pay the training costs of the larger European concerns. We shall return to this point later, but for the moment it looks as if from one point of view the inappropriately high training programmes of the large, often international firms were being grant-aided from the resources of the smaller more 'relevant' training systems of the Indian sub-sector.

THE AUTOMOTIVE INDUSTRY:
EUROPEAN, INDIAN, AFRICAN

It might be suggested that the building industry is something of a special case in Kenya as in the rest of the world, and is bound to be resistant to formalised training. Its labour demands are after all very erratic, and a firm employing 500 men one month may require only a fraction of this number the next. This does not, however, entirely explain the resistance, for there are other sectors where similar patterns have emerged. In the car-related workshops, for instance, there is again a very wide spectrum from the large European importing-cum-repair works, through a parallel Indian sector, and down to an intensely competitive African arena. It looks as if the recent emergence of the Indian sector has been along the same lines as in the building trade, and much of the dynamism of the African car repair sector derives from its operating in an indigenised Indian mode. Widespread Indian use of African casual labour, the best of whom progressively learn to be mechanics on the job has been noticeable both in the industrial area and in Indian homesteads, where the family will often employ one or two primary school-leavers to learn the trade after hours. Such people will be taken on at a pittance, but within a year or two will have mastered all but the most highly specialised areas of car repair. Like their counterparts in the building trade, there will have been no formal theory, no trade tests, no off-the-job training, nor any specific training 'mission' on the part of the Indian. The readiness to open up such trade skills to Africans is simply explained by the rapid movement of many Indian families out of the caste craft confines of the colonial period, in the late 1950s. The business interests of many families diversified very swiftly from this time, and with some members of the family taking advantage of higher education, the trend was towards being less protective of the craft secrets of earlier years.

The very large number of Africans who picked up car repair skills in this manner from the late fifties to the present learnt in many cases a different style of repair than that available in some of the large European depots. The latter had a tendency, since they derive a great deal of their profit from spare parts, to train their mechanics to replace

rather than to mend. The tendency with many of the Indian workshops is either to mend, or to replace with elements from the Indian-run second-hand spare parts warehouses. It is of course the combination of improvisation and great technical skill that has made the Indian car repair sector so competitive *vis-à-vis* the European; and in turn the very under-capitalised African workshops (operating out of vacant building lots) need to utilise the same improvisation techniques. As with building trades, these African car repair agents can manage to undercut the Indian, by a very thoroughgoing reliance on the paying apprenticeship system — the result of which is that most little groupings will be assisted by between three and ten youths who have each paid about £20 to learn the trade on the job. From the policy viewpoint, it has to be admitted that the mechanic trained in improvisation after the Indian manner is likely to be a good deal more valuable in the rural areas for instance than the mechanic trained in the very highly capitalised workshops of the large importing firms. There is, however, the difficulty that this form of appropriate technology seems to be intimately linked into the low (or no) wage structure of the informal sector of the economy.

Following on these two case studies of the building and automotive industries, it is necessary before concluding to make a few more general points on the characteristics of the secondary school educated work force and the employers' stereotype of this group. The most important of these would seem to be the alleged high turn-over rate or mobility, their level of productivity and the aspirational framework associated with their schooling. They are all, of course, relevant to any major attempt to upgrade the level of education in the modern work force; and they throw some light on the particular phenomenon too easily called educated unemployment.

SECONDARY SCHOOLS AND TECHNICAL SKILLS

First of all, the majority of employers are certain that in the Kenyan context there is a world of difference between the attitude to employment of the primary school dropout or leaver and the secondary school product, and the little research so far done on this theme would confirm that the general contrast between primary and state-assisted secondary schools is very marked indeed.[6] The secondary government school, as was stressed in Chapter I, is institutionally quite removed from the primary context, and the 10 to 15 per cent of primary cohorts which succeed in entry have this separateness reinforced by dress, regular food, boarding facilities, graduate (often expatriate) staff, compound life, and school traditions. The strongest of these traditions is that the school is a preparation for employment in the modern (public or private) sector of the economy. One of the institutional messages of

the typical secondary school is that those who have persevered with education to the extent of reaching secondary will be rewarded with high wage jobs. In this matter of aspirations there is really not very much difference yet between the state secondary schools and the private or community ventures. For, despite the expansion of all levels of such schooling, those who reach secondary level at all are still the privileged 'talented tenth' of Kenya youth. Because of this, it is not yet really possible to suggest that the less good secondary schools have socialised their pupils to much lower expectations for their future jobs. So, if employers are looking for a group prepared to accept initially very low wages, they have to look elsewhere than even the inferior secondary schools.

In fact, the major division amongst schools in Kenya is not by school type as in Britain, but depends upon the number of years one has remained in the system. The source of much of Nairobi's most stable workforce is the thousands who either drop out or are discarded from the school system relatively early on. Compared with the trickle which gets through the selection system into secondary education, this is the bulk of the school-going population. Excluded from the secondary experience by lack of money, bad luck, or through inferior primary schooling, they have already been to some extent conditioned to accepting whatever they can find. They provide the 5/- a day casual workers on building sites, the 30/- a month nannies and child minders in the rural areas. And, from the perspective of this chapter, they are very often the group taken on as unpaid apprentices in the African craft world. Both European and Indian firms recruit them for their own preferred patterns of on-the-job training. Not having any alternative method of gaining a skill to live by, such primary school products fall quite readily into the job-specific training of so many of the small operators.

But this is not to suggest that such recruits accept with some sort of resignation a working life tied gratefully to a low wage. The interesting thing about the bottom end of the employment spectrum, particularly in Nairobi, is how determined so many low paid employees are to leave and set up in self-employment. This seems to be especially true of the young people who have been picking up craft skills in Indian building sites or engineering or automotive shops. There is therefore something of a mobility problem even at this level — despite the great demand for positions in paid employment. It is not therefore true of Nairobi that any job in the wage sector is worth holding on to for its security and small, steady income. Consequently, employers are threatened by the loss of workers to self-employment, or to higher paying firms who need to replace Indian *mistris* with experienced Africans. In some cases, they have tried to secure workers by employing more than one member of the family (on the understanding that if one leaves, all lose their jobs);

others offer their workers nominal shares in the company, or try to secure them through loans, advances or housing. This movement is not in fact evidence of a shortage of skilled people, for there is actually no lack of rough and ready welders, builders and mechanics, but derives more from a widespread feeling that at the moment there are a variety of profitable openings in the informal world of self-employment. It is thought, rightly or wrongly, that the £20 to £25 a month ceilings in paid employment can easily be exceeded by embarking on one's own.

Mobility at this level of the work force should not, however, be exaggerated. But its limited existence does make employers resistant to any very dramatic rise in the educational standing of skilled labour; and it may be assumed that there will be particular resistance to their co-operating in training a worker with a variety of marketable skills. And yet this is precisely the intention of the training levy—to insist that a skilled man is not held to a single process in a factory or shop floor but exposed to a wide range of other techniques in the work situation, as well as being released to an NIVTC for the more theoretical aspects of the general trade in which he is working. Moreover, the training levy is specifically designed to recruit the secondary school students into industry—the very group that many employers consider to have been unfitted by their long exposure to formal education.

Earlier in this chapter the employers' stereotype of the secondary graduate was discussed. Now in the light of the very great status differential between secondary and primary schools, it is perhaps important to see at what points that stereotype sticks. First, the boys in the government's secondary vocational schools have their job sights fixed on what they consider proper firms—those likely to be able to afford the sort of salary in technical work that their colleagues in academic schools expect to get from clerical jobs. When for example a group of final year students in such a school were asked in 1972 what firms they had been applying to or hoping to enter after school, the majority of responses named the corporate giants: British American Tobacco, Kenya Breweries, Metal Box and East African Industries (Unilever); the Ministry of Works and the East African Community's Railways, Harbours and Airways were the next most popular, and then there was a range of interest in local subsidiaries of the oil companies, IBM, Union Carbide and the European engineering and automobile workshops. Although some 65 individual firms were named by these 96 boys, not more than one or two mentioned Indian companies or some of the longer established local European firms. This is quite understandable. These boys do not know very much about local concerns which produce skilled labour in the ways discussed in this chapter. And what they suspect is that such predominantly Indian firms offer much labour and little pay, small hope for advancement and possibly bad treatment. They are therefore interested in the security of jobs in the

government and the East African Community's technical sectors, and particularly in that small range of companies which have model training procedures, and presumably higher salaries. They see themselves as advancing rather rapidly to supervisory and foreman positions almost as soon as their apprenticeship is completed.

This pattern of preferences is absolutely logical given that only a handful of companies are yet convinced of the value of secondary level technical school trainees. But as such firms and the parastatals can only naturally absorb a fraction of the schools' output, the rest have to adjust to industries which are, in the words of one manager, not convinced that the products of Mombasa Technical Institute are 'God's gift to Kenya'. Most companies will want proof that secondary school apprentices can be as productive as their other sorts of recruit, and are prepared to learn the job the hard and slow way. They will anticipate their sticking at apprenticeship for four years, then five years on the site or shop floor, then perhaps another five years as chargehand or assistant, before any major recognition can be expected. But the idea of getting rich slowly is not one that has so far needed to be accepted by secondary school students.

The major reason that trainees baulk at this pattern of very slow promotion starting from a low wage base is that they are not drawn, as in Britain or India, from a different social stratum than other aspirants to middle class careers, and are certainly not derived from families that have come to anticipate their children following in a trade tradition. Indeed, by virtue of being in a government secondary school at all, they consider themselves candidates for highly remunerative employment, and are consequently surprised that the wage and status differentials of the UK system have the effect of offering them in Kenya a starting apprentice wage substantially less than their friends going into the general civil service occupations. Also important is that, whereas in Britain the apprentice enters into contract with his sponsoring firm at age 16, the first year apprentices may well be almost 20 in Kenya, and in many cases will have spent several years struggling, through repeating his grades, to get into secondary school. It is difficult, having finally arrived at the goal of wage employment, to accept 250/- a month * particularly when the firm appears totally to disregard the relevance of all the years in school. Such a wage might be tolerated where it is quite clear that a variety of openings exist in the firm, and will become rapidly available after apprenticeship; but as has been stressed above, many firms have no coherent career structure, and are only going through the motions of training in any case.

Many of the smaller firms would also argue that although 250/- rising

* This approximate rate for a first-year building apprentice is likely to have been adjusted upwards since 1973.

to 500/- over a four-year period may not seem very much to the trainees, it is still more than they would want to be paying their less educated recruits. In addition, the principle that wages should go up automatically for each of these first four years is clear against the Indian and smaller European firms' axiom that wages should be related to individual productivity. And even though the training levy will reimburse the total apprentice wages during these four years, they are still going to be left with someone in year five who they will have to continue paying at this relatively high rate. In the meanwhile the trouble of insuring that their trainee gets an exposure to educative work throughout this long period is more than most small firms can entertain.

Apprentices react quite naturally granted that they are caught in a way between the low wage structure of so much of Kenyan industry and that tiny island of high wage employment for which their schooling and the potent draw of the international company have given them aspirations. Once they realise that in their fourth year of apprenticeship they may still only be earning as much as their clerical contemporaries will get in their first year of employment, they begin to look around. And in particular they start to try and raise the academic content of their training by demands for release to Kenya Polytechnic. In the past many apprentices have made use of the Polytechnic to raise their certification, and turn themselves into technicians instead of the skilled tradesmen which their sponsoring firms wanted. There has consequently been in the last few years a progressive closing of the Polytechnic option for craft apprentices, and an insistence instead that they should go for block or day release to the NIVTCs. This has been rightly interpreted by many apprentices as a shutting down of their chances of upward mobility, since the NIVTC is much more concerned with craft practice and proficiency testing than with preparation for higher technical certificates. Thus when building apprentices turn up there in dark suits, as if for the Polytechnic, it becomes easy for critics to caricature them as people who cannot imagine themselves 200 feet up on a scaffolding. There is, as has been seen, more than a grain of truth in the employers' cynicism, whatever the companies' own failings. So although it is difficult to be precise about the various influences at work, the result is that many apprentices 'surrender' — to use the East African term, and break their contracts for what seem more promising positions.

DISCUSSION

This rather tentative account of training problems in Kenya has concentrated on relating an imported model for the training of skilled

manpower to the actual variety of structure of industry in Nairobi. It has been concerned with what at one level looks like the attempt to force industry to develop a recruitment policy which could parallel the process of certificate escalation in the education system. That is to say, if the education machine was producing people with a particular pattern of aspirations for high status jobs, then industry should increasingly, Government thought, be made to recruit these. Secondary schools are the expression of people's desire for highly paid work; so, as a corollary, they should begin to be the source of skilled labour instead of primary school products. And this notion that the better educated are by definition more valuable to industry has been given some credence by its being already acceptable to the large international corporations. Kenya's model artisan is thus being predicated upon the sort of resource available to these firms, and it is hoped that their pattern of training can swiftly percolate the more resistant sectors of Nairobi's industrial area.

This seems to be in the short run rather unlikely, and in the long run it may appear that certain industries will simply be run down and vanish from East Africa rather than be manipulated along the lines of this training module. As the work-permit mechanism becomes more rigorous, such firms take on more and more of a laager mentality. The more extreme variety react to the loss of skilled *mistris* by working their remaining Indian and European engineers twice as hard. Now that even these skilled remnants are on work permits of, say, two or three years, it is even less likely that they will have the time to train replacement technicians. Reared in the colonial caste society, some of these managers continue to believe that they are 'certainly not going to teach someone of inferior intelligence—who probably can't remember one week what he learned the week before'. Others adjust and diversify their product to the kind of skill level they can acquire in their work force without much trouble or training; so, in one or two cases, as skilled workers have had to leave, their precision equipment has been sold off to make way for simpler operations. A large group of others have been caught out by the speed with which change has become necessary, and although they are not perhaps any longer opposed in principle to training, the vastly increased competitiveness of their industry, and the limited range of recruit that the government offers has led them to undertake forms of pseudo-training. Indeed, old methods and traditions continue, in the words of one training officer, 'behind a smokescreen of "training" as vast as that surrounding the British army crossing the Rhine in the last war'.

But one result of the legislation, despite this resistance, has been the growth of a sector of the economy that operates along lines diametrically opposed to the miniature high wage model being proposed. In this informal arena, there has been a relaxation or

complete transgression of the official regulations for training, apprenticeship and minimum wages. There has also been widespread indigenisation of the Indian on-the-job training pattern, and the result has been the emergence of a large group of Africans who are determined to be self-employed, and to improvise where they lack capital for equipment and wages. Associated with this lowest level of entrepreneur is a degree of fairly intense exploitation of labour, making it difficult for policy makers to give blanket approval to its range of unorthodox operations.[7]

As we have shown, this productive side of the informal sector can be credited with producing a range of very cheap goods and services suited to the low income of the majority of Kenyan people. It does this not only for the self-employed and subsistence elements in the population, but also makes it possible for the lower paid workers in the Indian and European firms to live within their small incomes by buying cheap locally-produced basic goods. And to this extent, as was noticed in particular for the building industry, the informalisation of the lower echelons of the labour force can work to the ultimate profit of the large contractor, whether foreign or local.

Although there are, therefore, clearly temptations in spotlighting the style, wages and products of this informal craft scene as an 'appropriate' response to Third World conditions, it is possible to romanticise its mode of operations, and exaggerate its separateness from the formal large company sector. They are, in fact, inextricably inter-related — at least in the Kenya context. To quite a considerable extent, the informal sector is initially stimulated by the presence of large formal sector concerns, and continues to be parasitic upon them for scrap materials and cutprice subcontracts. Before, therefore, policy-makers set up the informal world as an alternative way of life to the capital-intensive formal sector, it should be noted that the very slow growth of employment in the modern sector is sometimes causally related to dramatic increases in employment in the informal. In the contracting industry we have noted, for instance, that there could be a cutback in the formal workforce precisely because of the availability of cheap labour in informal African labour gangs. It is something of a policy dilemma, therefore, that the low cost, dynamic, petty capitalism of these small entrepreneurs cannot be treated as an entirely separate phenomenon and cannot begin to be formally encouraged over against the allegedly harmful employment effects of some international firms. Unfortunately for this perspective, the world of petty cutprice improvisers is largely spawned by a policy of *laissez-faire* formal investment higher up, and becomes eventually one reason why such firms are prepared to continue investing in Kenya.

Similarly, from the schooling and training perspective, it may be imagined that the style of both the Indian and informal African world

would be attractive to the many private foundations, national and UN agencies presently seeking an alternative to what they see as Africa's overheated school systems. Some of these groups, as we have shown, are currently very much involved in exploring ways in which informal training programmes can begin a process of deschooling Africans from what is seen as their blind and expensive faith in the western model of education. This is a complex task for any outside agency to contemplate, and in Kenya it is not made any easier by the fact that the highly schooled and certificated product opposed now by the international foundations is precisely that encouraged by the international firms.

CONCLUSION

Since the bulk of the foregoing was written not very long after the introduction of Kenya's Industrial Training Act, it may be useful to conclude with a number of observations gathered in mid-1974, by which time the levy/grant system had been operating for more than three years. It is possible to be rather clearer now about some of the trends that were just emerging two or three years earlier.

1. The expansion of the craft apprenticeship programme

One of the most interesting developments by mid-1974 appeared to be the rather large numbers of apprentices being registered in contrast with the early 1970s. In 1974, for instance, almost 500 fresh apprentices had been taken on, and there was every evidence that the trend would continue into 1975. On closer inspection, the pattern of recruitment is still dominated by the Ministry of Works, the firms with Kenya government participation, and the larger international companies such as Unilever, Mowlem and Booker Bros. Admittedly, a significant number of the local European and Indian companies had become involved in the scheme, but this had been quite largely the result of a personal sales drive in Nairobi's industrial area by the ILO experts attached to the industrial training project. This campaign to 'sell apprentices' had so far not made very much impact on the total pattern of apprentice figures. For instance, in the building trades of carpentry, masonry and plumbing, over the last four years, the Ministry of Works alone had a total of 107, the large European concerns 100, and the Indians approximately 24, even though the Indian sector continues to dominate all but the very largest urban building in Kenya.

It was also apparent that the apprenticeship programme was still very much centred upon Nairobi, where pressure could reasonably be brought to bear on companies; there had been scarcely any impact

upon the industries located in Kisumu, Nakuru, Mombasa or the other smaller towns. Indeed, it was noticeable that although the second National Industrial Vocational Training Centre had been deliberately sited in Kisumu in 1973 to encourage the participation of local industry in training, only a handful of these local firms were so far represented, while the majority continued to be drawn from the companies with head offices in Nairobi.

2. Development in the Technical Schools

Corresponding with the joint Government/ILO/UNDP project to expand and improve apprentice training, the Ministry of Education had further formalised the technical courses in the schools from which apprentices were normally drawn. All such schools now offered in 1974 a full four-year secondary course culminating in an East African Certificate of Education (Technical). This was a certificate which had considerable common ground with the ordinary academic EACE, but in order to ensure that the students were attractive to industry, it was agreed that they would not be allowed to sit the EACE(T), until they had satisfactorily passed a series of practical phase tests. In fact the declared aim of these schools was still to turn out skilled workers for industry, but the context in which they were now schooled created more than ever aspirations beyond the rank of skilled artisan.

Paradoxically, the government attempt to use the technical schools to create a really solid and acceptable future craft apprentice ran parallel with a student attempt to use the technical schools to gain jobs of a high status and security which an ordinary academic form four education could no longer guarantee. Widespread knowledge of the unemployment of academic school leavers translated itself within three years into a fascination for technical schooling on a scale unsurpassed in the history of African education. This expressed itself most dramatically in the communal and regional fund-raising for seventeen self-help institutes of science and technology, one of which was already fully operational by late 1973.[8] It also had the effect, lower down the education system, of directing primary school leavers' attention towards technical rather than academic school entry. Since there were only some eight technical schools out of a total of some 800 academic secondary institutions, it may be imagined that the competition for entry quite suddenly became intense (in one school some 3 000 primary students made it their first preference, even though there were only 120 places). The result is that the technical schools have for the first time in their rather chequered history captured some of the best qualified candidates from the quarter of a million odd primary-school leavers.

With such students, it is going to be difficult to maintain the position where technical schools are terminal at form four, and lead directly to

craft apprenticeship. Like any other rigorously selected student minority, they are interested in opportunities for further training, and occupations that afford mobility. Pressure accordingly is building up for such students to be allowed to proceed to forms five and six, and positions are being sought in industries which will allow release to higher education in the Kenya Polytechnic or University. It seems unlikely that these students will be content with the role of skilled journeyman for which the system is presently training them.

3. The Indian Craftsman Replacement Programme

A large number of the manufacturing and maintenance firms have had to move during the last decade from an almost complete reliance on Indian technical and supervisory skills to a position where they had few if any Indians left by 1974. Many of the large motor vehicle firms had 50 to 60 Indians in a single branch ten years ago and have now perhaps two or three left. Even in the building trades, there are often only a handful of Indians left at the highest supervisory level. This is typical across a whole range of enterprises, even though there are still some companies that continue to rely on the old colonial formula, and do so by hiring *citizen* Asians (who do not need a work permit) where they might once have had non-citizen. In general, however, the Indians have been replaced by Africans with long experience in the company concerned, and whose skills, exclusively learnt on the job, are very specific to the processes used in the firm. Such workers, taken on as casual labour at the factory gate ten to fifteen years earlier, have assimilated the main skills of the Indians they worked under; their educational qualifications range from none to standard seven (end of primary school), and their labour mobility is rather low. Their wages, like the Indians they replaced, are related to experience and productivity and not at all to formal trade qualifications.

So in a large number of companies, it is now no longer a question of fighting off the Africanisation of the technical workforce; this has been effectively completed in many cases, and the Indian replaced by an African made in his image, but paid less. The issue now is how to get the majority of local and many international firms to prefer a highly schooled technical employee to their skilled but less educated workers. In a word, how are the expensively produced students of the technical schools to be accommodated as craft apprentices, now that the Indian replacement phase is almost over? It comes down to wages and mobility. The reorganised apprentice training at the NIVTC will normally insure that the trainee will, within his three years, take all three government trade tests. He will thus, within the first three years in his firm, be automatically entitled to Grade One trade test wages. With the exception of the Ministry of Works and a handful of large international

firms, most companies in Kenya are simply not prepared to pay wages of between 800/- and 1000/- a month to a man with only three years' experience. Although, therefore, it is going to be possible through persuasion to attach apprentices to some of the local companies through the levy/grant system, it will probably prove very difficult to insure that they stay once their apprenticeship is completed. Many will leave of their own accord and will gravitate towards that minority of institutions that recognise formal qualifications, and offer avenues of upward mobility.

In fact, the more formalised and rigorous the technical school and apprentice training becomes the more likely it is to separate itself from the needs of the majority of local industries in Kenya, and to predicate itself upon the recruitment and wages policy of the government corporations and the most sophisticated international companies. Having achieved a measure of substantial Africanisation amongst their technical workforce, most companies dislike now the idea of replacing their relatively cheap, less educated workers by a group from secondary schools who they suspect are volatile and promotion conscious. And there is, as we have seen, some evidence that technical school graduates are less likely now than before to undertake long term service merely as skilled workers.

It could, therefore, be suggested that the Industrial Training Act, which aims through the technical schools and the NIVTCs to reproduce the British model apprentice in Kenya, has still by no means indigenised itself. Even if it maintains its present recruitment of 500 a year after the ILO pressure is removed, this is still less than half of the annual leavers from the few technical schools — not to mention the tens of thousands of ordinary form-four leavers. At the moment the apprenticeship programme has no impact at all upon the ordinary secondary school leaver, and within the present terms of the Act is not even applicable to the quarter of a million annually leaving primary schools, most of whom will have no further formal education or training.

Its present small coverage of industry and considerable costs are naturally of concern to the programme administrators who increasingly feel that the whole thrust of the Training Act has a rather élitist orientation; they would like to offer something of relevance to the majority of Kenya's workers, now quite outside the scope of any formal training. Given, however, the limitations of personnel and space in the two NIVTCs, it is difficult to see how the demands of the present apprentice programmes can be combined with any significant gesture towards the majority of those who are acquiring or have acquired their skills on the job. It will certainly be worth experimenting with night classes for some of the thousands disqualified by education or lack of sponsor from the daytime programmes.[9] However, it may very well be found that the highly qualified personnel, the capital intensive

machinery and the assumptions about wage structure associated with the NIVTCs are rather alien to the context of low wages, intensive labour exploitation and improvisation with few tools or simple machines that are the mark of so many of the smaller Indian firms, and the very large and proliferating number of African firms. It is just such an improvisory use of tools and simple hand operated machinery amongst a group of Africans that is the subject of the next chapter.

REFERENCES

1. Republic of Kenya, Sessional Paper No. 10, 1965, *African Socialism and its Application to Planning in Kenya* (Nairobi, 1965) quoted in Republic of Kenya, *Kenyanization of Personnel in the Private Sector* (Nairobi, 1967), 2.
2. On the dimensions and political implications of this competitiveness, see further, Colin Leys, 'The limits of African capitalism: the formation of the monopolistic petty-bourgeoisie in Kenya', in *Developmental Trends in Kenya* (Centre of African Studies, Edinburgh University, 1972), 1-25, reprinted in his *Underdevelopment in Kenya* (Heinemann Educational Books, London, 1975).
3. This later changed to an East African Certificate of Education, with technical subjects, and practical phase tests.
4. Government of Kenya: *Kenya Education Commission Report,* Pt. 1 (Nairobi, 1964), 75.
5. Annual Report, Federation of Kenya Employers, 1971 (mimeo),
6. For contemporary data on secondary school leavers in Kenya, there should be available in 1977, the present writer's study: *Jobless in Kenya: the Social Life of the Educated Unemployed.*
7. Much interest has focused on the informal sector in Kenya due to the recent employment mission; see ILO, *Employment, Incomes and Equality* (Geneva, 1972) Ch. 13. For an analysis of this report's perspective, and in particular its view of the informal sector, see Colin Leys, 'Interpreting African Underdevelopment: reflections on the ILO Report on Employment, Incomes and Equality in Kenya', Institute of Commonwealth Studies Seminar on *African Urban Politics,* March 1973.
8. For a fascinating discussion of the prospects of these seventeen institutes, see E. M. Godfrey, 'Technical and Vocational Training in Kenya and the Harambee Institutes of Technology', Institute for Development Studies, *Discussion Paper* No. 169, Nairobi.
9. An evening class for informal sector mechanics was run at the Nairobi NIVTC for the first time in September-October 1974.

CHAPTER IV

Small-scale African Enterprise I: indigenous machine-making

The problems facing the lower strata of small-scale African producers are certainly no less complex than those afflicting the more highly schooled and more formally trained. But at the very point when governments and international agencies are most anxious to reach out in some way to this level of operator, there is considerable ignorance about the basic constraints and opportunities in the world of petty production. In this and the following chapter, therefore, an attempt will be made to suggest something of the mode of operations in two different types of productive activity. It must be emphasised that the artisans discussed here are all at a level substantially beneath those that might hope to obtain loans or credit through one of the formal government schemes. Enterprise in these lower layers of Kenya's economy is very diverse. It is hoped, nevertheless, through these case studies to sharpen up some of the discussion surrounding this part of the informal sector.

The main themes raised in the analysis are the following.

1. *The role of intermediate technology in the informal sector.* As was noted in Chapter I, intermediate technology is being recommended with increasing frequency for the more relevant development of the poorer countries of the world. Such technology is perhaps too often presented as a series of appropriate devices designed and introduced to Africa by specialists, rather than as a local feature that can be co-opted or discouraged. There are, however, some formidable obstacles lying directly in the path of such local technology.

2. *Skill acquisition and competitiveness.* The present account also illuminates in some detail the consequences of open access to skill in the informal sector and the ensuing over-competition. This suggests a pattern of dependency of many informal operators upon the formal wholesale merchants, although as we shall note later the mobility of

many petty producers alters the terms of this dependency.

3. *Impact of formal, large-scale industry upon the informal producer.* There is clearly a great deal to admire in the improvisation and ingenuity of the artisan world, as it recycles the refuse of the formal sector, and develops markets not penetrated by the large international and local firms. Still, its supplies (viz. scrap iron), workplaces, personnel and profits are constantly at risk, since so many of the variables in production lie outside their direct control.

4. *A role for aid in the informal sector.* Although the following two chapters are concerned to document and analyse a particular style of productive activity rather than outline a programme of action towards the informal sector, some of the discussion should perhaps prove helpful for policy-makers involved with this stratum of the economy.

There have been valuable attempts to construct a typology of informal sector operations both legal and illegal, and to analyse the crucial links between the income available at the bottom of the economy and a nation's wider dependency upon western capital and technology;[1] but there has been a surprising lack of information on how particular 'industries' actually function in this informal arena. Some observers may well consider it quite pointless to follow Henry Mayhew a century later, and to document in Nairobi or Accra the African equivalents of his street musicians, woodworkers or needlewomen;[2] and there is certainly the danger that the mode of life and ingenuity necessary to make ends meet in this whole area can be idealised — especially by non-Africans — and the whole exercise may then merely divert attention from any integrated understanding of the larger political economy. There is, for example, evidence that some analysts and planners who lived through (and possibly contributed to) the unemployment-of-African-school-leavers crisis of the 1960s initially welcomed the emergence of the informal sector, much as whites applauded Booker Washington in an earlier era for claiming that blacks wanted to start at the bottom, and preferred hard manual work in the South to easy clerical work in Northern cities. Similarly there has been delight and surprise amongst some to discover in the last year or two that apparently for all the talk of urban and rural underemployment, thousands of Africans who had failed to squeeze themselves into the relative security of the 'modern' sector, are actually *working*. Nor had exclusion produced despair or political bitterness. Everybody was too busy working for that.

It is no accident in fact that the informal economy and non-formal education have both become the object of sophisticated local and international study at about the same time in the early 1970s; the first, as we have suggested, indicates a switch away from the seemingly insoluble problem of expanding formal sector employment, while the second is equally gloomy about the cost and expansion of the formal

school system. The euphoria with which people saw capital being sunk in the formal economy and its associated education and training system appears to have evaporated. It has been replaced, in the eyes of some observers, by a disenchantment with the African élite which both formal sectors have helped create, and a variety of pleas and proposals for equity in national life. Enter therefore the working poor.

So far so good. But with the new emphasis on the poorest strata, there soon arose a number of complications. Many suggestions for giving a better deal to these really marginal small producers, or, in agricultural extension proposals, to the 'laggard' farmers emanate from donor agencies or from foreign action research teams with some local participation; but as their recommendations for helping the working poor have tended to be wrapped up in a wider package of proposals for income distribution, land reform, controls on foreign investment and correction of the urban-rural imbalance, it is difficult to see how any single part of the package could hope to be implemented on its own.[3] Short of a complete revolution in national priorities.

Influenced partly by this logic, another strand in some of the most recent research has therefore tended to be rather pessimistic about the possibility for significant change in any isolated sector of the national economy. Knowledge of the exploitative connections between urban and rural areas and the wider complex patterns of Third World dependency look like making it increasingly difficult for field staff to concentrate whole-heartedly on limited improvements in rural industries and employment, designed to help the really small man. This disillusion about meaningful change at the micro level, because of the immanence of 'the system' is likely to be felt in the West first; eventually however graduates from departments of history, economics and politics in Third World universities will also have been exposed to something of the same critique, and may feel that, short of a more fundamental restructuring of the international and national relationships, there is not very much that they as *individuals* can achieve in the various social service ministries or voluntary agencies.

If we can summarise the rather parlous status of this informal world therefore, as it has been knocked about in universities and aid circles recently, it might be expressed as follows.

1. By the late 1960s, both radical and conservative students of African affairs were, rightly or wrongly, moving towards a disenchantment with the *sluggish* growth of the formal economy and the dramatically *rapid* growth of formal education.
2. Disillusion with the ruling élites and the associated galloping inequalities produced the search for alternative styles which might suggest a better deal for the poor majority; hence the focus on the informal economy and non-formal education.

3. Concurrently with this search for alternatives, development work in Africa and the policy recommendations connected to it came increasingly to take into account elements from the Marxian theory of underdevelopment. In more or less watered down form this had the effect of suggesting that individual initiatives at the field or micro level would at best be tinkering with much deeper imbalances and patterns of dependency.

4. Thus, no sooner had the informal economy and non-formal education been identified as productive objects of policy than it became commonplace to stress that the activities subsumed under informal economy and education were not so much alternatives to the prevailing system as symptoms of its malaise. You could not exalt into national policy a sector that was the yellow underbelly of the beast you wished to transform.

5. Although much of this debate had been carried on by foreigners inside Africa and without, both they and some local intellectuals appear to have discovered the plight of the working poor, only to decide rather rapidly that unfortunately nothing can be done about it.

6. This debate, while perhaps analytically valuable to understanding Third World poverty, has underlined the very limited goals of those few agencies or institutions already committed to the amelioration of poverty *within* the existing political system.

So in a situation where the main thrust of governments in the Third World is not aimed radically at altering present patterns of urban-rural imbalance or centre-periphery relations — beyond a general approval in principle for rural development — the particular practical problems of the very small entrepreneur, for instance, have remained the concern of a few unco-ordinated initiatives in most countries.

In Kenya, for example, these have been one or two voluntary agencies, notably the Christian Council of Kenya which has promoted and sustained Village Polytechnics, and is presently concerning itself with urban squatter and jobless artisan programmes. There has also been some valuable survey work carried on by individuals in the University of Nairobi's Institute for Development Studies, and there a number of the key policy issues surrounding rural industrialisation have been given attention through its programme of seminars and conferences;[4] and there is finally the body of thinking which has been connected to the very recent establishment and first footsteps of the four Rural Industrial Development Centres. These are located in provincial towns. They are not intended as miniature industrial estates, but rather to connect themselves with the existing range of small business in the surrounding areas, providing advice and where possible stimulation to new product design and development. At the moment (1974) the centres are very much feeling their way, drawing heavily on the

technical personnel available from the Danish and Norwegian aid agencies responsible for their foundation and early support.

These then are the three main areas of practical activity touching the problems of the smallest rural or urban producer. Their clientele constitute what could be called the fabricating section of the informal economy — the very grouping which we have seen attracting some considerable scholarly attention.

We return therefore to our starting point: that although a good deal — possibly too much — has been written first on the significance and then the irrelevance of the informal sector as a policy or development area, most of this has been concerned with how satisfactorily to characterise this sector or fit it into some analytical model or framework. There has been very little written in any detailed way so far on the structure of particular industries, the development and change in their technology, the patterns of employment and training involved and their profitability. In fact, on the issue of technology it is rather assumed in some of the literature that although admirably hard-working, these petty entrepreneurs turn out rather shoddy lines because of their poor handmade tools; that their simple product types have somehow got stuck, and that this stagnation of rural craft is therefore one of the areas in which the new Rural Industrial Development Centres can be particularly active. There is in this approach, however, a rather serious lack of historical perspective, and a tendency to assume that what a particular survey may reveal for an area in, say, 1970, has probably been very much the same in the past. Consequently, for most modern artisan activity in Kenya, there is a complete blank on the process whereby that craft has spread or contracted during the colonial and post-colonial periods. There is similarly very little known about the personnel who at any one time appear to be smiths, carpenters, or masons in the informal sector. Do they have only one skill? Or is the skill they practise this year different from last and likely to be different again in one year's time? Do they regard their present craft with any satisfaction, or do they have one eye all the time on how they can escape up out of self-employed craft into the security of employment?

Most of these questions are not amenable to traditional survey techniques, particularly those that probe the income, wages, savings and future plans of the enterprises. Surveys are also rather clumsy instruments for measuring the developments in technique, personnel and training over a decade or more. It has consequently been necessary to restrict this present research to very small fragments of the entire informal economy so as to allow fairly detailed case histories and product histories to be constructed for particular crafts.[5] It is hoped that the result will not only be of value to the student of technological history in Kenya, but also to those groups mentioned above whose work

involves understanding the difficulties and aiding as relevantly as possible this stratum of petty craftsmen.

This present account is of a wasteland industry that supplies the whole of Kenya with bicycle carriers, foreguards (for strengthening the front wheel) and stands, for fitting to the rear wheel. For cutting and working iron and steel, the industry naturally requires more than hand-tools. It has consequently developed hand-operated machines — not bought from the usual European or Indian sources, but constructed out of scrap iron and steel by some of those in the industry. Since hand-made Kenyan machines are not a regular feature of the informal economy (or the modern sector of the economy for that matter), it may be useful to trace over a period of years the skill involved in making the machines, and the various products which they have made possible. Initially, however, it is important to place the extreme infrequency of indigenous African machine-making within some kind of wider historical context.

THE COLONIAL RACIAL ECONOMY AS A BARRIER TO AFRICAN SKILL ACQUISITION

There are several points that can be made about the impact of colonialism upon the very slow emergence of African entrepreneurs. At one level, it can be argued that the decision to protect, at all costs, settler agriculture against African cash crop competition so reduced the rewards of local production that African aspirations were usually directed elsewhere. Normally what little money was available went on acquiring as far as was possible that form of education associated with the ruling European élite. The relatively small African group which had received this education by the late colonial period tended to identify with the characteristics of the bureaucracy that increasingly employed them. And they consequently favoured when they came eventually to power at independence the same preferences for monopoly and protection that had marked settler agriculture and large-scale expatriate commerce and industry.[6]

Because of the racial ordering of activities from European administrative and executive styles downwards there was a corresponding lack of interest amongst aspiring Africans in the late colonial period in the middle stratum of Indian enterprise. The common view of these matters is that Africans despised the cut and thrust competitiveness of this Indian sector until such time as they were in power, and could try to apply these same old settler principles of monopoly and protection to the Africanisation of formerly Indian retail and distribution networks. There is an element of truth in this. But what is more important than the recently initiated African takeover of retail and distribution outlets

is the Africanisation (in a quiet revolution over the last thirty years) of a whole range of *products* formerly made by Indian artisans. As has been pointed out already,[7] almost all the household possessions of a low income African family today are originally Indian artefacts. In the first decades of colonialism such household goods were made exclusively by some of the Indian artisan communities using hand-tools and their own labour. Increasingly, production of many of these craft items fell into African hands. Goods previously produced for the local Indian market in the main towns gradually came to have a national circulation.

The process may be termed the Indianisation of the bottom reaches of the economy, for the hundreds of African artisans took over into their own little workshops or on to open ground the creative use of a variety of scrap materials, and Indian patterns of trade training. But for reasons that will be examined later, what had not happened by the time of independence was the emergence of more than a handful of Africans who could extemporise in the use of machinery.

Indian workshops, by contrast, from relatively early in the colonial period were marked by the presence of simple hand-operated machinery, some of it imported from India, and some constructed *in situ*. With this quite restricted range of machines, it was possible to develop further machines which were of considerable value to settler agriculture processing. Quite frequently, in fact, settlers would have an Indian mechanic or *mistri* established in a simple workshop on the estate, whose business would be to develop machinery relevant to the particular needs of settler agriculture. In the early days, white farmers had little foreign exchange and even where they were forced to purchase the power unit overseas, they used Indian skill to create a machine around it. Coffee factories are an obvious example. These were designed to wash and grade the beans by size and weight before sending them off for processing, and many individual large estates established their own. Often the only imported item in them was the motor—all the rest of the grading equipment being built up around it. And the same was true of many operations in the smaller European and Indian owned processing plants in Nairobi, Mombasa and the main towns. In fact, many of the Indian engineering workshops which in the 1970s are characterised by very specialised power driven lathes have only recently emerged from using very much simpler equipment, and doing work where a good deal of the equipment had to be improvised.

Very few Africans had access during the colonial period to situations where they had the opportunity to improvise personally with even simple machinery. Admittedly many were exposed to the Railway workshops, and its training school, but, given the racial stratification in jobs, this usually meant Africans training as operatives to work alongside Indian technicians or engineers. In addition, a good deal of the technical training which governments insisted was so appropriate

for Africans equally turned out to be at best preparation for routine semi-skilled work in the public or private sector of the economy. The much more highly developed trade and technical schools of the independence period are even less of a training in creative improvisation than their forerunners. They aim at British style apprenticeships in the large-scale expatriate firms and technical ministries.

MACHINE-MAKERS: A KIKUYU CASE STUDY

With this much background, it is appropriate to turn to one of the small groups of mechanics who have improvised simple machinery to give themselves products with a national market. The key family from which the skill in machine construction (in this account) derives is located in a small village in the Kiambu District of Kenya's Central Province. Significantly enough, the family has a blacksmithing tradition; the great grandfather of some of those working in the industry today was a traditional Kikuyu smith who made spears and knives at the turn of the century. His son, Kagotho, appears not to have practised the art, but this may have been related to the fact that he was one of the thousands of Kikuyu who left their home areas to go up into the settler White Highlands in search of work or grazing.[8] Kagotho had six wives, and does not appear therefore to have been one of the really indigent squatter familes. Indeed, at a certain time many relatively well-to-do Kikuyu migrated to the Rift Valley, not so much because they were landless at home, but to escape the tax which had to be paid on each wife, or to get grazing and cultivation rights from some of the settlers who had alienated more land than they could at that time afford to cultivate. It was quite common for such families to have one wife on an estate here, another a hundred miles away and another looking after a plot back in the 'Reserves'. At any rate, this particular family had at least one wife on Lord Delamere's estate and another nearby in the enormous holdings of Captain Harries.

By the early 1940s, the technical skill seems to have re-emerged in at least two of Kagotho's sons, both called Mutang'ang'i, but from different mothers. The older of the two had started to make braziers and water carriers out of scrap metal on the estate, and was soon being encouraged by Captain Harries to use his blacksmith skills to make simple chisels and hammers for use on the farm. However by 1946 both parts of the family had decided to leave the White Highlands and go back to Central Province—possibly part of a wider move to reduce squatter numbers as settlers took more and more of their land into direct cultivation. Once back in the little village of Githiga—some twenty miles from Nairobi—the step-brothers followed two rather different patterns of employment. The younger brother, after a year or

two, had attached himself to a nearby white coffee farmer—the boundary of the old settled area is only a mile away from the village—and his skills were soon being linked to those of the owner to produce whole coffee grading machines for sale to other farms. Following the Indian practice outlined above, the whole system would be assembled in the farm workshop, with the aid of electric welding and hand operated metal cutting machines. Once a coffee grader for the farmer's own coffee factory had been successfully made as a prototype, the owner proceeded to use Mutang'ang'i to construct more for sale to neighbours. Over the years, these have gone to many parts of Kenya, even outside to Uganda and Tanzania; and one complete system was taken all the way to Katanga. Other types of farm accessory have also been constructed, but nothing on the scale of these graders.

A period of twenty-six years has been spent in employment on this white coffee farm. Mutang'ang'i's wages in that period would not be in the range of ordinary farm workers, which have risen from some 50/- a month to almost 80/-(K) in the 1970s (in white owned farms). The African farm worker 'élite' who either worked in the Big House, or acted as overseer, chief dairyman, or general mechanic have always attracted a higher wage. Head servants, for instance, will have reached some 200/- a month by now, and mechanics perhaps 400/- to 500/-, but these will have risen very slowly indeed over the years and will not have allowed much saving beyond covering school fees, and possibly buying a single share in one of the land purchase companies. Thus, this man's skills have been restricted to one form of wage employment and only now as ownership of the farm is transferred to an African is he likely to leave and set up on his own in Githiga village. If he can purchase some of the farm tools he has used, and if he can get a licence to operate a small metal work business, he may shortly be involved in that increasingly popular local workshop industry of making metal window frames.

At first sight his history seems little different from thousands of other industrial workers in the large scale Nairobi enterprises. In fact, however, his experience deviates radically from those who work in the large capital intensive processing lines which turn out international brand-name goods, where the very idea of local product differentiation is anathema. It is very much closer to the intermediate Indian factory or workshop in Kenya, where individual workmen can largely make, replace or adapt the machinery component in the production process, and where as a consequence skills are constantly being learnt which can be practised personally in self-employment.

The older brother, during this same period, had devoted himself entirely to building up his own business rather than being employed. Neither of them had had any schooling—a very common occurrence in the Rift Valley, and one they shared with a large number of the most

skilled Indian artisans of the time. This brother, however, seems to have gone straight into diversifying in his home area some of the tool making he had been doing in the White Highlands. For a time also he seems to have continued production of the softer sheet metal products such as the charcoal braziers (*jiko* in Swahili) and water cans, recycled from oil drums and other industrial metal waste. But the critical step into actual machine making seems to have been taken in about 1950. By this time, he had doubtless noticed at close quarters the scope offered by some of the simpler imported machinery at his brother's estate workshop; he had also worked for a time in the Indian workshop quarter of Nairobi, and had seen some of the quite crucial machines required for their metal-working.

At any rate, he began devising his own metal-working machinery, employing some of the principles observed in the imported models, but building them up entirely out of scrap iron and steel. A number of common features mark some of the hundred odd machines that he has probably turned out for his own use and for sale during the last two decades. A few of these will be mentioned briefly.

1. Most machines bring pressure to bear through a simple gear mechanism, at the junction of the lever and the body of the machine. The teeth of the gears are cut out of heavy metal by hacksaw.
2. Machines for cutting or punching iron of up to $\frac{1}{4}''$ thickness require steel cutting edges; some of them for the handshears may have a 2 ft long cutting surface. To provide the steel for the upper and lower blades of these large machines, Mutang'ang'i uses heavy duty scrap lorry springs.
3. Spring steel cannot be got into the shape required without black-smith skills; it has consequently to be heated to a high temperature in the bicycle-operated bellows 'to get the steel out of it'. It can then be cut, shaped, and edges filed, reheated and plunged into cold water several times, to 'become steel again'. These cutting edges can give service for years without renewal. With punch machines, the handmade dies are brought down into a base of prepared railway track.
4. Because of the absence of solid floors in such rural backyards, machines are built on to heavy wooden poles of telegraph width which can then be secured, without needing a workbench or floor fastenings.
5. Machines may cost as little as 30/- to 40/- for the various scrap components, and the simpler kinds can be made in a week or so of full-time work; more complicated models needs a good deal of experimentation, and can take several months to complete.

Thus the basic types of machine required for most of the production processes in his workshop are (i) punch (ii) bending (iii) cutting (iv) polishing. But most of the products that have been made over this period require combinations of several machines to complete. For

instance, his fence post nails use only two machines, but his aluminium ladles require no less than ten separate machines for different operations. The mention of ten separate machines making ladles in a tiny African village may sound sufficiently unlikely to make us pause and examine whether what sounds like a rustic Heath Robinson line-up really bears any relationship to local product demand or personal profitability. And furthermore, if it does, we should examine whether this knack of improvising machinery is something for which there is itself a demand in the countryside. What evidence is there that such skills can be transferred at low cost to other members of the community?

There is not much chance for assessing in the 1970s what sort of market he enjoyed for his products in the 1950s. At that time he appears to have been making large runs of containers for coffee farmers around his area, as well as hinges and bolts for doors. Like so many Kikuyu artisans his development was rather radically curtailed from 1954 to 1958 by spending four years in detention at the time of the Mau Mau emergency. Very shortly after coming out, however, he successfully exhibited some of his artefacts in the Nairobi Show, including a trap for wild animals, milk buckets and wood-working tools. Although the then Governor, Sir Evelyn Baring, is said to have admired these, it is indicative of the prevailing doubts about African artisan capacity that a search was allegedly mounted in Nairobi hardware shops by some civil servants who suspected that such things must have been bought, not made.

One useful outcome of the publicity was that Mutang'ang'i was authorised by the Governor to be employed by the local community development officer to teach some of his technical knowhow to village orphans and some of the young schoolboys. For the two or three years between 1959 and 1962, on-the-job training was officially institutionalised in his little workshop, which was in consequence granted more space by the local authorities.

THE CREATION OF AN ARTISAN SOCIETY

This shortlived government recognition of Mutang'ang'i as a skill model was very much in tune with a less formal movement that had been gathering momentum from the 1940s. Whether officialdom knew it or not, they were recommending for this particular blacksmith industry something very close to what was happening already — not only in machine-making, but in all the modern crafts associated with wood, textiles, sheet-metal, leather and stone. Without wishing to exaggerate its significance, the period around the late 1950s and the early 1960s saw a major move towards what could be called the creation of an artisan layer in African society. Prior to colonialism, most of the peoples in Kenya lived in systems with a minimal division of labour, and there

was consequently very little in the way of craft 'guilds' on the West African model, let alone the very much more rigid craft specialisation in countries like India. There were notable exceptions such as blacksmithing which in many tribes tended to be an activity restricted to some subgroup and one in which the skill was passed from father to son. (Indeed it is still possible today in Kenya to find smithy groups with grandfather, father and son working together on the traditional artefacts.)

Admittedly, from as early as the 1920s the impact of the immigrant Indian artisan society had been making itself felt, and as will be seen with oil-lamp making,[9] certain Indian artefacts had become entirely an African preserve by the late 1930s and early 1940s. The adoption of such Indian skills by Africans turning to self-employment was however still on rather a small scale. For one thing, there was no shortage of openings for employment in the expanding European and Indian industrial sectors during and after the Second World War, and with the circulation of money in the rural areas still artificially restricted by the controls on African enterprise and particularly on the cash crop production of coffee and pyrethrum, little incentive to set up as an artisan in the smaller provincial and district township was offered. Several factors however combined in the late fifties to speed the development of an artisan society in rural and urban areas.

For one thing, the wholesale evacuation of thousands of Kikuyu from their urban employment into detention probably had an impact on self-employment—particularly in the rural areas—that has been so far neglected in the literature. Very large numbers of those taken out of circulation for four years (1954-58) had been employed in the Indian fabricating sector in Nairobi; and when they were finally released from detention it was extremely difficult for many of them to get passes to return to the city without long delays. They were under pressure instead to return to their villages, and lacking any other means of income, they began in many instances to practise as best they could by themselves the skill on which they had previously been employed. The Emergency thus acted as a forced decentralisation of skill from Nairobi to the rural areas.

Second, within a year or two, many of this first generation of skilled workers were suddenly besieged by the many thousand primary school leavers pouring out of the expanded school system of the late fifties and early sixties. Large numbers of these soon found that they could not get, with their seven or eight years of schooling, the kind of opening in the formal sector which had been available to their fathers or elder brothers, who had had four years of schooling or less. They turned therefore to some of these slightly older artisans and asked to be taken on and to be shown their skill. As we have shown earlier,[10] a fee of between K£5 and K£30 would often be charged for learning to make or

repair a limited range of items. This learner's fee could be waived in the case of certain close friends or village mates. And where the young people needed to get a small cash income as their first priority, they could usually come to an arrangement with the older artisan to do casual labour for him at about 1/- to 2/- a day.

There were really therefore two types of approach to these older workers. First those wanting as rapidly as possible to master a particular line of work which they could then carry on by themselves. This request for rapid mastery usually needed a fee. The other group were using the artisan community to get an income — however small — for school fees, for clothes or for drink. They would be either too poor or could not give the time to acquiring the skill in full at one time. But with both groups, the background was not dissimilar. They were almost certainly the *first* in their families to be attempting to pick up tinsmithing, panelbeating, automechanic repair, watch repair or any one of a hundred occupations. There was therefore no particular family leaning towards a specific trade — no special disposition to learn and stay with father's trade — as in parts of Europe and Asia. There was nothing much to go by in starting to follow some skill in Kenya, except that Mr X or Mr Y was prepared to accept the boy.

As the older artisans were in practice restricted by their own experience and rural demand to making a rather limited series of items, it was possible for trainees to pick most of it up in a matter of months — not in a European apprenticeship of many long years. They could then practise what they had learnt for some time, and switch just as rapidly to some other trade. Similarly the boy who had not the money to learn one skill completely could drift around from plumber's mate to builder's mate to yet some third occupation, all in the space of a year or two. This embryonic artisan society therefore can be characterised by extreme mobility, and while one aspect of this restless movement can perhaps be traced to a lack of any special family trade commitment, there are a number of equally important stimulants, as we shall see in a moment.

Before, therefore, returning to the machine makers, it should be stressed that the 1960s in Kenya did see the explosion of thousands of young people into artisan activity. This was possible because of the readiness to accept trainees, and the speed with which the trainees became masters themselves. Within a year they could in turn be taking on fresh boys and so the process would continue, so that by the end of the decade a skill picked up from some older craftsmen could already be at several removes from the original source.

SKILL DIFFUSION AND MACHINE-MAKING: THE SECOND GENERATION OF LEARNERS

It is not intended here to trace and analyse the subsequent history of the

forty odd trainees that have passed through Mutang'ang'i's hands in the last 15 years, but rather to look at the small group who in 1973 were supplying most of Kenya's demands for bicycle carriers, foreguards and stands, and whose expertise flows back originally to Githiga and Mutang'ang'i's machines. The group were in the autumn of 1973 concentrated on a single site, on waste land in Nairobi, close to the football stadium. It is one of the oldest sites of informal sector industries, producing the entire range of tin and metal goods, as well as a certain amount of wooden furniture. The location is only a few hundred yards from the edge of the formal industrial area of Nairobi, and is consequently suitable for acquiring scrap metal and wood from the factories without much transport cost. It would be difficult to identify this particular bicycle industry as one with a national market. There is, after all, just a cluster of between five and ten people working directly under the Nairobi sun, and beside them, stuck here and there into the ground some stocky wooden poles with rough metal contraptions strapped to them.

It has the impression of being a single business enterprise, presumably a co-operative of some sort, since nobody is conspicuously in charge. In reality, it is nothing of the sort. Among the full complement of nine people that might be found there in September, there were no less than five individuals working in their own right, two others in a joint business, and two employed helpers. The machines appear to be used as common property, but in fact they belong to three individuals only, one of whom no longer works his personally but rents them at 30/- a month to those entrepreneurs who do not own machines. Apart from the schoolboy helpers, the whole group of workers is of the same age range, between 25 and 30; they all come from the same village, Githiga, but they are not related to each other. Several of them were, however, classmates from Standard I in the little Githiga Primary School which they had entered in 1956. By the time they emerged from this some nine or ten years later (most of them repeated at least two standards), the primary school certificate was already obsolescent as a means of getting a job in the formal sector of the economy.

In examining their seven or eight years of post-primary activity, it is possible to highlight several of the main structural features of working in the informal sector of the economy. The chief of these is the constant tension between employment and self-employment; or in other words, once the young workers have acquired a modicum of skill through the methods outlined above, they may be offered a wage of between £3 and £6 a month by their previous master. This may have to be accepted for a month or longer if the recent trainee does not yet have his own basic tools, but soon enough the employee has worked out that he is making goods worth a great deal more than the £3 he is receiving a month. There is no obvious obstacle to his switching from employment to self-

employment overnight. In the urban informal sector at any rate, these roadside boys do not need premises; they don't need to acquire a trading plot, and they don't need a licence. So there seems nothing to prevent them from telling the master that they intend to work in their own right.

The second feature, however, is that despite this relative openness of access to self-employment, rent, food and bus fares can so rapidly devour the initial 'capital' of 30/- to 40/- with which some young people launch into self-employment that they are frequently driven back to employment in order to meet some quite tiny expense they have met in their job. With these Githiga men, there is really no shortage of casual work available, if they have somehow to find a few pounds. None of it is easy or well paid, and it is only possible to save the bulk of it by living at home and having no family commitments. The main options are given below.

1. Doing casual labour for some of the big men in the village, such as digging certain measures of land for an agreed price of, say, 40/-, or a double latrine, 30 ft deep for 60/- to 90/-.
2. Going back to work for Mutang'ang'i on his various machines, and collecting a monthly wage of £4 to £6 depending on one's skill and experience.
3. As the settled areas are very close, it is usually possible to work on the large European-owned carnation and chrysanthemum farm a few hundred yards away, and again the wage is not much different from the casual labour in the village. A little over three shillings a day for unskilled work, and four to five shillings for the slightly more skilled.

The other distinguishing feature of this informal artisan world is the very circuitous routes people have taken to reach the job they happen to be doing. This is not only a question of dipping in and out of employment on the road to self-employment, but, in the case of these boys, moving through a whole variety of other skilled occupations before fixing on this particular machine-aided metal industry. Indeed, it is probably misleading to use the word 'fix' for a group of very independent individuals who *happened* to be working in the same line of business during part of 1973. We shall therefore give an idea of the diversity of their previous work, and we shall pay particular attention to those who have made machines for themselves.

The case of Gacuiri

Most of the elements of petty entrepreneurial activity are clearly shown up in this man who is in some ways the most successful of those who passed through Mutang'ang'i's workshop for a brief period in the 1960s. He has the same father, Kagotho, as the two older Mutang'ang'is, but

his mother was one of Kagotho's youngest wives. There is consequently a gap of some thirty odd years between these stepbrothers. Because of being born, however, into one of these established blacksmith families, he appears to have had from a very early age that familiarity with metal, wood and bits of machines which is perhaps too frequently alleged to be missing in the pre-school years of African children. In his case, it took the form of making wooden models of some of the tools he saw around his stepbrother's workshop, and once he was in primary school, he seems to have been one of the main makers of the wooden carts used by the boys for racing downhill and carrying water drums for their parents. These are themselves a rather ingenious demonstration of recycling scrap, since the better ones use old bearings, pieces of scrap pipe, and various old wheels and second-hand timber. Gacuiri sold his for some 4/- each or rented them out for small goods in exchange. During his school vacations in the later years of primary, he carried on two petty industries to supplement the family income; he began to construct *jikos* out of scrap metal, and also ran a small tea kiosk. Naturally, he spent some time in employment with Mutang'ang'i.

The mid-fifties was a very difficult time to try to go through primary school in many parts of Central Province. As a consequence of the Emergency and the detention of so many of the household heads, it was frequently difficult to start school at the age of five or six, and only too easy to drop out if the small family income could not meet the fees. In addition, many of the poorer families found themselves adversely affected by the government decision to create a system of individual land tenure, and this was particularly the case with some of the families who had spent twenty to thirty years up in the Rift Valley away from their traditional home. Kagotho's own family appears to have been one of those dramatically affected by these events, since, just as Gacuiri was coming up to primary school age, his father is said to have hanged himself over the loss of a piece of land.

Whatever the truth of this, Gacuiri was clearly himself one of many thousands of primary school students who found themselves in a sense victims of school expansion in the period immediately prior to and just after Independence. The year in which he entered Standard I (in 1957) there were in the whole of Kenya just 11 900 students finishing Standard VIII at the end of primary, and competing for entrance to secondary school or for direct entry to jobs. By the time Gacuiri emerged himself in 1966, just two years after Independence, there were no less than 146 000 leaving, and only some 25 000 to 30 000 would find any sort of place in a secondary school. This situation had been aggravated by two factors. The principal of these was the abolition of the old Standard IV examination which had removed three-quarters of the children from the schools after only four years' attendance. Such a ruthless weeding-out device was almost bound to be removed as

independence approached. But paradoxically of course its very ruthlessness had insured that the primary leaving certificate had some value since only a small minority had been allowed to reach the top of the school. As soon, however, as progress throughout primary was unimpeded by any such barrier, very large numbers began to pile up against the next hurdle of secondary entrance, and simultaneously the primary school certificate became of not much more value than a spent bus ticket.[11] The second aggravating factor was that the period of primary schooling was reduced from eight to seven standards in 1966, and consequently rather more students were leaving in that year.[12]

1966 therefore was the first year that the huge wave of previously discarded Standard IV failures reached the top of the school system, and it showed up in no uncertain terms the distinction between finishing primary and getting a paid job, or entering a secondary school. As fees to government secondary schools were between ten and twenty times higher than those in primary, education of a formal sort still effectively came to an end for many thousands of poorer children, once they had reached the last primary class. There was of course a very dramatic expansion of the self-help and the government sectors of secondary education in these years, but this did not greatly help families with little land or whose source of wage income through the father was precarious or non-existent. Occasionally, through drawing on kinship ties, such families would get perhaps one of their children into a secondary for a year or two, but this would normally be into one of the *harambee* schools where the fees are even higher, but almost everything else is of lower quality than the traditional government schools.

Faced with this situation, it is not possible to generalise on that part of Standard VII leavers who began very rapidly to be involved in what we have called the creation of an artisan society. Except to say that they had just as likely been selected out of education through lack of fees as by lack of merit. They would have probably started school that much later than their better off counterparts; they would have had to drop out more often and repeat standards here and there through the system. In the process of dropping out for a year or so at a time, they would have been forced to work at home, or find some casual employment. And consequently when they reached the top of primary, they would already have been exposed to the sorts of income opportunities in their immediate home area.

By the time Gacuiri left primary school at the age of about 18, he had certainly followed this pattern, and now seemed set to move through that restless process of employment and self-employment that we have described. His first post-primary venture was bicycle repairing which did not prove to be successful. To recoup his debts, and get a little leeway to start again, he went off to pick coffee on a nearby foreign owned estate. Typically there was an estate workshop, improvising

agricultural equipment for the farm and for sale outside. And after convincing the manager that he could carry out most of the basic metal-working practices, he was able to switch from the daily paid piece rate system of coffee-picking to a salary of 450/-, and was given the key of the workshop. He had reached in fact the same position as workshop overseer as his stepbrother had held in a nearby estate for some twenty years. In terms of cash in the hand, 450/- would seem a sizable salary to many thousands in Kenya; it is for instance twice as much as many domestic servants receive if they choose to work for some of the 25 000 non-citizens; and it is also twice as much as casual labourers in the formal sector of the economy are likely to get in a good month. And, as we shall see shortly, it is fully four times as much as a small local artisan will offer to a semi-skilled employee. All over Nairobi's industrial area, in fact, large numbers of monthly paid workers receive a wage in this region of 300/- to 450/-, and yet at this particular point there is evidence of quite considerable numbers of these younger entrants to the workforce refusing to accept it. Many, of course, never get the opportunity to turn such jobs down, since they do not have even the minimal skills or experience to be offered them. But it is equally important to note the reverse flow — of people frustrated at the working conditions and limited prospects of many European and Indian firms, and determined to try and make more money on their own. Quite apart, therefore, from the restricted opening in wage employment, people were stimulated in these immediate post-independence years by the very dramatic upward mobility of many close associates in the village or indeed the same primary school class; there was every reason why they should not be reconciled immediately to accepting a low wage — particularly if it was only lack of fees that had prevented their going ahead with full secondary education.

Gacuiri gave up his salaried post after only one and a half months and moved nearer to Nairobi, where he proceeded to make full time the braziers and water cans that he had previously made during school holidays. He would locate scrap for a few shillings in Nairobi, and get it taken out to his place on a borrowed bicycle. By this time, rather large numbers of others had turned to this sort of tinsmith activity, since it did not require more than a few shillings of capital to start with, and just a handful of tools. But to make it really profitable — as opposed to providing a subsistence wage — the artisan needed very easy access to scrap and an urban or small town market. Conditions were not particularly suitable where he was; so he turned carpenter-cum-builder, and proceeded to get contracts in the area to put up simple wooden housing. Normally materials are provided and the contract is just for the labour. As it proved easier to build the houses than to get the full payment on completion, Gacuiri found he was getting poorer and poorer. He decided along with a village workmate to try his luck in

Nairobi itself in 1970. His friend typified also the situation we have described earlier — of being uncommitted to any special family trade (since there was not one), and being ready instead to see himself take up any one of a number of occupations: driver, businessman, trader or manager. They decided nevertheless to concentrate on making braziers.

Starting at the bottom in Nairobi is not easy, unless there are already kin or friends established in some formal or informal enterprise. Without the hospitality of the village, it is essential, for instance, to find a minimum of 40 cents for food each day, and somewhere to stay for the night, since bus fares can otherwise consume a further shilling or two. It is not surprising therefore that really very few primary leavers stay there very long without a base, or that those who are determined to make good have to display considerable ingenuity. On the principle, therefore, that it is better to live off dustbins than out of them, the two began at night to cut up municipal dustbins into braziers — painting them over and selling them later to the Indian retailers.

Gacuiri and formal sector devolution to informal

The selling price is not good for those entering self-employment; quite often the young entrants need desperately to get cash in hand, and are prepared to undercut other producers in order to get this. Their bargaining power is even further reduced if they look poor, and if there is a question mark about the source of their materials. The issue of competition in artisan self-employment reducing the profits to the producer is one that we shall look at in more detail later in this section. It seems, however, that in Gacuiri's case he was able to show himself such a proficient supplier that the Indian retailers in a nearby cycle accessory store suggested they would buy carriers from him if he could provide them.

This suggestion highlights a process that will be re-emphasised later,[13] whereby whole lines of goods formerly made in the Indian workshop sector are transferred — not to successor African workshops necessarily — but even into the hands of Africans working without premises, on the roadside or open ground. The Indian (and increasingly African) distribution and retail networks can thus take advantage of the cheap labour and intense competition in these new African artisan industries; they can buy in bulk in Nairobi and sell up country at prices the rural artisan may find it difficult to undercut. The implications of this trend for encouraging rural enterprise are clearly of some importance, and will be gone into later. It does look, however, as if certain urban petty industries produce much more than the Nairobi market alone can absorb; consequently the intermediaries or distributors exercise a key role in providing an outlet for the surplus. Put another way, the extremely competitive informal sector in Nairobi

sells quite largely to urban formal sector merchants who control the distribution of these goods to upcountry formal sector merchants, and this in turn can make it difficult for informal rural operators to get a foothold. At the Nairobi end of this operation, the small suppliers can sometimes actually get less for their product one month than they did the month before.

When, therefore, an Indian cycle accessory store suggested to Gacuiri that he should begin to produce what they had till then been buying from a small factory in Kiambaa, it was very much a continuation of this rather lengthy historical devolution of production to Africans working without any overheads. What we have to examine at some point however is whether the African artisans were only able to undercut small factory production by dint of paying no rates, rents, or licenses, because they sometimes got their materials from unorthodox or illegal sources, and because they ate and slept in makeshift ways, avoiding for a long time any commitments of marriage or extended family.

Gacuiri meanwhile accepted the offer and went off to try and make a carrier with his simple hand-tools. The kind of carrier needed for African conditions can simply not be made out of metal that is cut by hand. Carriers are required to bear the weight of adults or of sacks of charcoal, or large containers for water or beer. The available imported ones were really designed to hold a briefcase or satchel in Europe. The latter type could perhaps have been made with metal shears, but Gacuiri soon realised that he would need to make a machine if he was to work the thickness of metal necessary. He had observed enough during his school vacations at Mutang'ang'i's yard to know what was necessary for machine construction — you needed a drill and bits, a hacksaw and a small forge. He managed to pick up the first for 6/-, improvised a handle for hacksaw blades, and made a small bellows from an old car bearing and other bits and pieces. He was then able to make his first metal cutter, on the basic Mutang'ang'i design.

Shortly he had made a sample carrier which he carried round to the five or six main cycle marts to get orders. By undercutting the only other source of supply, his orders were soon running in tens of dozens, and it is worth noting a few features of this man's business style before turning to the small number of young people who were to follow his lead.

1. He personally constructed some ten or more machines, for punching, cutting and rounding, so there was no question that the business was his alone, and that his various workers were employees. For a time, as we shall see, his technological lead separated him from any effective competition.

2. He had organised a very regular supply of scrap metal. Not all of this was necessarily 'scrap' in the accepted sense. Particularly as one

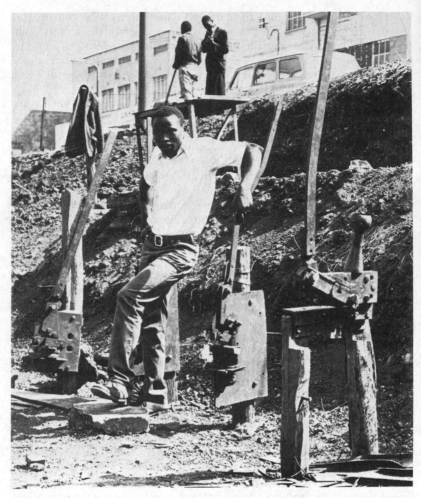

Fig. 4. Edward Gacuiri Kagotho with a selection of his hand-made cutting and punching machines.

component of the back carrier is ½″ round metal widely used in reinforcing concrete on all major building sites, there might well be a temptation to make arrangements that would be of mutual benefit to the carrier industry and to the night watchmen on construction sites.
3. Perhaps most crucial, he was the only person who searched out orders from cycle dealers. And unlike most petty entrepreneurs he did not merely rely on the five or six major Nairobi firms. Realising instead that such firms controlled the distribution to the major provincial towns of Kisumu, Eldoret, Nakuru, etc., he went personally with his samples

to the main provincial dealers, and by simply undercutting the Nairobi distributors' price, made them offers they could not refuse. Soon he was shipping off tens of dozens direct to the provinces by road and rail, and getting substantially more per dozen up country than the 45/- to 50/- that could be obtained in Nairobi. He even went outside Kenya to arrange an order of 200 dozens with Arusha in Tanzania, and was only prevented from completing this by difficulty in fixing an export licence.

4. Within the space of a year and a half he had diversified into making foreguards. Many Africans consider these essential in strengthening the bicycle's front fork and shaft for local road conditions. They were made entirely out of ½″ round metal, each pair linking the front axle and the shaft beneath the handlebars. Somebody with blacksmith skills had an advantage in constructing these, since each length of metal had to be fired and flattened at the extremity, and holes bored in it for attaching to the axle. Then, once these foreguards were established and popular, he turned to designing a bicycle stand for attaching to the back wheel.

5. He also began to make cutting machines for sale, and in this too followed Mutang'ang'i's example in Githiga. We shall look shortly at the implications of this machine making for intermediate technology; here it is important merely to note that a machine which can be constructed entirely out of scrap metal for 30/- to 50/- can easily command a selling price of 500/- or more, even in the rural areas.

In these various ways, Gacuiri had in two years built up what was clearly a very profitable business. Compared with the 450/- he had been offered as workshop manager in the coffee estate, he could well be dealing in several thousands of shillings in a single month. In this short period, it became possible for him to buy two shares of land at 1200/- each, two grade cows at 900/-, and construct a house for his mother for another thousand shillings. He still had, however, no permanent premises; his machines simply stuck out of the open ground in the vacant site named Burmah, and were closely flanked by a variety of other informal enterprises. When, therefore, in early 1972 Nairobi City Council circulated these squatter businessmen about imminent site development in the area, he transported all his machines back to the village of Githiga.

INFORMAL SECTOR EMPLOYEES

Although we shall later follow Gacuiri to Nairobi again in the autumn of 1973, this might be an appropriate moment to examine some features of wage employment in the informal sector, especially as Gacuiri may well have employed twenty to thirty individuals over this period. It is too easy to picture the informal sector as a mass of petty *self*-employed

people, and forget that a very great number of those involved are in fact employees. We have suggested that a good proportion of these, in the artisan worlds, give their labour in exchange for skill, and many others accept wages of 60/- to 120/- a month. It would be improper on the basis of present evidence, however, to characterise these wage labourers as somehow a different stratum or section from their employers. Possibly a case for some process of differentiation can be made out more easily with agricultural wage labour,[14] but in petty manufacturing, the skill and capital barriers are so slight that it would be surprising to find long-term wage employees.

What may be instructive therefore is to investigate something of the tension between employment and self-employment in this arena, through examining some of the employees. This needs to be done not over a period of a month or two, but for a much longer interval if any significant pattern is to emerge.

The journey from employment to self-employment

A case in point might be Gachangiu, presently a self-employed maker of bicycle carriers, foreguards and rear stands. He first entered the workforce in 1958 at the age of 17, and took two low-paid jobs with European settlers in Central Province—in the one case feeding hens, and in the second being a gardener or 'shamba-boy' 'for a European who was very cruel. He was beating people like animals. He would beat you with a stick or his hand.' Both these jobs, despite the working conditions, were defined presumably in labour office statistics of the time as being in the formal sector of the economy. He then moved across this artificial formal/informal division to work as a cook in a small local hotel. At 20/- a month he got less cash in the hand, but this was possibly balanced by receiving all his food free.

In 1961 when Mutang'ang'i was being officially encouraged to teach some of his skills to the poorer village boys, Gachangiu was one of those who joined him. His wage was some 30/- a month for the year he was there, and despite being small it seems frequently to have been paid in arrears. He decided to leave. And thus on the eve of Independence he seemed all set to follow large numbers of other young people into small-scale productive work. Possibly because of the heightened aspirations derived from Independence and the fact that his younger brother was just leaving for higher studies in Britain, through the help of a European sponsor, Gachangiu decided as a 19-year-old to attend primary school for the first time. Such very different levels of education in the same family were by no means uncommon at the time (or even now), and in their way, they possibly contributed to the less educated maintaining a high level of mobility and enterprise in the search for a paying job.

It is not easy to be moving through the village primary school as a young man in his early twenties; in Gachangiu's case he evaded local embarrassment by walking some 2½ hours a day to be far enough away to gain anonymity. Within four or five years he had sat for his Kenya Primary Examination, and he was back to looking out the same sorts of jobs he had been offered earlier. Indeed, his example points up a number of the issues in establishing any connection between primary education and informal sector activity. Merely to have completed primary appears at first sight to be of no value in itself; it does not assure any sort of well paid job; nor does it help in getting into secondary, since regular fee income is crucial. Perhaps for those like Gachangiu who do not proceed any further, one of its chief assets is that it offers just enough English language to operate on the fringes of the English medium formal sector.

In Gachangiu's experience, primary schooling did not have any particular impact upon either income or type of job in the informal sector. He first looked after a tiny general store for a big man, at 70/- a month, and then after almost ten years he came round full circle to blacksmithing—this time not to Mutang'ang'i, but to Gacuiri who was by now set up in Nairobi. He was persuaded to become an employee in his carrier-making business, and from May to December 1970 worked at 75/- to 80/- a month. By this time the tension of receiving low wages in an apparently very profitable concern was becoming acute; he threatened to leave, and received a rise, to bring his wage to 120/- a month with his meals given free. Just two months more of working at this new rate, and the move to self- employment came. Gachangiu and another of Gacuiri's employees set out by train for Kampala, 400 miles away, hoping to develop a local carrier industry there, since they had heard correctly of the large numbers of bicycles deployed around the Uganda capital.

They had not gone even as far as Nakuru in Kenya when the morning paper told them that General Amin had come to power, and that no Kenyans would be allowed to enter the country. They stopped accordingly in Nakuru, and hoped to use their savings of 200/- to get into some small metal industry of their own. Without any but simple hand-tools, there was not much option, except to buy old oil drums and start converting them into braziers. But the profits on their first few weeks' activity seemed so minute that they both succumbed to the formal sector once more. They were accepted as completely unskilled labourers, loading and unloading fertiliser in a European-owned company at 6/- a day. And, as we know in the operation of casual labour, that daily wage can be very irregular, depending on being taken on at the factory gate every morning.

One feature of many employees and self-employed people in the informal sector has been their disregard for the graduated personal tax

of 48/- per annum which is meant to be paid by all employed persons in Kenya. Partly because the status of 'employment' is very precarious and short term, very few workers in urban petty industries bother to make their payments. Until the tax was abolished very recently in 1973, the authorities continued however to prosecute offenders. Gachangiu was himself picked up by the police just three days after starting his new job, and spent the next four months doing prison labour on some of the land of large-scale farmers in the old White Highlands. His labour category was now presumably neither formal nor informal, but simply a variant of the earlier forced labour of the colonial period. We shall return to consider the incidence of harassment in the informal sector and the various proposals for improving the security of particularly its urban branch;[15] but first Gachangiu's jerky path towards present self-employment may be concluded.

Once out of prison, he accepted along with his friend the lowest form of casual work on an African contractor's building site — concrete mixing and carrying stones. After two weeks of this, he went further up the Rift Valley to his stepmother's plot of land, and was reduced to working in the forest and on her land merely for food. Realising that conditions in Central Province and Nairobi had been bad but that this was even worse, he cut his losses, selling his only possessions to cover rent arrears in Nakuru, and was back in his home village of Githiga by August 1971. A relatively skilled blacksmith of 24 years, his prospects not much different than they were a decade before, he now went back to the job he had learnt in 1961.

This time Mutang'ang'i offered him not 30/- but 130/-, and Gachangiu worked subsequently for two and a half months in this village industry. In the interim, Mutang'ang'i had diversified further into making aluminium ladles and fence post nails that were described earlier. Provided raw and scrap materials were available, the machines needed to produce these two items could usually make work for between three and seven people; they could then turn out some eighty kilos of fence nails, and some 200 to 300 ladles a day. The workshop seems in a way to have adjusted to the impermanence of the workforce: school children from poorer homes would look for a few shillings in the vacations and at the weekends, fresh primary-school leavers would rebound from an unsuccessful foray to town and take work there for a week or so, and then there would be the occasional older worker or secondary-school leaver marking time between jobs, or gathering a little reserve of shillings before venturing into self-employment.

Gachangiu's mind turned again after two and a half months to the need to escape; and this time he was contemplating going to Tanzania. He left Mutang'ang'i, but was persuaded to try his hand in somebody else's workshop a little nearer Nairobi. His employer was making some tin goods entirely by hand, and also some two and three thousand gallon

water tanks with modern machinery. Gachangiu was assigned to making water cans by hand at 75/- a month with food provided.

Four months of this informal employment and he decided to try Nairobi again. This time he was determined no longer to be employed by anyone. He found his one time Nakuru workmate (who had equally sped through a variety of jobs in the year) and they approached a Githiga man called Njenga who, like Gacuiri, had also learnt how to make metal-cutting machines, and was working on the same wasteland site at Burmah. They no longer asked to be employed, but suggested that they should rent his machines to make their own carriers and foreguards for sale. Njenga agreed that for every dozen they made, he should receive 2/50 cents rental.

The two of them set to work with a will, bought scrap metal, rivets and paint, and in one week alone had made almost eight dozen carriers at a sale price of 45/- per dozen. For the first time since entering the workforce in 1958, Gachangiu had more hard cash in his hand after one week's work than he had ever had in a whole month.

Although he now seemed to be launched fairly conclusively upon a period of urban self-employment, conditions change so rapidly and unexpectedly in these petty informal industries that it is difficult for even two workers to plan co-operation for a limited stretch of time. Within a month or two, for instance, his partner had again succumbed to working in the formal sector — although the opening was rather informally arranged. (The man's brother had bribed himself a job as inspector of pineapples, but agreed to let the blacksmith take it in his stead!) Gachangiu was now back to working by himself, which he continued to do over the summer of 1972, although he had now switched from renting Njenga's machines to using Gacuiri's free. This was possibly just as well since Njenga was arrested in October 1972, for being in possession of housebreaking weapons, and was subsequently out of circulation for some six months. But the perils of being self-employed without the ownership of the principal tools became much clearer early in the New Year. Gachangiu came back from selling a few dozen carriers in town to find the site of his industry quite abandoned; Gacuiri, fearing confiscation by the City Council, had, as we have mentioned, moved everything back to the village base. Once more Gachangiu was completely without any source of income, although he did have a few hundred shillings of savings.

He dipped briefly, therefore, into the illegitimate side of the informal sector — 'the night division' — and transferred scrap from building sites and Indian scrap yards to some of the informal African scrap dealers and metal frame makers. As this can be a risky business, and very irregular, he was relieved when he was able to re-establish himself in carrier making. This time he had brought back Njenga's machines from Githiga and was paying rent on them while their owner was in jail.

Finally, however, he decided to insure himself against any further disruption, and he began to make some machines of his own. By the early summer of 1973, he was his own master.

Before turning to analyse this kind of industry in more depth, it may be useful diagrammatically to represent the variety of Gachangiu's moves from formal employment (FE) to informal employment (IE) to informal self-employment (ISE), noting the diversity of occupation and the length of time in any single job.

1945	born			
1958	FE	Henman for European	30/-	few months
1959	FE	Garden boy for European	30/-	few months
1960	IE	Cook in African hotel	20/-	two months
1961	IE	Trainee-blacksmith	30/-	one year
1963-8		Primary School		
1969	IE	Shopkeeper	70/-	four months
1970	IE	Blacksmith for Gacuiri	75/- to 120/-	six months
1971	ISE	Making braziers	—	three weeks
1971	FE	Turnboy and loader	6/- p.d.	three days
1971	?	Jail (forced labour)	—	four months
1971	IE	Unskilled work on building	6/- p.d.	two weeks
1971	IE	Unpaid family labour in Rift		
1971	IE	Blacksmith for Mutang'ang'i	130/-	two months
1971	IE	Tinsmith for African	75/-	three months
1972	ISE	Blacksmith, hiring machines		three months
		then using Gacuiri's		six months
1973	ISE	Illegitimate trade		three months
1973	ISE	Hiring machines as blacksmith		two months
1973	ISE	Blacksmith with own machines		until 1974

For someone not quite thirty, this is rather a hectic catalogue of activity. There is perhaps relatively more security at the end of it, since at least there is now ownership of the means of production. But the owner still lived in 1974 under a makeshift shelter of metal sheets, some three feet high. It is, therefore, necessary to look at some of the constraints on income of people who finally do come to be self-employed. And this is possibly best done by looking first at the internal organisation and interrelations of those working in this economy with the more established African workshops and the foreign-owned large-scale sector.

THE STRUCTURE OF AN INFORMAL INDUSTRY

We have mentioned that in the autumn of 1973 what appeared to be a

single carrier-making industry in Burmah was in reality a collection of individual interests—five separate one-man shows, and a joint enterprise of two others. There is almost nothing resembling a co-operative about their business, even though they are all drawn from the same little village. In fact what they have in common is having shared more or less the sort of work-experience as Gachangiu's, which has been sketched above. Because of the openness of artisan society, they will have picked up a variety of skills beyond sheet metal work. Most of them will have done some rough and ready builder work; they will have been employed by both Mutang'ang'i and Gacuiri at some time or another. And they will have done a number of stints in the formal sector of the economy. Although they were all self-employed in September 1973, six months earlier, for instance, the pieces in the kaleidoscope were all different. Instead, three were employees of a man making carriers, one was building a secondary school, one doing carpentry on a foreign owned estate, one in the village, and only Gachangiu producing carriers on his own account. And six months after September the kaleidoscope might very well have changed again.

One of the most obvious features when looking at these seven most recent entrants to carrier-making is how the scale of their operations differs from that of Mutang'ang'i or Gacuiri. And yet the proliferation of such newly self-employed metalworkers, and their competitiveness erode the former near monopoly of those they learnt from. In a way, it almost appears as if those few people who were first to own machines and thus have a technological advantage contributed to the process whereby their lead was reduced. Both Gacuiri and Njenga, for instance, allowed village mates whom they had formerly employed actually to use their machines in their own right. In fact, once Njenga had moved from carrier making himself into the rag trade (in August 1973) he seems to have been ready to rent his machines to no less than five people at the same time.

It is not possible therefore to characterise these young workers as being motivated by a closed shop mentality—restricting access to the trade in order to protect their position. This could certainly have been done more easily with this particular industry than with brazier making, furniture, leather or oil lamps, where it is impossible to imagine any workable restrictions to entry. But, instead, carrier-making seems to share several features of the informal sector's open access. People may not be able to step so rapidly from being an employee to an employer as they might do in some of the other skills; still, the overall trend of its development appears to point in the same direction. This has obviously some serious implications for the structure of the business and the level of profits. The following is a sketch therefore of some of the central steps that threaten to reduce such a business from being a profitable operation for a few to being a subsistence activity for many.

119

Business base

Neither the family nor any other unit acts at the moment as the business base. This is perhaps understandable because of the lack of family trade tradition, and the likelihood that siblings will have very different levels of education, and consequently may find work in quite different sectors of the economy. Even when brothers are of the same level, and where both are trying to make their income in the informal sector, there is not necessarily co-operation. Njenga's younger brother was previously employed by him, and in September 1973 was being charged the same machine rental as the other five carrier makers. Similarly Gacuiri's brother works absolutely independently of him. This may well be of course a transitional stage, as the informal sector shakes itself down into a much more closed system, in which sons do follow fathers in the same narrow specialisation. But it is certainly not true of the generality of fathers whose readiness to train others made possible the informal sector. The older Mutang'ang'i himself is followed by children (some of them now over 25 years) who will work in the modern sector; so far none of them has taken up the father's traditional trade. His skills, as we have seen, are reproduced not through waiting a generation, but through the very rapid transit system of informal apprenticeship. We might suggest perhaps that the horizontal spread of skills is the dominant mode, and demonstrates the continuing force of the age grade system, as age mates transfer their knowledge and skill rapidly outside the confines of the nuclear family.

Competition and Co-operation

Although practical considerations seem to dictate the use of the same site, and various agreements about renting machines, that is about the extent of the co-operation amongst most of the carrier-makers. In September 1973, apart from two who were in a joint business (since dissolved) the others were each organising their own materials, production and sale completely by themselves. That is to say, each of them would personally search out an order and negotiate a price from some of the six main cycle accessory stores; he would then buy scrap, rivets and paint enough to complete that order, and then take it himself for sale. Since most of them were working on their own, without any paid employees, it was difficult to accept an order of much more than two of three dozen. If they were given an order for, say, ten dozens, they would then let some of the others help to make up the number. Generally, however, there was no common sales or orders policy, or any sort of bulk buying of scrap.

As a consequence their bargaining position *vis-à-vis* the Indian and African distributors became very much less strong than when—the year before—Gacuiri alone had been arranging the orders. Now, in 1973, as

many as six or seven prospective producers would be going in any one week to the distributors to search for an order. It is hardly surprising therefore that the middlemen began to take advantage of what appeared a proliferation of petty suppliers. Gacuiri himself who at that point was organising his return to Nairobi summed up the effects of this individual competition as they appeared to him.

Now they don't get much profit. They operate now in a way that doesn't look like a business. You see, business has got some hard points to understand. For instance, some time if you are in business and have a lot to sell, you don't let the buyer know; otherwise the price will go low. Now, however, these people order against each other. I have told them many times that they can make the goods if they like, as individuals, but only one man should go round to get orders, so that they may all be selling at one price, instead of all going round trying to find out an order for themselves. The shops are muddled to find that they have got five men apparently. . . . They should do it as a society or co-operative, and one man should make all the arrangements.

The time period over the summer of 1973 was too short to be clear about how prices would finally stabilise, but there had been some rather dramatic examples of the effects of individual competition upon price structure. We have suggested that the intensely individualised organisation of the industry causes this, but of course this each-man-for-himself style reflects the different motives attached to production by the various entrepreneurs. Clearly some artisans, after a long journey towards self-employment regard the business as one which has to be carefully built up and its markets secured. Others are treating the whole operation much more instrumentally — as a way of collecting enough cash to do something else. This difference in commitment to the industry in question determines the speed with which people combine and dissolve their alliances, and naturally those treating carrier-making as a short-term means to an end are not so fussy about holding out for the same price as the more career-minded producers. An example may help to sharpen up the impact of the target worker upon the carrier market.

The target worker in informal industry

One of the most recent arrivals to the industry in the summer of 1973 was Nene, another Githiga man, but somebody who had managed to go beyond primary as far as the first term in Form IV. With dropping in and out of secondary school through lack of fees he had taken almost six years to complete three and a half years of school. Shortly he had decided to learn plumbing on the job, through his uncle who had a small practice in the Rift Valley. For just over a year he applied himself

to this, and received 20 shillings a month for his labour. Such low wages (or no wages at all) are, we have said, tolerated in the process of picking up a skill, in the hope either of moving into the relatively well paid Indian and public sectors, or of setting up on one's own. After leaving his uncle, Nene soon experienced the variety of rewards possible: two weeks at 9 shillings a day with an Indian firm; two weeks at 15 shillings 60 cents a day with Nakuru Municipal Council, and two months with an African contractor at 13 shillings until he was summarily laid off. He was now a rather experienced plumber, but constrained by lack of tools in seeking jobs in the private sector, and through lack of influence in getting into a secure government or municipal vacancy.

He decided to take up carrier-making, in order to collect as rapidly as he could the 200 to 300 shillings which he felt it necessary to have to smooth his way into municipal plumbing. After approaching his village mates, and pressing them into letting him make carriers on their machines, he found that he needed some initial money to purchase raw materials for carriers, and to subsist in the town. He had therefore to have recourse to yet smaller target jobs first, in and around the village — digging latrines and measures of ground, working on the foreign flower export farm, even being employed by Gacuiri who at this point in early 1973 was making carriers in the village. Nene's example illustrated this succession of informal means to a formal end, and represents a whole layer of people who are moving through the informal sector with their eye firmly fixed elsewhere.

He entered carrier-making in a company along with two other village mates who until then had been employees in Gacuiri's carrier business. His first stands were made in early June and were fetching a price of 36 to 39 shillings per dozen. But by late August, Nene was actually selling stands to one distributor for as little as 18 shillings per dozen. Some of the other producers who had been on the site for more than a year regarded this as little short of a disaster. One man in particular had never in a year sold stands at less than 30 shillings and indeed had got over 40 shillings on more than one occasion; to him it indicated the necessity of concerted action: 'My feeling is that we have stayed here doing this job for a long time, and if we don't seriously consider the price, we shall come to nothing.'

It seems clear that the big cycle markets have naturally taken advantage of a situation where a larger number of petty carrier-makers try to sell more frequently small individual lots of stands and carriers, in contrast to when Gacuiri or Njenga actually *employed* most of the present producers. When only one or two men controlled most of the Nairobi trade, it was relatively easy to withhold stands and carriers entirely if the price was not acceptable. But with a few of the producers more anxious to get cash in the hand than to preserve the longer-term prospects of the industry, it was perhaps inevitable that prices should

take a downward turn. On an individual basis, one or two of the more established makers have tried to halt this by holding back some of their completed carriers or stands, or by simply stopping making stands altogether. However, any thoroughgoing co-operation amongst the suppliers is a long way off, and is made even more remote by some of the target workers.

As has been mentioned, one of their greatest difficulties is that none of them has the resources or labour to take on an order of, say, 50 to 100 dozens of any item, such as Gacuiri used to organise. Instead, as they individually collect materials to make a run of three or four dozens, they lose out to some extent on the economies of scale. The relative weakness of the small producers is shown also by the fact that their purchasers, if they are negotiating about the price of the carriers they have bought, will sometimes give only half the money on delivery, and tell the producer to come back in a few days to collect the rest. The calculation is that when the producer returns he will in all likelihood have spent some of the money, and will not be in a position to resist the offer of rather less than he was initially hoping for. This does not necessarily work out in this way, as on a number of occasions producers will at all costs avoid spending the money given, so as to be able to slap it down on the counter and demand their carriers back if the sum is not paid up in full.

It is absolutely typical of this kind of informal sector industry that price cutting and intense competition should actually be combined with no production at all. The precariousness of the labour force at any time in the industry is acute, as are the other 'accidents' of informality — the most obvious in the last year or so being the City Council's decision to clear the Burmah site where Gacuiri had been operating, and the six-month jail sentence on Njenga. For a period of at least a month, as a result of these accidents, production stopped entirely, and hence an opportunity was given to a *formal* sector factory to make several hundred dozens. In case it should appear that jail is rather an unlikely source of interference with informal industry, it must be stressed that receiving and reworking stolen goods is not exactly unknown to some of these petty producers. In fact, one reason that they can compete with and undercut formal factory production is precisely that they can buy materials either from scrap yards or from irregular suppliers who will offer stolen metals at a much lower price. Depending on police vigilance the 'night division' of the informal sector is occasionally strong enough to receive orders for particular amounts of metal required in various industries; but after a severe police crackdown, such a source of metal can dry up completely. This and other changes in the source of metals combine to force producers to spend a good deal of time, individually, on searching out the best offer. And because they are working sometimes on quite small margins and cannot afford to wait or

buy in bulk, they are frequently forced to purchase materials rather expensively, just as some of them feel they have to sell their goods whatever the prices.

Income within carrier making

Having noted some of the main factors affecting stability and co-operation in such an industry, it still remains to give an impression of the sort of income available to the various groups of carrier-makers in this wasteland industry. This is naturally not an easy calculation, particularly when in the span of two months an identical item was being sold for anything between 18 and 42 shillings per dozen, and when the metal to make this could have been derived from a variety of more or less expensive sources. While therefore some detailed case studies of income will have to await further research over a longer period, a general indication of the rewards from this informal manufacture can be suggested. First, provided the man can co-ordinate orders, supply of material and sales, there is no great difficulty in making 5 or 6 dozen carriers, stands or foreguards in a week; this would bring in between 150 and 200 shillings a week, of which one quarter to one third would have gone on materials, paint and transport. In a month, therefore, there should (other things being equal—which they never are in the informal sector) be a net profit of about 500 shillings. Second, if this figure is more or less accurate, it would suggest that one-man-show carrier-making can in a good month bring in easily twice the government's legal minimum wage for urban areas, and perhaps three times what the ILÔ mission to Kenya felt might be the average income of self-employed workers in Nairobi. Third, compared with the wages which we have shown people are likely to get by being *employed* in the informal sector, these independent entrepreneurs stand to get perhaps four times as much. That some such figure as 500 shillings is not far off the mark is confirmed by at least two of the producers stressing that they would not accept any employed job that brought them in less than that amount. Indeed, one of these had been making 500 shillings *in a week* for a time in 1972. During other periods however such as August and September 1973 when prices seemed to be falling, profits may well have been very much less, and it is easy to reflect, as Nene did then that 'the job only keeps us busy, and it prevents us from having to go out and steal or from wasting time in roaming about'.

There is a tendency in thinking about income and wages in the informal sector for outside observers to take up somewhat polarised positions, suggesting either that the whole scene is marked by a very intensive exploitation of labour, or on the other hand, that its wage rewards though limited are in some sense 'appropriate' to a poor country. Much of the recent talk about the appropriateness of low wages

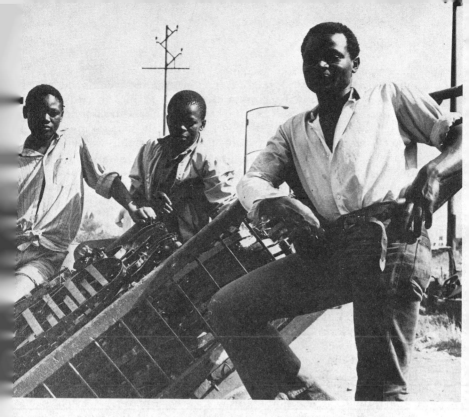

Fig. 5. An informal sector product: a load of bicycle carriers which have been constructed out of scrap metal on hand-made machines.

is as offensive as the older allegations about 'labour aristocracies' in Africa. We shall consider a little later what sort of structural connections there are between the wages received in petty informal industries and profits in other areas of the economy. Here it needs to be stressed again that the informal/formal division is meaningless as far as suggesting any difference in real wages for very large numbers of workers. There is a great deal of overlap between these two artificial categories, and a very great range *within* each. Something of this diversity may be indicated by examining the various types of labour even within the carrier-making trade, since the distinctions and grades have perhaps something in common with a good number of other industries.

1. There are, first, the four or five people who have made and own machines; only a few years back they were all in much pettier activities, of the sort that were sketched out for Gachangiu. Of the Nairobi group all but one have bought themselves into landownership in their own right. This suggests a parallel with the formal sector African

businessmen studied by Somerset and Marris who it was shown were very prone to invest in land.[16] It might in fact be even more compelling for operators in the informal sector to divert their savings towards land, since there is little incentive to improve a makeshift workshop on a site for which there is no security of tenure. Despite the general insecurity, however, there is a tendency for the more established informal entrepreneur to have his workyard marked off by a bamboo or wire fence. No permanent structure will be built on it, but it will nevertheless probably be rented from somebody who in turn will claim to have leased the area from the City Council. So far only Gacuiri has moved into his own yard — as recently as September 1973; the others still keep their machines on an area where no rent is charged and no yards demarcated by fences.

2. The second group are those who are renting the machines, like Nene. It was too early to be sure which way they would move, for they had only just come to be self-employed in this way in June 1973. They might move from renting to owning as Gachangiu had done, or just as likely might leave for some other opening. Indeed, by December 1973, Nene himself had given up. This does not necessarily mean that he and his colleagues were getting an insignificant income from it, but in Nene's case it did not measure up to his earlier expectations that he could collect a swift target wage: 'Things haven't worked out quite right as I had expected: in fact I had thought once I had started that I would be able to build a good house and buy a record player.'

3. The third group are the employees. All of the five self-employed makers on the Burmah site used to be in this category themselves — working for Gacuiri or Mutang'ang'i, but now they are so competitively on their own that they have little need for full-time employees. Still, one or two of the machine owners do use Standard VII boys during the school vacations, and for a time other jobless artisans will do casual labour for a day or so on the site. By contrast, Gacuiri's new yard in Nairobi was already employing four or five people as it started business again, and of course Mutang'ang'i in Githiga had his complement of three or more workers depending on the size of his orders. Since wages as an employee can be anywhere between 40 and 150 shillings depending on experience and productivity, it is perhaps not surprising that the employees of 1971 are the self-employed of 1973. Indeed, their mobility within wage labour, and their striving for self-employment is the most telling comment on those who admire the 'appropriate' wage levels in the informal sector.

DISCUSSION OF POLICY ISSUES

Having given an impression of the main features of recruitment,

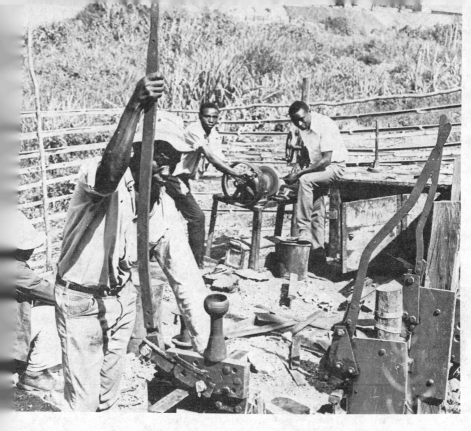

Fig. 6. Petty production in Nairobi. Note the hand-made machines and fenced-off yard on urban wasteland two minutes from the city centre.

employment and production in the carrier industry, it remains to suggest a few general policy issues that arise from it, bearing in mind particularly some of the bodies presently concerning themselves with rural development and its technology. The following would seem to be the key areas for planners considering the wider implications of the informal industrial sector.

Product Mix and Design

It has been mentioned earlier that a number of both local and overseas commentators on artisan industries deplore the fact that design of goods produced in the informal sector seems to be stagnant, and that there is very little diversification of product types. Two points need to be made on this. (1) There is really no way in which a survey of small industries on a *single* occasion can establish that design is stagnant. It requires a much more sensitive measure which taps the changes in product design over a ten or twenty year period. If this historical depth is added to the analysis of the goods which have over the last twenty or thirty years been

taken over from the Indian sector of the economy, it can be seen that there have been any number of improvements, adaptations, and style changes in such Africanised products. The example of tin oil-lamp making, discussed in the next chapter, is just one of many possible illustrations of this trend. (2) However, design cannot be separated from poverty, or in other words, the amount of the surplus available from agriculture determines what sort of product the consumer is able to afford. Better designs cannot be parachuted into a region of the country that can only afford the absolutely basic model of whatever product is being discussed. In some of the high potential agricultural areas of Kenya, for instance, it is no longer possible to sell the early 1960s version of the oil lamp, while in other districts, village stockists simply cannot sell the more recent design which retails at a few cents more than the old. Not much can be done about design in places where craftsmen cannot afford to practise full time, but only make things to a specific order, and often only if the client provides both materials and money in advance.

In the urban areas by contrast, design is less constrained by the pockets of the consumer, but is nevertheless intimately affected by the changing supply of materials. There is, for example, no difficulty in recognising the carriers made by the particular group that we have been studying; they are much stronger than carriers made in Kampala, or those produced from time to time in Thika and a local small factory. The main cycle dealers also acknowledge that they are the most sturdy on the market; this is not necessarily however because of product design, but because they use round metal from the axle up to the base of the carrier, and round metal is available in more or less orthodox ways from the booming construction industry in Nairobi.

Some of the conclusions about design change in urban and rural areas in the informal sector do raise some critical questions about any institution attempting to analyse and introduce more diversified or suitable product designs for Kenya. The tendency of bodies concerned with appropriate techniques and products is to identify a lacuna in the African rural economy, then design through their own technical expertise a simple product to meet this perceived need, and finally try to diffuse it amongst some of their more interested clients. Thus identification, design and diffusion all remain with the research body. It would seem to make for less dependency on expatriate expertise in product development, however, if, instead of deciding upon a number of lines to be experimented with, a body like the Rural Industrial Development Centre made its facilities available to the quite large numbers of people who are *already* experimenting on their own with various new techniques and new machines. The diversification of product types which is so frequently claimed to be lacking is also more likely to arise out of sensitive extension activities to existing

experimenters than from an outside analysis of what is missing in Africa.

Machines and Small Enterprise

Discussion on design cannot legitimately be divorced from an analysis of the tools and machines available. However, in making any sort of recommendations about machines, it is necessary to face the rather stark contrasts in technique in the rural and urban areas. These are the main categories to be borne in mind in considering potential improvements in this sphere.

Jobless (or tool-less) artisans

It is necessary to mention the existence of this group, if discussion of technique is to retain some sort of focus. There are really quite large groups of skilled and semi-skilled people in Kenya who do not practise their craft at all. Admittedly this is sometimes because of the petty restrictions which researchers have shown operate against many informal sector activities;[17] it is just as often because of poverty that they do not even possess the simplest hand tools of their trade. Occasionally, if they are given an order in the village they will go and make the article with somebody else's tools. Many of them, instead, simply accept unskilled casual work, or circulate some of the informal industries as 'kibarua men' (i.e. short-term, piece-rate employees). Lacking money for materials or tools, they will make a run of some item for two or three days, and then be sacked. As we have seen earlier, the last ten to fifteen years have produced large numbers of people who pick up a series of rough and ready skills. Many of these are jobless or tool-less, however, because they are not necessarily convinced they have found the job on which they can settle, and begin to save for tools. We had for instance the case of Nene, earlier, who having become a jobbing plumber in the standard informal mode lacked the tools either to be employed satisfactorily or to set up on his own. Within a month or two in carrier-making he had clearly gained enough money to buy himself into plumbing with tools, but did not do so. And he has now quit carrier-making at a point where he was competent enough to make cutting machines, but had not done so. Thus any programme that is concerned with jobless artisans (such as that being established by the National Christian Council of Kenya) needs to be informed as much with the attitudinal as the economic factors that keep artisans from settling down into one trade immediately.

Hand-tool industries

This is the commonest category of technique, and as has been mentioned frequently in the literature, the tools are often simple, old-fashioned and relatively expensive. The embryonic artisan society in

129

Kenya is predominantly based upon such hand tools, and the bulk of the informal sector products in wood, metal and leather are made with their aid alone. Quite a number of the tools not made out of high grade steel are made also by hand, notably soldering irons, certain kinds of hammers, and items like jemmys where cheap imported lines are not officially encouraged.

Power-driven imported machinery
A quite enormous gulf separates the hand-tool world and the next stage of technique in the rural areas which is in most cases the workshop blessed with imported machinery, whose acquisition has been facilitated by a loan. This will tend to have been given by either the Industrial and Commercial Development Corporation of Kenya or by District Joint Loan Boards. It is not the intention here to decry the linking of loans to such imported machinery, particularly when even a brief glance at some of these modern rural workshops gives the impression that the machinery is being put to good use; it is rather to suggest that equation of modern rural enterprise with relatively expensive machines both pre-empts the indigenous development of simple machines and dictates the types of products that will be manufactured. If the Rural Industrial Development Centres (RIDCs), the first four of which are operational, are to act as demonstration agents, then they ought to recognise that the most powerful part of their message perhaps derives from the gleaming British machinery in their metal working, wood, and general repair shops. Admittedly a report on Cottage Industries quoted in the Kenya Development Plan had recommended instruction of entrepreneurs in 'the use of simple mechanical aids such as the universal woodworking machines'; and this is just one amongst many machines purchased by the four RIDCs. It is doubtful however if a machine which costs 16 120 Kenya shillings can fairly be called a 'simple mechanical aid'. Nor is this the most expensive machine in the Centres. The Universal centre lathe with its tools comes to almost 30 000 K.Sh., and there are a good number of other machines whose price ranges from 3 000 to 10 000 K.Sh. The majority of such equipment is far beyond the range of the enterprising and successful workers in the informal sector of the economy. And this is not merely that they do not own workshops to which electricity can be brought (indeed there are a sizable number of artisans who have power available in their premises but still cannot afford to put anything at the end of the cables); it is that even the hand-operated imported machinery is beyond the sort of cash that petty entrepreneurs are likely to have in the hand at any one time. And it is cash that is necessary, for there is no arrangement at the moment whereby the small African artisan can pay instalments on machines, and thus slowly buy his way out of hand-tools into simple machines as a number of the Indian craftsmen did in the late thirties and early forties.

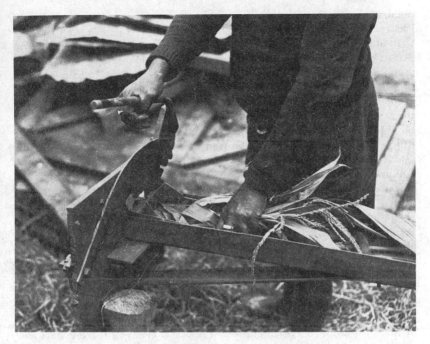

Fig. 7. A maize-stalk cutter. One of Mutang'ang'i's most recent improvisations in the village of Githiga, Kiambu District.

Unfortunately, the style of machines associated with the Centres is presently so capital intensive that the previous suggestion for bringing entrepreneurs to these places for experimentation with local design problems seems unlikely to be effective.

Indigenous machine-making

Given the practical exclusion of the vast bulk of informal operators from the world of loans, workshops and business extension courses, it is perhaps not surprising that a number of artisans have begun to edge their way into devising machines of their own, to facilitate certain processes, and enable them to make new products. We have been preoccupied here with machines which have enabled the development of a local consumer industry with a national market, but this is by no means a completely isolated instance. Here and there in other parts of the informal sector, individuals have been struggling to make components they needed and designing simple machines to help them. In so doing, these people are very much in the small-scale Indian craft tradition, and close to the Indian workshop practice of Kenya today. Their training and lack of resources has of necessity made improvisation a virtue. And the machines they struggle (sometimes unsuccessfully) to

131

make are very often based on the kind of machine which is still being used in small Indian repair shops.

In addition to the various hand shear types that we have discussed for carrier-making, individuals have been experimenting with small machines to coil springs for traps, heavy benders and guillotines for sheet metal work in the construction of tin trunks, and the wider range of machines associated with Mutang'ang'i's operations in Githiga. He is the best evidence not only of the value of machines in his own workshop, but of the demand for his kind of machines in other parts of rural Kenya. He estimates in fact that he has sold some 45 machines in the last five or six years, almost all of them in the range between 200 and 400 shillings, the principal among them being hand shears, maize-stalk cutters, and fence-post nail machines. The maize-stalk cutters are a perfect example of how there are niches that are not covered by the agricultural machines imported or made in Kenya's formal sector. With the growth in grade cow ownership and the consequent need to husband all fodder resources, a cheap machine that rapidly converted the unwieldy seven or eight foot stalks into pieces of digestible size had an obvious market.

Several further points need to be made about such machines. First, although a choice of technology expert or an intermediate technologist would presumably admire the appropriateness of technique and of product for a Third World context, there is a great difference between machinery which is thrown up in the work situation, and much of what is suggested as worth introducing by the Intermediate Technology Department Group (ITDG), for example. Digging out and publicising classic designs that have been superseded in the manufacturing catalogues in Europe is perhaps an important activity. But producing a Buyer's Guide to appropriate machines and processes, as ITDG have done, is very different from getting them adopted and diffused in any particular country. But perhaps too simply, those who could buy such appropriate goods have no reason not to buy the latest model, particularly if loan funds are available; while those who would have no attitudinal objections to this kind of second hand, or 'obsolete' machinery are almost by definition out of touch with those who would sell them it. There is certainly a market for classic simple machinery, but resurrecting and reintroducing European prototypes is an unnecessarily complicated procedure when a whole range of simple machines (of Indian and British make) dating from the inter-war years is already scattered here and there across Nairobi's industrial area, and when individual Africans have already begun to experiment with the manufacture of some of these.

A second point about such indigenous machines is, as we have seen, that although they are a very valuable asset, their manufacture is not so complex that it cannot be learnt quite rapidly. Within the space of the

decade after independence, in Mutang'ang'i's case alone, the skill had been passed on to several young people. We have mentioned Gacuiri, Njenga and Gachangiu, but there are at least four others who have also worked out for themselves, after a short period of employment at Githiga, how they could build their own machines.

Thirdly, these machines have made for a very effective import substitution of bicycle stands and carriers, without any of the usual ill effects resulting from standard substitution policies.[18] Unlike the restricted high cost market of so many protected locally produced goods, these two products feed into a wide market. And because of the positive local linkages in the supply of materials and machines to rework them, the end product can be sold, not at the artificially high price of so many import substitution goods, but at a fraction of what it formerly cost to import carriers from Europe.

Informal 'industrial' sector in relation to Kenya's large scale capital intensive firms

Having discussed the organisation of a fragment of the informal sector, and observed some of its main structural characteristics, we need to try and place this type of activity within some sort of wider context, and in particular try to assess in what sorts of ways the still largely foreign dominated large-scale enterprise interacts with the world of petty business. It is difficult to be more than speculative on some of the main questions about the significance of the informal sector; nevertheless those listed below seem to be the principal areas of debate.

Pre-emption of profitable markets by Indian and Western business interests

It might be suggested that the main constraint on the growth of the informal sector is that it only produces goods and offers services considered not profitable by foreign capital. That is, it makes those household goods for low income families which are not thought of as appropriate items by the better off strata of society. Nor does it even monopolise all cheap goods by any means — but only those which, unlike matches or soap, are actually restricted to a very low income market. It is not, however, sufficient to describe it as merely a flock of poor artisans making poor quality goods for Kenya's majority of poor people. This gives the impression of separate product markets for various strata in society, and does not pay attention to the fact that, looked at in time perspective, the informal sector makes today what the formal Indian craft community made yesterday. As the Indian craftsmen in many cases translated themselves during the late colonial period upwards into small industry and manufacturing, their places and products were taken over by the incipient African artisan society. This new group generalised into a mass market goods that had been originally restricted

to the poorer Indian families, but it also took over the Indian function of offering more cheaply to better-off families goods and services that could also be obtained from the large European companies. Thus Africans have inherited roles such as personal automechanic or petty contractor that were until recently dominated by Indians. And, as we have seen earlier, they are actually encouraged to manufacture certain items that could very easily be made in the Indian workshop sector.

The point is therefore that the informal sector has not been involved with the same limited line of goods from the start, nor can it be pictured as making only those few goods that the Indian and European companies never bothered themselves with. Looked at historically, indeed, it may appear more accurate to portray the informal sector in Kenya as something of a moving frontier, taking over year by year a wider range of products. At the moment, there is still sufficient slack to be taken up in expanding the production of local goods for middle and lower income markets that the role of the largely foreign-owned sector is not yet an explicit issue. There is, for example, a lot of potential still in developing further the production of building components such as metal and wooden window frames, storage tanks, as well as the booming market for sofa sets, kitchen and living room furniture, and a wide variety of beds. For a number of these products there is yet again a blurring of the line between the informal makers without premises or plots and those fortunate enough to own or rent some sort of workshop; a number of wasteland operators make wardrobes or beds with a finish equal to any of the unmechanised workshop people. Even on the clothing side, where it would be thought there would be little scope for development in the face of the local Indian and Japanese clothing factories of various size, one of the informal growth industries seems to be the production of woollen and cotton goods on one-man or one-woman knitting or sewing machines. These machines seem in a way, despite being imported, to perform a function analogous to some of those associated with the carrier industry; they are cheap enough to be acquired by large numbers of men and women who would not have the security to succeed in a loan application. They do not require power, and they can be set up either at home or in the alleyways between shops. These kinds of development suggest that as the diversification of an African artisan society is such a recent and on-going phenomenon it will provide for some considerable time a blunting of any very sharp distinction between foreign business wealth on the one hand and the poorer sections of the informal sector on the other. In fact the whole range of informal business activity gives the impression to many of those entering it of an alternative avenue of mobility to that associated with the formal higher school system and its occupational structure. It might be suggested that just as the enormous popularity of the school is underpinned by the belief that its top rewards are still substantially

open to any child rich or poor, so the whole informal world of local production and services is still young enough to present itself as a theatre where a man may make a good living, and even perhaps a small fortune. And apart from other reasons discussed earlier, this is a main cause for the speed with which people circulate amongst its multiplicity of occupations. Paradoxically, however, this very individualist get-ahead ethic tends to militate against any very substantial accumulation of capital and technological expertise in the hands of the more talented; they run the risk as we have seen of constantly losing their labour force and then being undercut by their self-employed former employees. It might be instructive indeed to compare the way artisan skills have been spread recently without apparently encouraging the emergence of any really formidable local capitalists, and the way the revolution of grade cattle has spread across whole areas of Central Province without being restricted to those who had significant holdings of land or of improved cattle already.[19] This part of the Green Revolution at least does not appear yet to work to separate even further the rich and poor farmer (as is so often argued); nor do so many of the industrial innovations we have been studying seem to make for further inequalities between the better and less well off. With both cattle and petty industry it is almost certainly too early to be sure how this initial equalising trend may be altered in the future. In industry at any rate, if we are looking for some sort of equivalent to the grade cow, we would suggest that it be found in items like the knitting machine or Mutang'ang'i's cheap local machines; the expensive imported machinery can only trickle down to a few.

The informal sector as a cheap labour, low cost of living subsidy to foreign firms based in Kenya

There are several elements in this, the chief of which is that the informal system with its ingenuity, extreme hard work and massive competition produces goods and offers services which have the effect of keeping the cost of living down, and thus allows large firms to continue to pay rather low wages to their workers. In particular, people who are employed in the lower end of the formal system (i.e. the majority) can live within these wages (a) because they have land and a wife's labour on it to supplement them and (b) because many of their consumption, housing and transport demands can be met informally. Thus low wages and high profits in the modern sector are made possible by the much lower wages and tiny profits in the informal arena.[20] Put another way, the increasing substitution of the African for the Indian artisan is working out sixty years later in the way that Lord Delamere and the other settlers hoped for back in the 1910s—that by training African artisans, the more costly Indians could be eliminated, and the settlers and the public sector thus achieve cheaper labour. In fact, for all the early settler

135

interest in this, the elimination of the Indian *mistri* did not come about during the colonial period at all, but only began in earnest during the late 1960s.

It is too soon to generalise about how this substitution has worked out in practice, but in some areas it has meant the partial incorporation of the informal sector into the formal. For instance, as shown in the last chapter,[21] in a good deal of building operations, work that would previously have been done by direct employees of foreign building or civil engineering firms is subcontracted out to African labour contractors, who can recruit their labour at the going rate in the informal sector. This is widely agreed by the firms themselves to be much more profitable than the old formal system. One part therefore of that moving informal frontier we have mentioned is this sort of activity of handing out to the cheaper labour world some operations from the formal sector. We had another example in the Indian distributor's suggestion that Gacuiri and others make bicycle carriers. It is this type of sub-contracting activity that the 1972 ILO mission to Kenya recommended should begin to be undertaken on a wide scale in Kenya. What was not noticed was that the system had already been under way for some time, and, while it might arguably have the effect of providing opportunities for Africans to organise larger operations, that it was distinctly profitable to the main European or Indian contractor.

The immediate future

Important as it is to show the ways in which the informal sector is taken advantage of by parts of the large-scale formal sector through patterns of subcontracting and cheap services, in the 1970s, it is necessary to try for a longer perspective in their relations. We may mention the following matters.

Possible changes

How will the present character of informal sector industries be altered as the diversification and shaking down of Kenya's artisan society continues over the next ten to twenty years, as we must assume that it will? At the moment, the patterns of schism and renewal of artisan groups, and the acquisition of multiple skills in quick succession by individual workers combine to produce a craft world on the move. Its apparent openness and expanding numbers are not merely the function of exclusion from modern sector jobs, but arise as much because it seems to operate as an alternative route to success for a few. Indeed it has to be remembered that the bulk of those Africans presently installed in permanent workshops, and who seem now secure and solid members of the formal sector are in most cases only a few years removed from being petty tinsmiths, carpenters, etc. themselves. They may be seen as having experienced the same sort of jet promotion as those many very

junior civil servants who at about the time of independence were translated into posts of much greater responsibility. These ex-informal people act also as a kind of reference group for the possibility of moving from *jiko*-maker to formal businessman, given enterprise, luck and timing.

The odds however against making it into a really secure position have probably lengthened in the petty business pyramid just as they have for the tens of thousands hoping to break lucky in the formal school system. Perhaps inevitably the main emphasis of rural industrialisation projects has been until recently the strengthening through loans of those entrepreneurs who were already relatively secure and experienced. It is naturally easier in industrial extension as in agricultural extension to concentrate on the progressive, and those who seem 'good bets'. This clearly raises important tactical issues for Rural Industrial Development Centres currently trying to define their target clients.

Concern with the changing nature of the informal sector cannot be principally focused on the methods and scope for upward mobility by the fortunate few but rather on the likely structure of rewards from future employment and self-employment for those expanding into its lower reaches. Some hints in this present discussion of carrier making might suggest a pattern of falling income following upon intense competition and under-cutting. But we need studies of other industries for longer periods if anything solid is to be said on the subject of such an 'involution' in the development of the informal sector.

National spread of informal sector products
The main reason for hesitating about any imminent fall in the range of wages and income available in the informal sector is the spread of these entrepreneurs and their activities geographically into even the smallest towns of Kenya, and the concurrent spread of the range of items produced. There are therefore really two moving frontiers that deserve attention — one is that already mentioned in which more and more products are Africanised into the informal sector, and the second is the little researched frontier in which a skill like metal or wood window-frame construction spreads into the larger centres up country and from there to smaller trading centres. To some extent therefore the prospect of too intensive competition is possibly avoided, at least in the short term, by being the first to introduce the industry in the relative protection of one's own home village or centre.

Even if we acknowledge the critical connections between the sorts of goods and services produced in these spreading frontiers of the informal sector and the changing structure of the larger scale local and foreign enterprise in Kenya, its operation does at least promise to bring to the vast majority of poorer homes in Kenya a wider range of very cheap household items than they have possessed in the past. To this extent,

some recent research has been correct to note the side effect of informal activity upon raising the standard of living of peasant (and presumably urban) families.[23] Circumscribed such activity certainly is by the existing patterns of large-scale capitalist production—so that for instance the informal frontier is clearly blocked by international brand-name soap, washing powder, cooking oil and beverages, to mention only a few of the products that are reaching out into the smallest rural centres just as powerfully as any informal sector goods.[24] Nevertheless, there are clearly many areas—some of them quite profitable—where local small operators will not be directly threatened by the large capital intensive firm.

The impact, indeed, of the large-scale upon this myriad of small enterprises is much more likely to be indirect, inasmuch as the limited resources of the state will continue to give support and encouragement to initiatives in modern production with modern technology. We have suggested that this is likely to be the pattern both in the urban and rural areas; while it will presumably continue to be difficult for the government to see how it can usefully relate to these thousands who might appear anyway to be totally self-reliant. It has already aligned itself with a development policy predicated upon expensive imported machinery, and by contrast, the operations of these informal machine-makers may well look like a curious freak. Far from being this, we would submit that given the ongoing Indianisation of production and training at the bottom of the economy, it is the sort of diversification that would be expected. It has the hallmark of improvisation that is so conspicuously absent from so much foreign industrial production in Kenya. And yet the artisan base upon which this machine making rests is still, as we have shown, so recently laid down, and its personnel so young that future developments can really only be guessed at. But whatever shape Kenya's artisan society finally takes, it seems probable that carrier making will not be the last significant small industry to emerge from the informal sector.

END-NOTE

In August 1974, a full year after the original study of the machine-makers, they were briefly revisited. The Burmah site was still operating in Nairobi, but there had been a very marked turnover amongst the workers, as we predicted. By contrast with the picture of over-competition painted earlier, now only two or three full-time carrier makers remained on site. One from the previous year had left to plant coffee on a European-owned plantation; another had gone into plumbing. Several of the others only very occasionally made carriers, but were much more involved in the metal trade—buying scrap and

new metal cheaply and selling it to the host of window-frame makers and others who were finding it increasingly difficult to get regular supplies. Even though the shortage of steel had meant that the price of finished carriers, foreguards and stands had gone up by approximately 30 per cent, one of the earlier carrier makers had calculated his time was better spent searching out the cheapest source of metal, then selling it, rather than labouring to convert metal to goods by himself. For the handful who remained in manufacture, demand for their products now outran supply, and in marked contrast with the previous year, they could afford to pick and choose amongst the wholesalers. Nevertheless, the fragmented Nairobi group were obviously unable to produce as many as were needed in the trade. It looked very much as if the characteristic insecurity and impermanence of this part of the informal sector would be unable to guarantee a regular supply of goods. It was felt consequently by the remaining makers that a local factory might shortly re-open and threaten their small headstart and livelihood.

Mutang'ang'i had also been faced with the shortage of scrap. He had had to give up the promotion of fence-post nails, since one other machine designed and sold by Gacuiri had started operating in Nairobi, and was monopolising the main source of scrap wire. He had consequently been concentrating on designing and marketing a new machine which diced maize stalks for cattle food with a fraction of the effort required by his earlier model. Again his local technology had pinpointed a specific need not met by the formal sector, and he had orders for his new machine that would keep him busy for several months. So far from designing merely cheap goods for poor people, his first two machines went on a personal order to the Provincial Commissioner of Kenya's Central Province.

REFERENCES

1. See C. Leys, 'Interpreting African Underdevelopment: Reflections on the ILO Report on Employment, Incomes and Equality in Kenya', Institute of Commonwealth Studies seminar, March 1973. Also, Keith Hart, 'Informal Income Opportunities and Urban Employment in Ghana', *Journal of Modern African Studies*, II, 1 (1973), 61-89; and 'The Informal Sector and Marginal Groups', *Bulletin* (Institute of Development Studies, Sussex) 5, 2/3, October 1973.
2. See passim, E. P. Thompson and Eileen Yeo (eds.), *The Unknown Mayhew* (Penguin Books, 1973).
3. For the difficulties of the ILO Kenya Mission in this respect, see Leys, op. cit. Another example of a report that mentions but rather plays down the political factors is P. Coombs, *New Paths to Learning* (prepared for UNICEF by International Council for Educational Development, New York, 1973).
4. Amongst others, the following are valuable, F. Child and M. Kempe (eds.), *Small-Scale Enterprise,* Occasional Paper No. 6 (Institute for Development Studies, Nairobi, 1973); I. Inukai and J. Okelo, 'Rural Enterprise Survey in Nyeri District, Kenya (Report to Danida), 25th February 1972, Nairobi, 51 pp. (mimeo).

5. Note Polly Hill's comments on methodology in *Studies in Rural Capitalism* (Cambridge, 1970), 12-13.
6. For the wider context, see E. Brett, *Colonialism and Underdevelopment in East Africa* (London, 1973).
7. Chapter I, 25-26 and Chapter V, 143.
8. K. King and R. M. Wambaa, 'The Political Economy of the Rift Valley: a Squatter Perspective', and F. Furedi, 'The Kikuyu Squatter in the Rift Valley', Historical Association of Kenya, annual conference papers, August 1972.
9. Chapter V. passim.
10. Chapter II, 50.
11. On the process whereby the job value of the primary certificate was eroded, see King (ed.), *Jobless in Kenya* (mimeo in Centre of African Studies, Edinburgh University).
12. A very graphic illustration of the wave of formerly failed Standard IV students proceeding up the system can be gathered from *Kenya: Ministry of Education Annual Report 1968* (Government Printer, 1969) table 34, 80.
13. Chapter V, 143 ff.
14. M. P. Cowen, 'Notes on agricultural wage labour in a Kenya location', in *Developmental Trends in Kenya* (Centre of African Studies, Edinburgh 1972).
15. Ichirou Inukai, 'The legal framework for small-scale enterprise with special reference to the licensing system', in *Small Scale Enterprise, op. cit.*
16. P. Marris and A. Somerset, *African Businessmen* (Nairobi, 1971), 118-20.
17. Inukai and Okelo, 'Rural Enterprise Survey', *op. cit.*, 18.
18. ILO, *Employment, Incomes and Equality* (Geneva, 1972), 180-2.
19. M. P. Cowen, 'Patterns of cattle ownership and dairy production, 1900-1965', mimeo, 86 pages.
20. Cf. C. Leys, 'Interpreting African Underdevelopment', *op. cit.*, 5-6; also R. Leys, 'The capitalist mode of production and its mediation in East Africa' in *Dualism and Rural Development in East Africa* (Institute for Development Research, Denmark, 1973), 188-9.
21. Chapter III, 73 ff.
22. J. Weeks, 'Uneven Sectoral Development and the Role of the State' in *Informal Sector and Marginal Groups, op. cit.*, 76-82.
23. Birgit Storgaard, 'A Delayed Proletarianization of Peasants' in *Dualism and Rural Development in East Africa, op. cit.*, 122. See also, passim, Institute for Development Research, Denmark, *Rural Industrial Development, Kenya* (June 1972, IDR Papers A, 72.10).
24. S. Langdon, 'The Multi-national Corporation in Kenya', seminar in Centre of African Studies, Edinburgh, November 1973.

CHAPTER V

Small-scale African Enterprise II: low cost light in Kenya

Unlike the really rather tiny group of machine-makers so far produced in the informal sector, the present chapter is concerned with a product that is made very widely across Kenya, and which, retailing at around 60 Kenya cents (5p), is within the grasp of most low-income families. The item is the small paraffin wick lamp, which is made principally out of reworked and soldered motor oil cans, with a removable wick-holder and separate small funnel for refilling with paraffin. Although one fill of paraffin lasts a long time, not much light is produced — enough for a single school-child to read by (at some risk to his eyes), or for a woman to find things while cooking. This study will pay some attention to the historical development and design changes in this form of light, but will be primarily focused upon the artisans who make these 'candles' (as they are termed in English locally).

Lamp-makers who work from dawn until nightfall in producing strings of lamps at a wholesale price of 20 for 5 shillings are much closer to the stereotype of informal sector activity than the machine improvisers. They make a product for which there is no competition either from cheap imports or from local factory production. The trade, therefore, should be valuable in providing an insight into informal sector potential at this very low level, and should throw up information on a number of rather vexed questions. What is the relationship between the centre (Nairobi), the smaller towns and the rural areas in this kind of craft activity? Do we have a picture of the decline of the rural 'fundi' (craftsman), and the ever increasing centralisation of tinsmithing in the capital and largest towns? How does the general description of skill acquisition in the informal sector (given in Chapter II) alter when it is applied across a whole industry? What kind of income and savings (if any) are available in this very labour intensive production? Finally, if candlemaking is typical of activity not carried on in the large-scale

141

sector of the economy at all, what are the policy implications of its present mode of operation?

The analysis which follows is based on information gathered on some 150 candlemakers from a variety of locations in Kenya. For Nairobi, all the main clusters of this particular tinsmith work have been covered exhaustively, so that the very great majority of all candle-workers in the following city areas have afforded data on their trade: Gikomba, Kirima, Eastleigh, Burmah, Bahati, Makadara and Kariobangi. It should, of course, be stressed that, particularly in Nairobi, job mobility is so marked that many of the three to six months trainees, target workers or casual labourers can elude enumeration even when an industry is visited in consecutive years. In addition, in a number of the provincial towns, the majority of local lamp-artisans have been visited. Embu, Kisumu, Eldoret, Thika and Machakos are towns which span four out of the seven provinces in the country. And then, at a much more local level, the trade has been examined in a number of rural market centres.

It should be mentioned that the physical aspect of the business differs rather markedly between Nairobi and most of the other locations. Principally, this is that candlemaking is carried on almost entirely in unregistered, makeshift premises in the capital, whereas it tends to be associated with a permanent or semi-permanent workshop or house in the towns and rural areas. At Bahati, for instance, the craftsmen have been located for several years under structures of bamboo poles, tin and polythene sheets. In Kirima, they are hidden away amongst the carcasses of gouged out lorries and cars in a similarly impermanent lean-to. One of the groups at Gikomba used to hire a fraction of a room in that area but has moved out to an erection of cardboard and bamboo which is rented for 40 shillings per month. The other group has not yet moved out, but as rents for any kind of permanent premise continue to go up, it would seem likely that it too would move on to wasteland.

Another distinguishing feature of the trade in the capital is that the clusters are relatively homogeneous. The two big concentrations in Gikomba are at the moment entirely made up of men and youths from the Embu District of Eastern Province; moreover, they are drawn from three contiguous sublocations of that district, Gichiche, Makengi and Nembure, which makes them rather close rural neighbours. The cluster at Kirima is usually made up of Kikuyu, and these too turn out to be drawn from a particular location (No. 13) of Murang'a District. There are only a handful of Luo or Luhya (from Nyanza and Western Provinces) actually working at candlemaking in Nairobi, and they are situated mostly on their own in Burmah Market and Makadara. The only really ethnically mixed site is that at Bahati, where a number of the oldest and most experienced tinsmiths are working; these are again Embu and Kikuyu from the same part of Embu District, and from a

limited number of locations in Murang'a District. It is also interesting to note that, despite the proximity of Machakos District to Nairobi, there were no Kamba in the Nairobi candle trade, in 1973 and 1974, nor any Kalenjin from the Rift Valley Province. In fact, as will be seen shortly, the trade in the capital is still dominated by the same communities as first practised in Nairobi in the early 1940s, and is entirely a male preserve, with the exception of one very skilled Luo woman working out of Kisumu.

THE INDIAN ORIGINS OF TINSMITHING

Tin technology, along with much else now characterised as African informal sector activity, is not the result of formal vocational training but of the presence of the Indian craft communities in East Africa. Such tin work tended to be associated with the Bohra Muslim community, some of whom had practised on the Kenya Coast and Zanzibar long before the colonial period but who began to push up towards Nairobi, Nakuru, Machakos in the 1900s and 1910s as the focus of administration shifted inland. By the 1920s, in almost all the district townships, such as Kiambu, Thika, Eldoret, Kakamega, Kisumu and Machakos, there would have been established Indian tinsmithing as well as blacksmithing. Thus, unlike many parts of the Third World where the arrival of cheap trade goods from the West was linked to a decline in traditional craft activities, Kenya, which did not have a wide spectrum of craft in the precolonial period, actually had a dispersal of new Indian craft workers across the country at the same time as modern trade goods began to make their impact. There thus occurred a very significant decentralisation of modern craft work spanning a variety of trades. It made possible the manufacture of a range of items from the lightest tin work to ox-carts and in some regional centres lorry and bus body-building.

As far as tinsmithing is concerned, the Indians originally made a whole range of goods in their little workshops, most of it aimed at the Indian community. In contrast with such general tinsmith workshops, it will be noted that the majority of those surveyed for this study were engaged *full time* on the manufacture of a single line of goods, the tin lamp, although some would be prepared to repair individual items from passers-by. This specialisation amongst candlemakers is the more marked in the capital, where the supply of materials allows fulltime concentration on one line, but is much less possible in the more rural areas where materials, demand and distribution all make for great differences.

Because of the expulsion of the Indians from Uganda, it is no longer possible perhaps very easily to reconstruct this episode of technological

history in that country. In Kenya, however, the earliest Indian makers of tin goods are in some cases still living, or are perhaps just leaving the country. It may, therefore, be worth putting down for the moment just a few fragments of what is a much more complex network, particularly since, as Africanisation proceeds apace, there will soon be no Indian craft workers left in towns like Machakos, Thika, Eldoret and elsewhere.

Mombasa appears to have dominated the tin-lamp trade during the 1910s and 1920s, with Karimjee Walijee one of the big producers. Up country in Nairobi there were soon quite significant numbers of Indians operating around River Road, 'Tea-room' and Bazaar Street. Esmail Abdulalli was around Jeevanjee Gardens, Noorbhai Alibhai in Bazaar Street, Essajee Amijee and Dossaji near the Khoja Mosque, Yujufali Ebramijee coming in the early thirties to Cross Lane. Some of these Bohra families had diversified so rapidly that, for example, a grandson may be running a highly mechanised modern factory in Nairobi's industrial area in 1970 when the grandfather might have been making a series of lamps, funnels and kerosene pumps entirely with hand-tools. In Esmail Abdullali's shop where in the 1930s most of the goods would have been produced by Indian labour, now all but the most sophisticated one-off orders are bought in from African tinsmiths.

In other towns, blacksmiths carried on a very wide range of metal industry in the 1920s and 1930s, including work on lighter sheet metal. Machakos, for instance, in 1974 had only one out of seven or eight Indian blacksmith firms remaining—Gulmohamed Juma. This firm had in its span of sixty years in Kenya gone from the manufacture of axes and ploughs, to ox-carts, to bodybuilding for lorries and buses. From time to time, it had made lighter tin goods, and, for example, one of the sons of the original founder had made his last oil lamp by hand in 1949. Up in Nakuru, a similar versatile blacksmith, Naran Devji, arrived in 1925, and in Eldoret, Purshottam Mawji came in 1932 after moving north from Dar es Salaam in 1911. At Kiambu, where today only two or three Indian families remain, there was a tinsmith, Alibhai Jamal, in the colonial period, as well as Indian shoemakers, builders, tailors and carpenters.

Prior to the 1930s, few of the early tinsmithing families appear to have had any more equipment or tools than their African counterparts today working in the shanty-workshops of Bahati, Burmah, Gikomba or Eastleigh. A pair of sheet metal scissors, a protractor, a small section of railway track, one or two punches, a hammer and a soldering iron. For the first time, however, in the thirties, it became possible for some Indians to buy some basic metal-working machinery on credit—such as a guillotine, top-and-bottom seamer and other machines for rolling and cutting rounds. With the advent of hand-operated and semi-automatic machinery, and the aid of the boom for locally produced goods during

the Second World War, one or two were able to drop their simpler lines and concentrate on making dustbins, galvanised pails, tin trunks, coffee tins, and watering cans. It would be wrong, however, to give an impression of some uniform pattern of successful diversification away from the simple tin goods of the early days. There is at least one workshop in Nairobi in 1974 which makes with hand-operated machinery the same little kerosene pumps that most of its own Indian competitors dropped in the 1950s; and it does this in the face of many Africans who make these without any machinery.

AFRICANISATION OF INDIAN TECHNOLOGY

Unlike the measures to Africanise the civil service or retail businesses, the process of indigenising skilled trades went on throughout the 1930s to the 1960s without any public attention. Here and there across the country, Africans were taken on in Indian workshops, initially to do unskilled work, while the actual manufacture remained in Indian hands. In marked contrast to the present learning system, the intention in many cases was not that the African should learn to make, say, oil lamps. Far from it: indeed, a few of the oldest informants described a situation in which their Indian employers used to protect their craft secrets from African competition. In the case of candlemaking, this meant that the crucial soldering operation was carried out perhaps in a separate room, while the Africans were really only intended to help about the workshop. One informant described how he took a lamp from the workshop to his home, so that he could unmake it, and see what shapes were needed in its manufacture. Obviously, in other workshops where the Indian skilled workers had moved on to making more complicated lines, there was not the same craft protectiveness. Gradually, therefore, discouraged or encouraged, Africans picked up the technique in the late 1930s and early 1940s.

In the present site at Bahati, there are a number of candlemakers who can trace back their own skill to Indian employment. Muthathai Nduiga, from Embu, was working for an Indian tinsmith, Mula, at Tearoom in 1938; another worked for Alibhai. But also during the second world war there had emerged the first group of Africans, who, having learnt the skill in employment, had moved out to set up on their own. The timing would obviously differ from town to town, but by 1944 there was a group of three or four related Murang'a men working in the African location called Majengo: three of these were brothers or step-brothers, Macaria, Mwangi and Gachehu, sons of Gakung'u.

In Nakuru, a few Luo and Luhya appear to have learnt in Ngata workshop, a European concern, employing Indians, Italian prisoners of war, and Africans, and turning out a wide range of metal goods,

including light tinwork. For the Machakos area, one of the transitional points between Indian and African skill appears to have been a man, Musioka, who was employed by one of the Indian candlemakers, and was actually taken to India for a time during the 1930s. He too had left the Indian by the beginning of the second world war, and was soon to be joined by his stepson, Zachary Mutiso Ngui, in self-employment.

Although the process would be slower in some workshops and regions than others, by the 1940s the skill had certainly moved away from any caste monopoly of the Indians. In small numbers, African tinsmiths were beginning to sell to the Indian wholesalers, and develop their own links to small African traders up country. Of course, the wartime development of locally canned Kenyan food in the formal sector of the economy produced very rapidly a good deal more scrap tin for recycling into oil lamps and other tin goods. Soon there would be enough discarded tins available for it no longer to be necessary to make the entire lamp body from individually cut pieces of flattened tin, as the earliest Indian smiths had done.

Skill acquisition and training, 1940-74

Once the tinsmithing skill had moved out into the hands of the first generation of African artisans, an informal system of training began to establish itself, which in its fundamentals was shared by most of the skilled trades at this time. It is possible to examine the main features of this access to skill for something like a thirty-year period, and in the process discuss whether the earlier rather informal training arrangements are beginning to fall into any more rigid system in the 1970s.

Character of the first generation
Only a very few of those who started making wick lamps in the late 1930s and early 1940s are still working in that same line today. By reason of their long stay in one field they have acted as skill models for a good number of much younger tinsmiths, as we shall shortly see. What such older men have in common is a very low level of formal schooling, if any. In addition, they came to self-employment in the informal sector after exposure to a variety of so-called 'formal sector' stints—on the coffee and sisal estates north of Nairobi in the 1930s, or as 'house boys', 'shamba boys' or turnboys for Indian or European employers. Two of them were employed as municipal sweepers before they embraced the lamp trade, or rather before they combined refuse collection in the early morning and afternoon with recycling some of that refuse for sale in the late afternoon and evening. Now, the informal sector has sufficiently diversified that it is no longer necessary for a candlemaker in Nairobi to search out personally his own tins; instead, specialised tin collectors will circle the petrol stations and factories to deliver as many

Fig. 8. Kenya's low-cost light: scrap tins delivered in hundreds to Nairobi lamp-makers.

hundred used tins as are required. As may be imagined this allows the urban maker to concentrate on uninterrupted production where his rural counterpart can often run out of tins or solder for as much as a week at a time. Nevertheless, these two older artisans continue to keep both jobs going. And, with so many other urban workers, they maintain strong links with the peasant mode of production in their home area.

Training arrangements
Available data suggest that there are really no hard and fast training parameters such as characterise the more rigid apprenticeship systems of other parts of Africa. Thus, a significant category had to pay some money to their instructor, another group were paid a small allowance daily during their training, while yet others were merely given shelter and food. A handful had to pay nothing and received nothing while they were learning. Firstly, amongst those who paid a lump sum there was a great deal of variation in what had to be given. Amongst, for instance, a random group of ten who did pay, five offered 100/-, while the rest had to pay 30/-, 50/-, 60/-, 150/- and 300/-. Almost invariably, however, something of this comes back through being paid a daily allowance of 1/- or 2/-, with food and shelter being added. Even if a trainee only stays with his master for three months, he will have

received back much of what he gave, discounting for the moment the value of his trainee labour. As for the payment itself, it does not seem reasonable to regard it as a way of *restricting* entry to the trade so much as part precaution and part training fee for those applicants towards whom the trainer has no particular obligations of family or kin. For instance, there have not been a great number of inter-ethnic training arrangements, but the few that do occur are more likely to involve this initial payment. Although we have in our sample cases where a Kamba has paid an Embu man, and a Kikuyu another Embu, there are just as many examples where Kikuyu have charged other Kikuyu; and Luo, Kamba and Embu likewise.

Another difference perhaps between those who pay and those who do not derives from the attitude of the would-be trainee and his parents on the one hand, and the varying state of the candlemaker's business on the other. Many parents in rural areas are eager for their children to get some training once they have finished primary school or failed to proceed to secondary. They view the various openings in the informal sector as 'courses' requiring larger or smaller 'fees' depending on difficulty and status. Candlemaking is not regarded as particularly taxing, and this is confirmed by a number of informants saying that their parents could not afford any course except this one. Thus when an experienced candlemaker is asked to accept a youth or a grown man for training, he may well ask for a training fee.

On the other hand, the tinsmith himself is often aware that he needs a helper, in order to raise his production beyond the maximum of 40 to 60 candles that a single man can manage in a full day. He is therefore just as likely to call a young man from his village as vice versa. And, as the candlemen say, you cannot ask for payment when you yourself want him to come. Similarly, there will be rural relations in many cases who are anxious to look for a formal sector job in Nairobi; they have no particular commitment to making candles, but are quite prepared to do casual work in the industry to maintain themselves in town while they are looking.

The rate of allowance typical for trainees in candlemaking suggests something about the income from the industry. The lowest allowance paid amongst the present informants was one shilling a day, and one shilling ten cents was very common. As with the lump sum payment, however, the range could be anywhere between one shilling a day and three shillings a day for people under training. Some appear to have stayed on the same allowance of two or three shillings for the whole of the training period. Others are able to describe in minute detail how the wage or allowance crept up from being, for instance, 1/50 in the first two months with a lump sum of 10/- at the end of the first and 20/- at the end of the second; how it rose to 3/50 a day in the third month, up to 4/- in the fourth month, and finally rested at 5/- in the sixth month.

It should not be thought that an allowance of some 2/- a day is restricted to the relatively young trainees; amongst the informants there are examples of men who have already been employed elsewhere for 15 to 20 years accepting two or three shillings during their training period.

In addition to a good deal of fluctuation with the allowances, there is also a certain amount of regional variation on the length of time required for training. The first principle seems to be that there is no parallel at all with traditional apprenticeship systems where learners are tied to their master for a long time after they have become fully productive. As was stressed in Chapter II, there is no indenture, no written agreement, but merely an undertaking to accept and train. Particularly as candlemaking has become a specialised tinsmith activity, the training period can obviously be much shorter than if a boy was being taken on into a general tinsmith workshop. It is possible in fact for the skill of candlemaking to be picked up very fast, and not surprising therefore that the training period is frequently as short as three months. For instance, in a sample of Nairobi based candlemakers, a three-month period was commonest, followed by two months, and then four and six months. A handful had only been under training for a month. These rather short learning periods might be suspect if the trainee had stayed on much longer with his master, and was perhaps claiming that he knew the trade much earlier than his master was prepared to recognise. But in the majority of cases, the learner went straight from his tuition to *self-employment*.

The training period seems to be shortest of all in Nairobi, while in parts of Nyanza and Western Province, the trainee may well stay for a year. The difference is perhaps explained in the much greater concentration upon a single product line in Nairobi. Because of the very favourable conditions for obtaining scrap in the capital, exposure to lamp-making can be fulltime, seven days a week with Sunday afternoon free. By contrast in the rural areas and smaller towns, there is often no opportunity of fulltime production and consequently it is more difficult for the trainee to gain competence rapidly, or for him to be sure that without migrating elsewhere he can set up on his own. Whereas in Nairobi it is soon perfectly obvious to the younger man how many scores (or *koria*) of tin lamps he can make in a day. It is also very easily discovered that a *koria* is sold to the Indian or African wholesalers at between five and seven shillings depending on style and quality. Since it is common to make between two and three scores a day in ordinary conditions, it does not require primary school maths to calculate that an allowance of three shillings a day can be bettered in self-employment.

The move to self-employment is much easier to accomplish in the city also because of the absence of red tape. In the informal sector there is usually no requirement for a trading licence, or need to operate out of a formal work premise. And it is also possible occasionally to sleep on the

job, and thus avoid the very severe rent normal for even the smallest room in Nairobi. There seems to be surprisingly little acrimony between master and pupil at the transition from training to self-employment. The learner may try to push his wage or allowance up beyond 20/- a week (or 3/- a day), and he may then be offered 5/- if he is particularly productive. Quite commonly, if the master refuses to pay more, he will simply go into self-employment but stay in the same workshop as his trainer, using some of his tools, paying a proportion of the rent and taking advantage of the same suppliers and distributors.

There are, then, in the city almost no long-term employees in the candle trade with the exception of a single old man who has been employed in the business on and off since the 1950s. He now gets 5/- a day, and his workmates explain that he has not been able to establish himself because of drink. Just a scattering of the others have been employed for a few months or up to a year after completing their training and received wages of between 60/- and 100/- a month until they left. Up country, there is probably a good deal more variation, as we have suggested, particularly since general tinsmith workshops are more common than concentration on a single product. In Eldoret for instance there are more employees than self-employed in candlemaking, but this is because, at the moment, lamp production is dominated by a Luo workshop which does radiators and other tin goods. He does have ex-trainees who are self-employed, but only one of them operates in the town. His present employees have been with him longer than would be common in Nairobi, but they are for their 4/- to 5/- wage doing a variety of work, not all of which would be easy to duplicate in self-employment.

In general, however, we may say that the more specialised the line of tinsmithing, the more likely is self-employment to be embraced rather rapidly. As against the year or two years that it takes to acquire tinsmithing in a youth centre or village polytechnic, the system in the informal sector reproduces skill at considerable speed, and unlike the formal and sponsored non-formal institutions the skill is very specific to a particular job.

Formal education and candle training

There are a number of important issues to be raised on the relation of education to this kind of informal sector activity. Although we have suggested that candlemaking is by no means one of the more prestigious of jobs, a good proportion of the workers have been exposed to school. By contrast with a recent survey of petty producers in Dakar where an average of 73.3 per cent had no school across four trades—furniture, shoemaking, tailoring and mechanics, Kenya's candlemakers are relatively educated. If we take the 75 informants on whom there is the most detailed information, we have the following picture:

Standard VII or VIII	21
Standard V or VI	14
Standard III or IV	18
No Standard to II	20
Form I or II	2
Total	75

Of course, this picture partly expresses a more general spread of primary education across the whole of Kenya than is true of Senegal. In fact, the trend towards a primary educated workforce is more marked than is apparent in these figures, since a good proportion of the illiterate artisans are those who began working in the 1940s and 1950s. Thus in one of the candle clusters in Gikomba area of Nairobi, which has a rather young complexion, only 3 of the 19 workers have had no primary education, while 10 have reached the last or second last year of primary school.

The location of their schooling is also significant. Almost without exception the primary school was in the particular area of Murang'a, Embu or western Kenya where the parents had their family plots. Which is to say that the very great majority of Nairobi's candlemaking community are migrants from the rural areas. Only in the oldest grouping at Bahati are there two or three youths who have been born and educated in Nairobi, and who are now helping their fathers full-time or during the school vacations. We suggested in Chapter II that there was a tendency to migrate to the centre in search of training even for informal sector jobs. This is certainly true of many in our present sample, who could easily have acquired training in Embu and Murang'a, but chose to come to Nairobi.

It is not, naturally, the case that in the informal sector any more than the formal, a person sets out from the rural areas with a particular category of job in mind. Rather, he has a particular list of acquaintances and village mates who he knows are working in Nairobi in a variety of positions, and he intends to circle these in search of advice about work. Just as, in carrier-making in the last chapter many young boys from Githiga village arrived at Gacuiri's site, so in the tinsmith business, boys from that particular rural part of Embu are likely to turn up in one of the two Gikomba candle industries, or in the older industry at Bahati. If they have spent a few months in town to little effect, or, just as likely, if they have a job in the informal sector which puts them in a rather dependent relationship (e.g. pulling an uncle's handcart, working in an older relative's kiosk), they will often prefer to work with a group of their age mates. In yet other cases, as we saw earlier, they will be asked to come from the countryside and join an already established candlemaker from their area.

A distinction was drawn in Chapter I between the status and aspirations of the typical primary school child and the very select group

who cross over into any sort of secondary school, and it was suggested that the very *ordinariness* of most primary schools would not be a barrier to working in the kind of conditions common in shanty workshops. It is interesting therefore to note that out of the 150 candlemakers for whom we have information, only two had done any secondary schooling. And both had done this for two years only, in private day schools. There is not very much that can be made out of the experience of only two cases, but both seem to have used the candle trade more as a base to make forays into other jobs, or as something to fall back upon, until a better opening presented itself. One of them, for example, had acquired his training from an Embu relative in the Gikomba group; he had then made off for employment in an Indian workshop. After a few months he had to leave and was back in candlemaking at 5/- a day. A year later he had landed a job in African Ropes and Twines at 7/10 per day; he remained on casual terms there for a year and a half, and again took up candlemaking for a year. By 1974, he had left it once more to help run a brother's bar in Nairobi. However, mobility of this sort is by no means restricted to secondary school boys.

Returning to the critical nature of the divide between primary and secondary, it is possibly more significant to see if any of the older candlemakers, with little or no education themselves, have managed to get their children beyond primary school. Not many of these older men have enough children of secondary school age to have a clear picture, but of those few, only one, Zachary Mutiso in Machakos, has two children in secondary school and four others in primary school. Three of the other older men working at the Bahati site have boys who have reached Standard VII. These boys seem to have joined their fathers in fulltime candlemaking, just as previously they would have been assisting in the afternoons after school and in the vacations.

The fact that these first sons have not managed to make secondary school does not necessarily suggest that their parents have no hope for them to go beyond primary. It is quite common for the oldest son to relinquish his educational career to make money to help put the younger children through school. This is also the case with several candlemen who do not have school age children yet themselves. One of these is actually supporting two of his brothers in government secondary school where the fees are a minimum of 450/- a year each.

Apart from these cases, there is still a rather strong impression from the data that many candlemakers simply did not get the chance to continue with their education. The two commonest causes were the death of parents and their inability to pay the school fees — even at the primary level. This meant that they had to go out to work, first for a few years around the village and then further afield. But again, as we have stressed, their parents did not have the money to launch them on some

of the more expensive informal 'courses'; so they had to start at the bottom in menial work, or the pettiest of trade such as selling Aspro and shoe laces at the bus station. It is difficult however to generalise in this area, for, as we shall see in looking at the income and savings from candlemaking, these artisans are by no means all stuck in a backwater of unrewarding work with no prospects.

Networks of skill

We have suggested that many of the skills in the informal sector are reproduced at very great speed through these rather flexible training arrangements. This particular branch of tinsmithing has one of the shortest training periods, and it is consequently quite possible to have received training one year, and to be giving it to somebody else the next. Of course, by no means everybody trains others, and those who do train, do not necessarily do it continuously. Even so, a good case can be made out that in candlemaking as in other informal sector activity, certain men can justifiably be called *skill models*. Over the years, ten, twenty or more have passed through their hands, and some of these have continued the trade in self-employment, while others have left it for other work. A few of these key men will be mentioned, to show that this kind of petty artisan activity is not a recent phenomenon in a state of complete flux, but has already got some considerable continuity of personnel to counter what we have said about mobility.

Name	Site	Length of time in Candlemaking
Zachary Mutiso	Machakos	1942-1974
Kimotho Gakiabi	Bahati	1950-1974
Joshua Ireri	Bahati	1963-1974
Muthathai Nduiga	Bahati	1938-1974
Jacob Njiru	Gikomba	1963-1974
Nyaga Geteria	Gikomba	1968-1974
Gachamu Mathenge	Bahati	1953-1974
Njagi Nyaga	Gikomba	1959-1974

Since such men know in some detail who trained them, and who in turn they have trained themselves, it is possible to construct quite elaborate skill networks or genealogies. For instance, Kimotho was one of many who picked up the skill from the first Nairobi makers around Majengo; he in turn has trained at least twenty over the ensuing years including two of his sons more recently. Njagi Nyaga learnt from Kimotho in 1959, and has similarly had about fifteen to twenty people through his hands, of whom one, in 1963, was Jacob Njiru. The latter has been one of the most enterprising and productive men in the business and has consequently attracted a large number of trainees. Several of his ex-trainees are still firmly in the candle trade, among them, Nyaga Geteria who trained in 1968. And so on.

Because of this continuity and the drive towards self-employment, really rather large numbers of young people have been exposed to the skill. But while there may be some advantage in a rapid system of skill acquisition in a country like Kenya which lacked any very wide range of pre-colonial skills, it is also the case that what can be lightly acquired can just as lightly be dropped for something else. After all, unlike a four- or five-year tinsmith apprenticeship, only three months has been lost. On the basis of the present evidence, therefore, it seems really that decisions about training are not determined by any anxiety to reduce competition amongst candlemakers. Even those, such as the above, who appear to have a long term commitment to the trade do not seem particularly concerned about the possibility of overcompetition. In fact, the only remarks which touched on this issue at all were made in Kisumu, and reflected a fear that Nairobi candles might undermine something of the local market. It may well be, however, that despite the occasional trans-tribal training arrangement, competition is really most effectively reduced by accepting trainees in the main from a rather restricted geographical locality. It is not then strictly accurate to describe *the* Kikuyu or Embu as dominating the candle trade, but tiny sub-sections of Embu or Murang'a District seem to have a hold on the trade, in the same way as in the formal sector an influential man or personnel manager can give a whole line or section of a firm the stamp of his own village.

Income and savings in a part of the informal sector

It is clearly difficult to be very precise on a subject where apart from customary restraint about earnings, there is always the suspicion that government may wish in some way to levy or license this group of petty urban entrepreneurs. In addition, there is a considerable difference between the motivation to save of some of the younger artisans and those with families at home, who may need some regular supplement for school fees and household expenses. So the range is great. Nevertheless, self-employment is so widespread in the trade that there is a fair amount of consistency over what a single man may produce in a day, in favourable conditions.

Many workers agree that they can turn out three *koria* or scores in a day given satisfactory supply of tins, and solder. This can be increased if a very simple style is being produced, and decreased if a very sophisticated model is attempted. Granted this variation, the wholesale price of a single *koria* is between 4/50 and 7/-. It should consequently be possible to have a gross return of some 13 to 20/- a day or 80 to 120/- a week. Against this would need to be set some 10/- for used tins and perhaps another 10/- for solder and soldering fluid. A charcoal or wood brazier needs to be maintained throughout each working day, but this

can be shared amongst several individual workers. Most premises, also, have to be rented, even if they are of the most informal sort, but this too in the urban areas of Nairobi can be substantially reduced, by seven to ten people sharing the monthly rent of, say, 40/-

In principle, therefore, a net return of some 60/- to 100/- a week should be possible. This can of course be considerably increased if there are one or two well-organised trainee helpers attached. It is also possible in Nairobi, unlike the smaller provincial towns, to arrange for irregular supplies of items like solder. Dealing in stolen goods is not something that can make much difference to the candle trade (although a lump of cheap solder is a pleasant windfall), but it is quite a critical feature of some of the more expensive services offered by the informal sector.

From this monthly income of 250/- to 400/-, a good number of those with commitments in the rural areas find it possible to send a remission of 50/- to their parents or wives. Obviously there is a good deal of fluctuation, and the men stress that it may be as high as 80/- or 100/- in a good month but down to 30/- or 40/- on another occasion. It is interesting also that investment in land purchase and grade cows that marked off a number of the machine-makers in the last chapter is also a characteristic of the more dynamic, younger candlemen. Four of these had contributed 400/- to 500/- to one of their local land purchase societies, and two others had put in amounts of 700/ and 900/- over a period of years and months.

Indeed, the majority of the candlemakers, and not only the more successful, maintain close ties with the rural areas. And since there seem to be obvious limits to what can be ploughed back into the business itself, it makes good sense to invest any available surplus in the family holding.

Relationship between Nairobi and the Provinces

Given the physical dispersal of Indian skilled workers into quite small towns during the colonial period, Nairobi has never been the only place in Kenya where it was possible to learn tinsmithing, or where it was possible to carry it on at some profit. As we have suggested, it has also existed continuously in provincial centres like Mombasa, Machakos, Kisumu and Thika. However, after the second world war the availability of scrap shifted dramatically in favour of Nairobi, reflecting the increasing centralisation of food processing and other import substitution industries in the capital. Rising car imports and the mushrooming of petrol stations meant that the small oil can could from the 1960s become the basic element in the candle, while the lid of the Nestlé's dried milk tin was used to form the top.

Something of the buoyancy of the by this time completely Africanised candle industry can be gained from noticing some of the main design

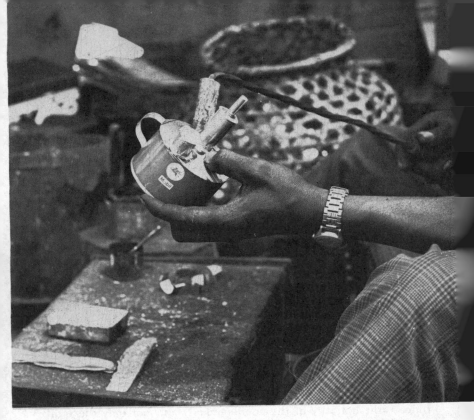

Fig. 9. Kenya's low-cost light: the finished wick lamp made from the re-cycled scrap tin.

changes in the period 1940 to 1970. Initially, the first generation of African artisans had merely copied the Indian precedent of making very small candles, with flat tops and a single funnel which had to serve both for the wick and for refilling with paraffin. By the end of the Mau Mau Emergency in the mid-fifties, the size had increased, the top cover had been rounded out into a shallow dome to make it more attractive. The next major change came just about the time of Independence when the two-funnel style was introduced — one for the wick and one for filling (which made it a good deal safer and cleaner). Following Independence there has been a riot of more elaborate models made in Nairobi by particular operators in smaller numbers. Candles have been raised on elaborate stands, have been given wings and nose cones like jet aircraft, and have been made more sturdily out of discarded camping gas tins. None of these more expensive styles has had a mass appeal, since the majority of consumers need to buy the cheapest possible form of light.

Despite this, certain patterns of consumer demand for particular types have begun to emerge, and to some extent these reflect the uneven development of cash incomes in different areas of Kenya. In Central Province, for example, it is now virtually impossible to sell the old

single-funnel candle, since almost everybody prefers the convenience of the post-Independence style with two funnels, even if it is a few cents dearer. There are other parts of the country, however, in Rift Valley, Nyanza and Western Province where shopkeepers will only stock the single-funnel style which sells at about 55 cents (2½p). They feel their customers will not be prepared to pay the extra 15 to 20 cents for the Nairobi version.

Interestingly enough, recognising this preference for the cheaper style, one of the most go-ahead Nairobi candleshops has from time to time switched to making hundreds of scores of the simpler model, and they have been distributed personally to wholesalers in Kericho, Sotik, Busia and Kisumu. The rural candlemaker is clearly at a disadvantage also by not being able to make long runs of the same style of candle, even if he wants to. In a village or small town he can usually only muster an assortment of very different tins. In fact, even in Kisumu one of the local complaints was that a few of the Nairobi-based Luo candlemen were making things difficult for them, by sending large quantities of 'beautiful candles' into Kisumu.

It does not however look in the short term as if Nairobi will necessarily monopolise candlemaking even though it will influence styles. In fact in a number of towns like Eldoret, Thika and Kericho, new people have recently opened their candle business, after trying Nairobi and finding it just too expensive. There is, therefore, here and there, a move back from Nairobi which needs to be set against the obvious attractions of the capital on other accounts. And if this is true of candlemaking, it is even more obvious with informal industries such as those using wood, where Nairobi is less at an advantage.

DISCUSSION

When we come to view the spread of this sort of petty artisan activity more widely, and estimate its general significance for urban and rural employment generation, as well as its application to training programmes and technology, there are a number of points to be made.

Candlemaking is just one of many petty productive skills that are not prepared for in any of the formal training institutions. Along with a variety of other tin and metal products, it is in Nairobi almost always carried on without permanent work premises. Originally, as we saw, the run of such basic tin goods would have been associated with general Indian tinsmith shops. But in Nairobi's informal sector, each of these tin or simple metal goods seems to have separated itself off almost to the exclusion of others. Thus the group we have been concerned with concentrate on tin lamps. Another very large group across the city make the tin charcoal burning braziers (*jiko*) while others make watering

cans, cooking and washing vessels, and so on. This is less true of the small village artisan, who will to a much greater extent have to be a generalist, often making things only to order. He would not at the moment have the materials or market to do otherwise. Leaving aside the more general African tinsmiths who do operate in the pattern of their Indian predecessors, and many of whom seem to have diversified very successfully into products like huge galvanised water storage tanks, we may say that policy makers at the moment are more concerned with the really small urban producer and his rural counterpart. What, they ask, are the really critical needs in petty urban and rural production which perhaps the formal training and support organisations of government could do anything about?

It might appear from one angle that it was not worth wondering how to aid such petty producers; they were already working hard and long in manufacturing a specialised product. The conditions of work were not enviable but were tolerated, and obviously income was generated, even if this was not enough to keep the wife and family in Nairobi itself. The line of least possible interference is not necessarily the best in this sphere, any more than it would have been when several hundred small communities strove to provide themselves with *Harambee* secondary schools. As it is, government, through aid to self-help education has substantially affected for good the quality of these schools, and avoided the development of a completely unregulated back-street education sector. In the same way, it would be very much in the tradition of Kenya self-help policy since Independence to examine the contribution of unregulated self-help artisans, to see if even a minimum of formalisation might be advantageous. The following might be the main considerations.

1. Candlemakers produce the only indigenous form of cheap light in Kenya. The wide market for their product is itself an indication of how very few household articles the ordinary family can afford. The same, of course, could be said of many other items produced by the urban informal sector. Cheap though such goods are there are still many rural households which cannot afford to cook by charcoal or paraffin, and do not use any artificial light. This has to be borne in mind in any new policy towards the informal sector, since it is from there principally that several of the most basic household articles have emanated. And it is presumably to the benefit of the majority of low income families that a much wider range of cheap locally produced goods be made. Diversification of product is not however something that can be brought about by fiat. Certain preconditions need to obtain both in the rural areas and amongst the producers.

As far as the producers are concerned, the last ten to fifteen years has witnessed quite an explosion of skilled workers in the basic trades. Only

a small minority of these have the good fortune to have acquired workshop accommodation and got machinery. The rest are much more restricted in their trade, and although there is a great deal of dynamism and mobility amongst them, they do not seem poised to diversify in the way that was open to the Indians in the 1930s and 1940s. For one thing there is no readily accessible layer of hand-operated machines which they can buy, and so they stay with basic hand tools, and invest their profits not in the business but, as we saw, in land, school fees and their rural home. For another, there is no security of tenure for the seven or eight sites of informal candlemaking in Nairobi — or for the majority of cheap metal workers, spray painters, mechanics in the capital for that matter.

It would seem in both these matters that something could be done in the way of assigning petty workshop areas without infringing the planning priorities of Nairobi City Council and in extending some form of credit that did not require substantial security. At this point, however, it is worth being realistic about such possibilities. First, as urban building land is at a premium for the private investor and the city council, it should not be imagined that it will be any easier in Nairobi than in London or New York to legislate in favour of those without power or influence. Secondly, it will also be much less difficult to offer credit to two or three of the better placed candlemakers than to design a policy that will improve the working conditions of the majority. In this kind of way, 'aid to the informal sector' could well come to mean aid to a handful to escape the informal sector.

2. The same difficulty emerges when we consider the possibility of aiding the informal sector through skill improvement. It has to be admitted that skill improvement courses are not required in order to make better candles; the design of these has developed satisfactorily on its own. If evening courses were tailored to the needs of such practising artisans, they would probably end up by offering them the chance to take government trade tests in sheet metal work. And this in turn would be seen by some of those attending as a way to move from the roadside to formal factory employment. Even so, there certainly is a case for mounting a variety of subsidised skill improvement classes which could operate out of the Nairobi and Kisumu NIVTCs, as well as from the new technological institutes scattered round the country, as they come into service. Something along these lines would certainly help redress the balance at the moment whereby it is really only possible to get extra skill if a man is employed already with the large scale firms and government departments mentioned in Chapter III. And in any case, quite a number of the operators in the informal sector are determined to remain in self-employment whatever happens.

3. Most of the agencies both national and external which are concerned with promoting or aiding African enterprise in Kenya have

found that a key motive behind attendance at traders' course, business extension services, or becoming a client of the Rural Industrial Development Centres has been the hope of a loan. Being a businessman and getting some sort of loan are seen as synonymous. At the moment, the one thing that has never been conceived even as a remote possibility by people like these candlemakers is that they should qualify for a loan. After all, the loan business is currently seen from the bottom as a reward for success and influence, rather than an aid to becoming successful. So if some programme of aid to the informal sector in Kenya were launched, it would begin to be assumed by some of its members that they too could qualify, if only they attended sufficient evening classes, etc. Part of the trouble is that there is so little machinery intermediate between hand-tools and the now rather sophisticated power tools from the West that a loan has to be of some size to make diversification at all possible. The range of cheap hand machinery bought by some of the Indians on credit in the 1930s is almost unobtainable from the West nowadays, and as far as we know there has been little attempt to consider for Kenya such intermediate machinery as is still widely used in India itself, and doubtless in China. The natural tendency in Kenya, as we showed in the last chapter, has been for loan recipients to go for the most up-to-date equipment, and in this they are encouraged by the machines available in the big export-import showrooms.

It might however be possible, in devising some form of credit for the informal sector, to investigate the relevance of less expensive hand-operated machines from countries where they are very widely used, and where, unlike Kenya, there is a whole range of products intermediate between the 50 cent tin lamp and electric light. The consumer in East Africa has nothing between the tiny candle and the imported hurricane lamp, now selling at not much less than 30 shillings.

It must be said finally, however, that there are obvious limitations in any kind of programme that attempts to treat the informal sector in isolation from the wider political economy of the country, since its physical aspect and its relative powerlessness are a reflection of the fact that industrial and development priorities lie at the moment rather far away from Candlemaker Row.

It will perhaps be easier to appreciate the relative position of these smallest petty producers once we have described in the next chapter the total skill situation in a Kenyan village.

CHAPTER VI

The Technical Form of a Kenyan Village

So far we have analysed in general terms the development of both
formal and informal technical skills, and have provided profiles of two
rather different types of informal sector industry. Since much of the
discussion has been at the national and urban level, it may be useful to
localise the main issues at the level of the village. It should then be
possible to see much more clearly, for instance, the relationship between
school and skill, or between formal and informal training opportunities.
Particularly as it is the village that is currently the concern of so many
local and expatriate development agencies, it should be of some value to
outline the present provision of technical skills within a single rural area.
Proposals to aid or foster rural skill formation may at least then take
cognisance of what appear to be some of the key structural features of
skilled manpower in the village.

For the moment, any conclusions that may seem to emerge need to be
regarded as tentative, bearing in mind that only a single village is under
review. There is good evidence that rural areas in Kenya are by no
means developing at a comparable rate, and it is not therefore being
suggested that the skill pattern of a single village can in some way be
generalised upon the whole country. On the other hand, by selecting a
village in one of the more developed districts of Kenya, we may well be
examining a network of skill that may shortly spread to other parts of
the country. This particular village is only a matter of twenty-five miles
north of Nairobi. Like the majority of the so-called rural areas of
Kenya, there are significant features of its economy that are intimately
associated with city life and city income. Twenty-five miles therefore
may not be dramatically different from several hundred, as an
anthropologist has recently observed for a part of Western Kenya:

> Although Maragoli is located 250 miles from Nairobi and has no town
> centre of its own, it cannot be classified as a 'rural' or 'agricultural'
> area. Instead, it might be more appropriate to think of Maragoli
> with its dense population, two- to three-acre family plots, spread of

social services, and dependency upon town income, as a dislocated Nairobi suburb. Furthermore, the constant flow of men and money between town and location functions to articulate the community into the mainstream of contemporary Kenyan life.[1]

We shall examine accordingly the development of various categories of rural skill, but in the process we shall be constantly reminded of the interaction of urban and rural skill. It is worth stressing this incorporation of rural with urban at the outset, so as to avoid giving the impression that we may proceed to deal in isolation with the rural artisan. Admittedly there are some current programmes—such as the village polytechnics and the rural industrial development centres—which concentrate on the creation or upgrading of a skilled *rural* entrepreneur, and the village polytechnic movement in particular presents perhaps at times almost too marked a contrast between its 'successful' graduates who remain in rural self-employment, and the group who seek to use their skills in the city. The image of the self-sufficient village community is of course an attractive one, but any realistic programme for the diversification of rural skill must take some account not only of the urban draw, but also of the urban origins of several rural skills. The conventional picture of the city draining off rural craft is inadequate for what seems to be happening in Kenya.

The village of Githiga is in the Githunguri Division of Kiambu District. Like so many other small trading centres, it has little stone shops round three sides of a fenced-in market area. The built-up village proper only has two or three other adjacent roads with a scattering of bars, small hotels, retail and trading stores. It is almost equidistant between three much larger towns—Limuru, Kiambu and Githunguri—and so most of the day there is a little line of very second-hand taxis waiting to be filled up. The whole area is densely populated, and the planned village merges immediately into the surrounding homesteads. The climate is moist through a good part of the year, and the ground high enough for small-holder tea, and not too high for coffee. All-year-round pasture has allowed a generous sprinkling of grade cows, even though some of them remain in pocket-sized allotments. In general, therefore, there is a wide opportunity for cash cropping, and the fertility of the land is confirmed by its selling price of six to nine thousand shillings the acre. People in this area have had individual title deeds for their plots for over fifteen years now, and there has in this time developed rather a brisk market in land. The range of ownership is now rather wide, from people who have to hire plots to cultivate, to a group of substantial residents with good acreages of tea and coffee, and perhaps fifteen head of grade cattle. The other significant feature of its location is that it lies only a mile or two from what are still called the 'settled areas'—where ownership was reserved to Europeans during the colonial period. Their significance now is that in addition to peasant

cultivation there is a cash income available within walking distance of the village. These tea and coffee plantations and flower export farms, despite their low wages, offer large numbers of the poorer women, girls and men the opportunity of casual or more permanent labour as circumstances require. Thus the 'formal' sector is only a stone's throw from the village. There is obviously a great deal of difference between a village like Githiga on the fringe of the plantation sector and those camps, labour lines or communities that are physically located inside the plantations of Central Province or large farms of the Rift Valley Province for instance. Such estate communities may rent plots to cultivate, but are physically cut off from the local networks of transport, trade, skill and credit that are available to Githiga.

THE FORMAL CONTRIBUTION TO VILLAGE SKILL

The local school system is naturally the largest formal institution at the village level. There are in fact two primary schools serving the area around the village, but we shall be more concerned with the larger of these, Githiga Primary School, which is nearer to the centre of the village, and in 1974 had an enrolment of 1 050. There is also a *Harambee* school in the village which started in 1966, produced its first Form IV group in 1969, and had become double stream throughout by 1971. One of these streams was government-aided, while the other retained the much higher fees of self-help schooling. There was thus a relatively good coverage of formal education in the area, even though by no means all the children in the age group were managing to start — let alone to finish full primary school. This became evident in 1974, the year that the President announced that primary school would be free for the first four years. It was found necessary in almost every school in what had been thought the very highly schooled district of Kiambu to build at least one more Primary I classroom. Across the country, this meant that Standard I attendance had increased by something in the region of 50 per cent or more. It is worth mentioning this dramatic increase in 1974 because, if the enlarged cohort proceeded to complete primary school, there could be as marked a change in post-primary opportunities in six years' time as there was initially just after Independence. In such an event, the presently rather favourable terms of access to some kind of post-primary institution could deteriorate rapidly, and many then have to resort to less formal modes of training.

As long, however, as Kenya's primary schools (with the exception of those in the municipalities) have to raise funds locally to construct and maintain school buildings, a substantial degree of dropping out is to be expected. Githiga, for instance, levies a building fund of 100/- per

parent per year, and this is actually as high as 200/- for the first year that a parent uses the school. As a result, most of the 29 individual classes are housed in permanent buildings. The slowness of conversion from wood to stone or concrete has not markedly altered the ordinariness of such a primary school, but it has presumably meant that there is a layer of parents who find the building fund beyond their means.

Returning however to the issue of skilled employment in relation to the primary school, it must be admitted that there are considerable difficulties in determining a pattern. If primary-school leavers are traced only two or three years after they have finished Standard VII, it will be found that their occupations have not become clear. Some will still be repeating primary school in the hope of improving their grades, others will be midway through secondary, some will be taking a training, and others will appear to be working. We suggested earlier — in Chapter II — that not too much importance should be attached to some of the first jobs that a young leaver may be doing around the village. Often such young people are marking time until they are older, and it serves no useful purpose to categorise them as milkers, cooks, domestic servants. For this reason, it seemed wiser to examine groups of primary children who had already been out of school for seven or eight years.

However, in looking at those who left Githiga primary school in 1965 and 1966, we need to be careful not to generalise about the primary school leaver. These particular cohorts were obviously different from their predecessors, since they were some of the first leavers not to have been weeded out in the old colonial examination of Standard IV. They were not a pre-selected group, and in that sense they were similar to Standard VII classes of the 1970s. On the other hand, there was still only a single Standard VII class leaving Githiga's two primary schools in 1965, whereas in a few years' time there were four Standard VII groups coming out of the schools.

Even allowing for the very small sample of 93 from one village, a number of suggestions emerge that have implications for the wider generation of skills.

1. For almost 50 per cent of the leavers from these two classes, the issue of a job did not arise for at least two to four years' time, since they succeeded in getting into a government or *Harambee* secondary school. They did not necessarily achieve this immediately, but, after repeating and changing schools, a remarkably large number of these leavers did reach secondary school. We have suggested earlier that exposure to a full four years at secondary school does not *at the moment* dispose a student to start from scratch in acquiring skill in the informal sector. He may well take semi-skilled, *kibarua* jobs for several months, or even up

to a year or two, but he will tend not to be *self-employed* by the time he has been out of secondary school for three to four years.[2]

This is, of course, not entirely a matter of the students' aspirations, although this is important. After all, secondary school entrance does not only divide the younger generation; it is also a reflection of an existing division between those rural parents who can afford secondary education and those who cannot. Such a division should not be over-emphasised, since there are many very poor parents whose children enter and complete secondary through great sacrifice on the part of parent and child. Nevertheless, the slightly better off parent can afford to have his children repeating classes at the top of primary, two or even three years running, which has been shown to increase chances of success in the national examinations. Equally, if his child does not get a particularly good result in the next main examination, at the end of Form IV, the better off parent is more likely to have the connections and friends which are often so crucial when it comes to deciding among large numbers of candidates with indifferent qualifications. The child of the poorer parent, by contrast, may well reach Form IV, but he has to achieve a good result in the examination for his or her path to be straightforward thereafter.

2. Seven to eight years after leaving primary school, the group which are most likely to be *self-employed* are those who were not able to proceed to secondary school. But if we set aside for the moment the girls who got married and who are working on their own land, the majority of our sample are in formal sector employment. In fact the ratio of formal sector to petty self-employment is of the order of three to one. This general figure needs to be broken down somewhat, since these categories are by themselves not very illuminating. For instance, at the more successful end of the formal sector employees, there were people who had installed themselves in international firms (Metal Box, Gailey and Roberts, Dalgety, insurance) but at the lower end of the formal sector, the distinction between the two sectors becomes hard to insist upon. The group who were working on the two nearby flower export farms (one African-owned, one European) or employed with a rural building firm would be defined as formal sector employees, but an examination of their case histories makes it hard to separate them from the currently self-employed. There is nothing particularly formal about the bottom reaches of the formal sector — least of all the wages; and it could be seen that many of them had been in and out of the two sectors in much the same way as we noted for some of the carrier-makers in Chapter IV.

Similarly, if we list those who were actually self-employed in August 1974, we have to admit that a few of these had just begun to work on their own, and others have already gone back to employment since that time. Nevertheless, as a great deal is written, particularly in the advisory

165

literature, about the critical role schools could play in preparing pupils for self-employment, it may be worth pausing to examine a group of not untypical youngsters currently working on their own. The spread of their occupations is as follows:

watch repair	plumber
retail trader	driver/mechanic
woodcutter	windscreen and glass repair
prostitute/bargirl	slaughterer
currency note maker (jail)	petty scrap iron dealer
painter	farmer

What is significant about this very small list of occupations seven to eight years after school is not only their variety, but the difficulties it suggests in running prevocational courses in the upper primary school. By contrast, many of the official proposals for making the primary school more relevant concentrate on offering masonry and carpentry, and occasionally vehicle repair. Such courses are not in fact on offer in any of Kenya's primary schools, but reform proposals give the impression that these are the most obvious preparations for self-employment. As we pointed out in the last chapter, however, there are a large number of informal sector occupations such as candlemaking that the formal school system could not effectively provide. And even where there might seem to be a fairly standard body of knowledge to be communicated—in mechanics, carpentry and building—there would be no way of replicating the actual conditions under which rural skills are practised. These conditions naturally affect both the knowledge and the tools that are needed.

The greatest obstacle, of course, to the effective manipulation of the school system to communicate skill is that the whole of the Standard VII class have their sights fixed on secondary school entrance. Those who ultimately fail to enter secondary would be the likeliest candidates for prevocational training, since they are the group we find most frequently self-employed. But they are a group who only begin to be defined by failure in the national examinations, or failure to raise secondary fees, by which time it is too late to use the primary school.

3. Primary schools and career advice. It would be possible to construct a very complicated chart of informal sector occupations by listing the jobs of all the primary school leavers and drop outs from Githiga over the last ten years, but such a list is not itself illustrative of the system that shakes pupils out into the informal sector and makes them choose a particular skill within it. We shall come in a moment to examine the networks of informal training opportunities that perform this function. It may, however, be worth asking whether the formal primary school (even if it cannot train people itself for the informal world) could at least offer them more information than it currently does. At the present, there is almost no *career advice* of any sort in the average

primary school, beyond suggestions about various secondary schools. It would seem a good case could be made for constructing a directory of post-primary training opportunities, from village polytechnics, to secretarial classes, to youth centres, and it might be possible to refer to indigenous training arrangements. Some such directory, sponsored by a voluntary agency or preferably the Ministry of Education, would go a long way to aiding the thousands of primary leavers who aspire generally to have some relevant course, but have no way of picking amongst the various establishments that they hear are in Nairobi or in some nearby town.

4. Primary schools and the secondary technical graduates. The most direct way which the primary school appears to contribute to skill formation is by getting a few of its successful leavers into some of Kenya's eight technical secondary schools. Earlier on, we drew a picture of the impact of such technical schools upon the formal sector of the economy, and it would be perhaps useful to analyse what more particular kind of influence technical graduates exercise, when viewed from the standpoint of a single village community. It will be remembered that the technical schools are Kenya's only source of skilled apprentices, and that a great deal of planning has gone into reorganising both the schools and the NIVTCs in Nairobi and Kisumu so as to deal with the larger numbers that the industrial levy would bring forth. Since there are only eight schools for the whole of Kenya, there is not a very large group to analyse from Githiga alone; nevertheless, over a ten-year period (1962-1973) thirty-two Githiga students have been traced.

The pattern that emerges is remarkably close to the general picture of Chapter III. With one or two exceptions, all the technical graduates are working for large private companies, parastatals or the technical ministries of government. Predictably the roll call is, in the private sector, Kenya Breweries, East African Industries (Unilever), Metal Box, Gailey and Roberts, Campagnola; a scattering are in smaller firms: Aspro, Avery Scales, Vono, the motor firms, and a plastics company. While in the public and parastatal group, there are represented the Ministry of Works, the Railways, the Air Force, Nairobi City Council, Power and Lighting, the Maize and Produce Board. That is to say, all but one or two are working with institutions of the sort that have coherent training programmes of their own, and arguably, do not require a special technical school to act as a feeder. Secondly, despite this group of thirty odd all coming from the same village, it would be hard to identify any direct transfer or dispersal of their skill to the village itself. Ordinarily, young men who had been put through prevocational courses at school in metal, woods, electrical or building, and had then gone on to serve their time with firms might have been expected to act as skill models in some sense. In fact, as has been

stressed before, the Kenya version of Britain's apprenticeship programme does not produce men who remain as skilled craftsmen in the UK mould. A few years after they have left their technical schools, many of them are not noticeably different from their counterparts who attended good academic schools and found good clerical positions. The spin-off to the village from this formal technical skill is really negligible. If they are successful, they may have a car that needs sorting or a stone house that requires village labour to build, but the artisan skills that the school system provided are unlikely themselves to be in evidence.

The two from the group not currently in the large-scale formal sector do not really alter this general description. Both did have jobs with Nairobi firms of the sort mentioned above, but one found it temperamentally difficult to stay with any job, the other left his parastatal to become the clerk of a local building firm. Nor was his position clerk of works, for despite technical school, he appeared to have no practical experience of building at all.

This is not to say that the bulk of these technical graduates will remain in formal sector employment for their working lives. Some of them may well move to organising their own business once they have built up the capital and contacts. If they did this, they would be repeating the pattern of some of the very early NITD graduates from the 1920s and 1930s, who, after five, ten or twenty years on a white farm or in the Public Works Department, would come back to their home area and take to business. Indeed, in the village of Githiga there is an example of just such a man who graduated from Kabete in 1933. He did four years in various estates including Delamere's: he then took a break of three years in his village farming, before returning for three further years to the 'settled areas'. Once more he returned to the village and tried to establish a carpentry workshop and retail store during 1944 to 1947. Conditions were still against him, so he took a further ten years in the White Highlands, and only finally became a one-man village sub-contractor in 1957. Along with a non-Kabete stonemason, he was in fact responsible for a good deal of the building at Githiga primary school. So it could not be said with him that the expense of his training at Kabete had been entirely of benefit to the white farm and plantation sector.

Two further points should be made about the older and more recent Kabete artisans. In the colonial period, the structure of village demand made it very difficult to sustain, say, a village carpentry business. People like the man we have been discussing did attempt it, and when they did so, the actual conditions of work would not have differed substantially between a typical artisan position on a white farm and one in the village. The critical factor was mainly the irregularity of income in the latter. With today's Kabete people, on the other hand, there is a much larger differential between paid employment in Kenya's large scale firms and the life of a village *fundi* (skilled man). It seems likely

therefore that at least for the short term Kenya's contemporary apprentices will deploy their talents in the formal sector and if, here and there, they do return to their village area, it will probably be as employers of local labour rather than as skilled workers themselves.

Before leaving the subject of the technical schools viewed from the village arena, we may mention that the perception of these schools as a relatively secure path to formal sector employment infects Standard VII students in Githiga and surrounding schools as it does elsewhere in Kenya. Amongst four such boys entering technical secondaries in 1974, there were registered the following very high scores in the Certificate of Primary Education: A, A, B + ; A, A, B; A, A, A— ; A, A, A—. These kinds of marks stamp boys as the élite of the primary school world, and if they are generalised across the country, will ensure in four years' time an even more talented work force for some of the foreign-owned firms than they have had to date.

5. The other formal post-primary options: youth centres and village polytechnics. Githiga has had a youth centre for more than ten years. It has traditionally offered two-year courses aimed at some formal certification—in tinsmithing and tailoring. It also offers home craft. There was unfortunately not time to look in very much detail at its contribution to village development over this decade and more, but there was a distinct impression that student numbers had been declining so rapidly in the last five years that instructors had had to be removed to other areas. This is not necessarily the case in other parts of the country. But it does perhaps suggest that more research might be done on the relationship between youth centres and informal learning opportunities. If the latter are rather well developed in the immediate vicinity, it may be difficult for a conventional youth centre with its two or three courses to be sufficiently flexible.

This flexibility of provision was much more explicitly built into the aims of village polytechnics. Ideally, they were not going to follow the usual trade school model with carpentry, masonry and vehicle mechanics as the core of the curriculum. Instead, courses were to be mounted in response to the skilled needs of a particular rural neighbourhood; they would respond to felt needs, as well as offering courses in skills that were absent but promised to generate some local demand. And once a course had outlived its purpose, it would be dropped, and some other area explored. The conception was a worthy one, and was rather reminiscent of the multi-purpose role of the Jeanes Teachers in Kenya during the colonial period. But it was easier for a single Jeanes Teacher than for an institution like the polytechnic to remain sensitive to the changing pattern of local skills and employment.[3] A few outstanding polytechnic leaders did achieve this innovative, *ad hoc* approach to course provision, but it was generally easier to offer the traditional fare, appoint instructors and orient the

teaching to the acquisition of government trade tests. Plumbers, masons and carpenters could then be turned out in numbers unrelated to the needs of the locality. The difficulty of doing anything very different from this should not be underestimated. Indeed, the cost of offering a wide span of courses to small groups of students — and particularly the cost of dropping some and starting up others — can really only be met by taking advantage of practising craftsmen as part-time instructors, or by switching the emphasis from 'training' to work, as in the case of one polytechnic in Western Kenya.

> The principle of training as work is the essence of Shadrack Opoti's conception at Soy. . . . In this conception the polytechnics are not a training institution or a school but a support base for outside workers. Trainees never leave the institution as such because they have never joined it; thus the concept of 'leaver' becomes an irrelevant one. Trainees join a work group rather than the polytechnic itself. . . . Training simulates work conditions as much as possible and lasts only as long as is necessary for the acquisition of the skill in question. Thus for two of the most imaginative activities which have emerged from Soy — systematic bee-keeping and rural bakeries — the training period is two weeks.[4]

At any rate Githiga village does not itself have a polytechnic, nor is there any in the immediate vicinity that could be reached by village residents. The absence is not perhaps surprising in view of the apparent decline of the youth centre, but it underlines the point made earlier that the village polytechnic movement has not yet localised itself as an obvious object of self-help finance. This is not of course a question of poverty, but of priorities, since the village was very ready to fund its own *Harambee* school back in the late 1960s, at a cost much beyond what a polytechnic would have involved. In addition, it might be suggested that the comparative lack of interest in this level of institution derives from the unemployment of primary school leavers not being as glaring an issue as some literature might allege. It is admittedly difficult to define or measure rural unemployment with any great certainty, but there is in Githiga at least little impression of a 'massive and mounting rural unemployment problem' such as Coombs has referred to as recently as 1974.[5]

As we shall see, young people circulate a good deal from job to job — which may not say much for job satisfaction. Equally, however, it suggests that employment of some kind is not difficult to come by that they find themselves afraid to move. If the problem is to be identified at all at the village level, it resides more in the Form IV leavers than those from Standard VII. For instance, from the small sample of 1965 and 1966 leavers from Githiga, there were only one or two Form IV boys who might conceivably be called unemployed. Beyond these, there is a group of more recent Form IV students who have not been gainfully

employed for one or more years. Almost by definition, these tend not to be children of very poor parents; in fact, as in the West, they are likely to come from the better off families. They may therefore be quite smart and travel to Nairobi quite frequently to see if anything 'turns up'. What seems to distinguish them from primary-school leavers is that they are prepared to mark time for a year or two, and, as we suggested in our contrast of primary and secondary 'styles', they are much less ready to do casual (*kibarua*) work in the village.

Returning, then, to the issue of formal post-primary provision, we must say for Githiga at any rate that of the several hundred skilled people on whom we have information very few indeed came through the youth centres, village polytechnics, the National Youth Service and the other programmes of this type. The majority get access to skill and work through less orthodox channels.

INFORMAL ACCESS TO SKILL AND WORK

In contrast to the two or three courses offered by a local youth centre, we do not mean to imply that informal access to skill is a highly diversified, flexible alternative. In fact, some of the current phrases, such as 'indigenous learning system', 'informal learning opportunities' convey an impression of *organisation* that cannot be supported by the available evidence from Kenya. There may well be ten, twenty or thirty different types of petty production being carried on at the village level, but obviously this is no guarantee that a student can get access to them. Clearly a good deal more work will have to be done in depth on village skills, before it will be possible to describe them as a system. But for the moment, we shall outline what appear to be some of their structural features, even though this must be rather tentative.

Range of skilled activity (informal)

Before examining the question of access and training, it may be useful to give an indication of the span of skilled work we meet within Githiga. This list is not exhaustive by any means, but covers most of the different categories:

tailor (sewing machine)	knitting-machine operator
blacksmith	tinsmith
shoemaker/shoe repair	watch repair
furniture maker	carpenter/housebuilder
stone mason/builder	mechanic
driver	radio repair
metal windowframe maker	bicycle repair
sign writer	barber
painter	plumber

Naturally the number engaged in these trades varies very substantially. Masons, carpenters, mechanics and tailors predominate, while others, such as sign-writing or windowframe making, will only have perhaps a single worker and a trainee. Since this is so, there is clearly more chance of getting into some sort of relationship with the former, as a trainee or casual worker than into the less common lines. This raises the question, however, of how these various skill options are actually viewed by those seeking employment. Are they viewed equally as trades worth training for? Are some of them seen rather as casual ways of making a little money, without necessarily any particular commitment to the trade? Is the village version of this skill or trade conceived of as fundamentally different from working as an artisan in an Indian or small European firm in the towns? Can a line be drawn between skilled and unskilled village work?

Open-access training

A number of these questions will be taken up in looking at particular trades a little later, but at the general level it seems as if access is much easier in some lines than others. Occasionally, it appears that the training function almost outweighs the productive aspect of the business, with the owner taking on many more trainees than he can possibly generate work for. It is perhaps easier to visualise this commercialisation of the training aspect taking place in a larger town, but there is certainly one very clear example of this pattern even in a village like Githiga. It is organised around a single car mechanic who has no less than nine trainees, all of whom appear to be paying around 400 shillings for their course. This informal sector training is not taking place in a large garage with a variety of second hand cars for practice purposes, but on a fenced-off portion of open ground with no permanent building of any sort. Like the system we noted in Chapter II, the trainees are not exclusively drawn from the immediate area; a few come from a hundred miles away in Nakuru. This particular case illustrates the rapidity with which training can be reproduced in the informal sector, for the young man who organises the activity has not been many years out of a similar sort of training himself. It also affirms the substantial *schooled* element that is taking advantage of this opportunity. At least three of the young men are Standard VII, two reached Form II, and one was from Standard V.

It seems difficult to characterise this particular arrangement as a restrictive apprenticeship system in which trainees remain with their master for an extended period. On available evidence elsewhere in Kenya, they are unlikely to remain much beyond a year, and there would be no sanction invoked to make them stay longer — certainly nothing along the lines of the Nigerian ceremony of apprenticeship

completion. In fact the system seems much closer to paying for a typing course, for instance, than it does to some of our conventional notions of craft protection, or master/apprentice relations. This analogy of the typing or secretarial course may well be quite close to the mark, for in a country which has no long tradition of divisions between clerical, skilled manual and unskilled jobs, there is no reason for any skill not to be exchanged for money if there is a market.

The existence of such a 'garage-school' even in a relatively small centre like Githiga is itself indicative of attitudes to skill amongst school leavers. It suggests that lacking direct access to employment after school, many young people are aware that they need a relevant 'course'. Some may have succeeded in getting taken into firms as casual workers, but many will have found in a spell of job seeking after Standard VII that employers often require experience. This presents them with the classical dilemma of the job seeker; you cannot get a job without experience, and you cannot get experience without a job. In this situation, the next best thing is to get on to some course that will provide relevant training. At the moment this is still more common at the secondary school level, where after an initial failure to find a job, young people make one last plea for course fees from their parents and launch themselves on a variety of disciplines: diplomas in salesmanship, accountancy, surveying, technical qualifications (sometimes by correspondence), radio and TV engineering and servicing, refrigerator repair, business studies, secretarial and copy typing. This world is not entirely without standards and intellectual rigour, but few school leavers, particularly at the primary level, have the knowledge to tell a poor institution from one whose training has some value. This village level garage school differs in many ways from these larger institutions with their classrooms and certification, but it feeds upon the same widespread determination of young people to acquire vocational experience. And this is something, as we have shown, that it is almost impossible to acquire through the state's technical education services.

It could be argued that these very uninstitutional garage schools offer a more relevant training experience than a handful of high cost technical and trade schools — or at least more relevant to spreading across the country rough and ready mechanics, who are used to operating without premises and sophisticated equipment. Without a wider survey, it would be difficult to know whether this category of training is itself expanding. Certainly, this particular one is the first of its kind in Githiga, and was only started in 1974, but there are others not very far away. For instance, for at least six or seven years would-be car-mechanics have been going from Githiga to Githunguri nearby to acquire garage training with a certain mechanic, and a few have gone to a similar garage in Limuru, ten miles in the other direction. There is an interesting question about the employment opportunities for people

trained in this mode, but we shall return to this when we examine, a little later, the interconnections of village and urban employment for car mechanics.

Other varieties of access to village skill

The example of the garage school was deliberately discussed early, so that it should not be thought that there is a uniform village style of skill acquisition. A few of the other main arrangements will be mentioned now which seem to apply more or less widely in petty production. Apart from the building trades which will be analysed in a separate section, one of the more obvious skill models in Githiga is Mutang'ang'i Kagotho, whose machine-making was discussed at some length in Chapter IV. For this reason, we only note here a few features of his training function that are relevant. The first and most important point is that unlike the garage school his training has not been put on a commercial basis, and this in turn stems from his concern with production. Labour is required usually for a series of limited runs on his hand-made machines. Much of this is not particularly heavy work, so it is quite suitable for primary school children, in Standard V to VII, or for secondary school boys during vacations. The means of production determine the labour and training requirement; thus it is not perhaps surprising that there are no young people with him who have paid three or four hundred shillings to be engaged. It is not known whether young men have approached him to be taught his style of blacksmith work for a fee, but certainly at least one of the Nairobi-based Githiga smiths had turned boys away who wanted to pay. His reasoning is interesting and indicates the beginnings of how possession even of limited machinery can alter attitudes to training: 'If I take on somebody, I will want him to do the heavy, dirty work—drilling lots and lots of holes with the hand-brace; so if the father has given me four hundred shillings to teach his son, the boy will soon complain that he is not learning anything'.

However, as was pointed out in the earlier chapter, even without an explicit commitment to train, certain young boys do definitely progress beyond being operatives. Some who worked on and off in his yard for a number of years have learnt the basic principles of machine construction, and have used these to good effect in the urban areas of Burmah, Gikomba and Mathare Valley. The process seems little different from that which operates in Indian building firms for instance. The talented boy who is initially hired as a casual labourer gets progressively trusted with more and more of the important operations in the yard; he may help to repair a machine, or cut a new gear. After a period he realises that he can build one himself. We have here, therefore, the selecting-out of originally *kibarua* people that we

noted was widely used in the more formal sector of the economy also.

We should perhaps be careful not to overemphasise this process whereby young boys move from *kibarua* workers to become skilled and self-employed. This is certainly a very dramatic and widespread phenomenon both in the villages and towns. But naturally there are other young people who move less rapidly to acquire skill and better wages. This may be illustrated in the case of two ex-trainees of Mutang'ang'i presently working in Nairobi. They worked together in Mutang'ang'i's yard in 1965, although one was fully ten years older than the other. They both started there at the same wage of approximately 40 shillings, but in the next ten years their paths had diverged very markedly. The older man had run through a variety of skilled informal sector jobs — building shanties, making furniture, dealing in charcoal — and had ended up by purchasing two machines for making fence-post nails, and employing two labourers. The other had remained with Mutang'ang'i for seven years, and his wages had risen to 6 shillings a day by the end; he then took two further spells of employment before becoming one of the nail-maker's labourers — at 5 shillings a day. He had by no means resigned himself to this kind of employment; in fact by 1974 urban informal sector wages had made him determined to be self-employed.

Returning to the village, we should stress that industries on the scale of Mutang'ang'i's do fulfil an important function for the young people from poorer homes; they can get access to some skill, and, most critical, get a little money at the same time. This latter is of course the main drawback of the institutional ways of acquiring skill — that the learners do not get a subsistence allowance during their training. As a consequence, the children of the poorest families — particularly those whose fathers are dead or who have no older brothers — cannot afford not to be paid at least something whilst they learn a skill.

Before coming to examine in greater detail a sample of the other larger village industries, there are a few points that can be made in general about the mode of operation in many of the smaller productive enterprises.

Non-village origins of village skills

We have suggested that it really is not helpful to think of the village as a unit that generates its own skilled people. Historically, a good deal of skilled village manpower has been produced in the formal sector of the economy. Most of the older generation of village *fundis* were drawn into wage labour in the white plantation and large farm sector, or the Indian intermediate firms. Skill was acquired predominantly with Indians in Nairobi and the Rift Valley towns of Nakuru and Naivasha, or in fewer cases from some of the work attached to tea and coffee estates nearby. A good number of families from this area of Kiambu migrated further

afield to work as squatter labour for the large mixed farms of the White Highlands. As conditions for squatters deteriorated in the 1940s, they began to come back to Central Province, and many were later forcibly evicted from the Rift Valley to their place of origin. Similarly during the Emergency, large numbers of skilled Kikuyu, working for Indians or in the public sector in Nairobi, were villagised (with or without a period of detention first), and for several years after the official end of the Emergency, it was almost impossible to get permission to migrate to the town. In other areas of Kenya, even without this period of compulsory villagisation, the strength of the peasant mode of production has meant that urban workers regularly return to their small holding, and, in between jobs, will often spend a year or more combining farming with some type of non-farm skill. As a consequence, one source of skill for the younger generation is these older *fundis* who have retired from wage labour to self-employment in their village.

Even if we look briefly at the younger skilled group in the village, we can see that a number of them acquired their competence outside. We have already mentioned that mechanics, until recently had no garage school in the village, and went to Githunguri, Limuru or Nairobi. Again, very recently, the first radio repair man has arrived back in the village after acquiring training in Limuru. Similarly two other non-traditional skills — using knitting machines and making metal window-frames — have just arrived in Githiga. In fact, the first metal windowframe maker only came in mid-1974, and interestingly enough seems to be the first Luo craftsman to practise in this exclusively Kikuyu village. He had himself become skilled with Indian workshops in Nairobi, but had been invited by a Kikuyu employed in the public sector to come and start a joint business in Githiga. Within a few weeks he had a Kikuyu trainee, paying two to three hundred shillings to acquire this line of skill. In the case of the knitting machine girl, the skill had been bought as far away as Kericho District in the Rift Valley, and the girl had first hired then bought her own machine. And the same would be true of a number of the other skills.

From the point of view of rural development policy, it is obviously a promising sign that, contrary to popular opinion, so many young people are prepared to try self-employment in their local areas. As should become clearer in a moment, it is not the case that having set up in the village, they necessarily stay there. But there are sufficiently strong rural ties and just sufficient of a market demand for people to try village entrepreneurship. This last must be one of the main distinguishing features between the older and younger generation of skilled worker. The older people stayed for much longer periods in formal sector employment during the colonial era when conditions for rural self-employment were very unfavourable. Now the pace seems to have quickened very dramatically, and young people move very rapidly in

search of better opportunities than the lower reaches of the formal sector seem to offer. With the rise in the productivity of many rural areas, village self-employment is at least one option that young people are prepared to consider.

Interaction between rural and urban informal sector activity
As a corollary of what has been said above, it may be argued that the informal sector production in the village has to be understood in relation to similar activity in the urban and small town sector. Of course Githiga's petty workshop sector does not relate in any general way to the urban sector; rather the network is based on those Githiga people who operate in Nairobi and other cities. Just as we saw with the making of oil lamps for some of the Embu producers, so also Githiga migrants to the city know where their village mates are working, and can get some casual work on a daily basis if need be. As explained in Chapter IV there are a number of urban counterparts to Mutang'ang'i's yard in Nairobi, and they provide a natural base for boys connected to them at home. There are also a group of Githiga mechanics who work out in the open in one of the main concentrations of informal car repairers in the city. And there are individual carpenters and tinsmiths working out of the locations in Kawangware, Mathare Valley and Grogan Road. This is not to say that Githiga's urban connections can be satisfactorily divided into informal and formal sector workers. Boys who have worked or trained as village tinsmiths will know where Githiga smiths have established themselves in the city, but they are just as likely to have contacts with some of the Indian or European firms where there is a tradition of employment from their village.

For this reason it is definitely misleading to set up the informal and formal as rigidly separated from each other. A recent article drawing on Buganda data has set forth the two sectors in an extremely polarised fashion.

> There are two distinct employment sectors open to these young people, the formal sector and the informal sector. The two sectors have different characteristics, different recruitment criteria and different rewards.[6]

As we pointed out in Chapter II, however, although it may be acceptable to use the term informal sector as a convenient shorthand, many features of its informality extend deep into the allegedly formal sector. And not least, as we shall see shortly, in matters of recruitment.

Skilled and unskilled in the village
In designing new approaches to rural skill creation, a good deal more work needs to be done on the position of the unskilled. There is considerable interest in examining skill formation in its indigenous mode, to see if it can be broadened, and enriched. Indeed the

impression also is sometimes given in the literature that it is the design of the various skill programmes and projects of different countries we need to examine, to discover which might be most relevant in rural areas. This concern with the specifically skilled groups (as defined along European lines) neglects the possibility that for many people the apprenticeship to skill is through unskilled work. An important point about the origins of many informal sector skilled people is their time spent in casual and unskilled work — as diggers, turnboys for taxis or lorries, milkers, domestic servants, tea and coffee pickers. This work is critical because of its impact upon the *motivation* for acquiring skill. Such occupations are widespread amongst the children of low income families, and the low wages and conditions associated with them adjust them to acquiring a skill under similarly rigorous condition. What therefore may seem admirable about the *low costs* of transferring skills to young people in the village must to some extent be seen as conditioned by the previous experience of the trainees. It makes it difficult then to draw up a typology of Kenyan village skill acquisition as a system of trade-profiles complete in themselves. One reason the skills are transferred so cheaply is that the skilled are in fact very close to the unskilled. The poverty of the process has constantly to be borne in mind since a good deal of what seems distinctive and significant about Kenya's 'system' — its improvisation, hand made tools, low costs and speed of skill reproduction — is actually determined by lack of choice. We have therefore to be rather careful about isolating the skill acquisition stage of many of these young people, and removing it out of the wider context of income and opportunity in the village.

A TYPOLOGY OF VEHICLE-RELATED EMPLOYMENT

We come now to look in some more detail at how some of these features of access to training and employment work out for particular trades in the village. The motor trade is especially interesting since it offers many insights into the relation of formal and informal employment. In this context, however, formal sector employment in the motor industry does not refer to employees who have gone through technical school and the official apprenticeship, but to workers in the big motor firms who typically have become skilled in other ways. The true UK style apprentice is a very rare animal in the motor trade indeed, since there were in 1974 for the whole of Kenya just a little over a hundred in training for motor vehicle maintenance. These other categories, however, may be divided up into a series of inter-related institutions which link up Githiga's interest in the motor trade at various levels. Principally these are:

At the village level	garage-school and village mechanics
	part-time mechanics, and retired mechanics
	taxi-drivers to nearby towns
	neighbouring garages and garage-schools
	mechanics and drivers on nearby settled areas
	the lorry owners and their turnboys
At the city level	the large-scale European motor firms
	drivers and mechanics in public sector service
	mechanics in Indian firms
	an African-owned driving school
	wasteland mechanics.

The elements have been set out in this way to demonstrate some of the difficulty involved in taking one item, such as the village mechanic, and considering in what ways his training, his equipment and his prospects may be improved. It is being suggested that if the intention is to aid the informal sector, then it is necessary in this instance to see how the village mechanic and his urban wasteland counterpart interlock with parts of the formal system. One general example will suffice: it is common to read proposals for how the informal sector may be stimulated to expand by encouraging the formal sector to *subcontract* some work towards it. But what is less widely understood is that the informal sector is already intimately associated with formal employment. (a) A very great deal of the business of urban informal mechanics comes from people in formal jobs who expect to get the same repair or replacement done at half the price they would pay in the large-scale motor firm or official agent. This not only takes advantage of the cheaper labour and lack of overheads, but also of the informal sector's rather unconventional access to genuine spare parts. (b) People in salaried positions also use the actual employees of the large-scale motor firms to do work informally, out of hours. This is openly acknowledged, and often favoured on the grounds that, apart from being cheaper, it pushes some of the profits towards the local man rather than the multinational firm or its subsidiaries.

Going back to the village mechanic and his origins, we may trace much of the early training opportunities to one or two men who acquired their competence in the 1920s and 1930s as driver/mechanics on the white estates. One of these skill models, Dedan Mbiro (now retired), trained three of his sons in the village, and also two nephews. As there was little work during the 1950s in the rural areas, not surprisingly his trainees dispersed to employment—to Indian garages, white estates and one as far as Uganda. This was not a final dispersal for all of them, for with the rapid post-independence development of trade, roads and transport, a first group of mechanics offered village car repair from around 1963-65. At least two of the ex-trainees reappeared at this time, to become village mechanics.

179

Village repair was itself associated with the growth of private car ownership, and of second-hand taxis that served the local small towns. Seven or eight different men came together in small groups or as individuals over the period of the middle and late sixties. None of them was practising in the village as a mechanic in 1974, but it is instructive to see their redispersal, based as it is on rural skill and influence in the formal sector.

This skill was either from the older Githiga mechanics, or, in the majority of cases derived from the nearby Githunguri garage-training. In this sense it was strictly informal, and yet, even after very short field experience, some of them were able to move into firms like Marshalls (the Peugeot agent), Blackwood Hodge, and a large African-owned driving school. Of course, in mentioning moves into large formal sector firms, we are no longer really discussing the issue of the training *per se,* since there is no direct connection between the quality of instruction at the Githunguri garage and access to some of these large motor vehicle firms. It is essential to have some such prior experience, but only as a precondition. There will also need to be some way of relating to the firm, through a village patron already established there, or through village mates. In fact, the system that we noted in candlemaking in the informal sector, whereby two tiny rural areas produced the bulk of Nairobi's candlemakers, has its counterpart in the formal sector. This means that Githiga's urban mechanics are not dotted individually across Nairobi's industrial area, but are clustered in pockets. At least seven were attached to a driving school, five were in this firm, three in that and so on.

We have therefore a web of patron-client relations that intersects with the process of skill creation which has been described. In many cases access to a particular firm (if there is a vacancy) is not due to another mechanic or skilled man on the roll, but to a villager on the clerical, supervisory or junior management side of the company. Often, however, it is due to the presence of a long-serving trusted *fundi*— particularly in the Indian firms—whose own character and recommendation is taken as a kind of insurace for the new entrant. It will be remembered from Chapter III that given the surplus of job applicants, many employers in the formal sector have delegated the engagement of labour to foremen, line supervisors, or personnel managers.

It can be appreciated in the light of these recruitment patterns that the development of informal sector skills at the village level can be very much affected by employment opportunities in the formal sector. Nor is it being suggested that some access to the large-scale firms somehow undermines the village mechanic. Indeed, it might be argued that it is a positive encouragement to the village sector. For one thing, large numbers of Githiga people have used the driving school to get their

driving licences. Secondly, a mechanic in a large motor firm is in a good position to buy one of the cheaper second-hand cars that come in the way of the firm. In at least two cases recently, such mechanics immediately left the firm once they had their old cars, and turned to the village taxi trade (*matatu*). A good number of the fifteen odd cars amongst the village's *matatu* drivers may have arrived through this route, and this in turn can produce more work for the trainee mechanics of Githiga's garage-school. The pattern therefore is not uncommon of: informal training, then informal self-employment, then formal employment, finally informal self-employment.

There are just one or two more strands to the description of motor vehicle skills that require mention. In addition to the village opportunity of acquiring competence, there is also a Nairobi-based group of wasteland mechanics from Githiga area. Here, too, there is the possibility of getting skill in exchange for a training fee of 200 shillings although the training function seems to be subordinate to production. It was not possible at the time to look very carefully at the enterprises amongst these Kaburi mechanics, but at first sight it seems surprising that the fee mentioned is rather lower than the more rural areas. One of the principal advantages of working and training in this large concentration of mechanics at Kaburi is that the trainee can get access to experience in lorry repair, whereas at the moment very few lorry owners will let village mechanics repair their vehicles.

The mention of lorry owners introduces a final aspect of these rather involved relationships. By 1974 there were some ten lorry owners in the immediate Githiga area. They will presumably have particular mechanics to maintain their vehicles in Nairobi who may or may not be originally village mechanics. But even if such maintenance is still primarily carried out in Nairobi, there may shortly be a handful of ex-Kaburi mechanics offering lorry repair in the Githiga area — at least if this work follows the pattern of other informal sector industries.

In summary we may say that skill in vehicle repair presents a very different picture from candlemaking, and this derives principally from its variety of relationships with the formal sector. In candlemaking it was not possible to cross over and practise the skill in the formal sector; a move to the formal sector meant abandoning lamp-making in favour of something else. On the other hand, in automotive repair skill, the formal sector certainly did not seem to discriminate against mechanics who had been trained in less conventional ways. The training at Githunguri allowed people (if they had the contacts) to practise in the foreign-owned sector, and equally offered them the basic skills for practising up country, without access to modern factory conditions. It faces therefore potentially two ways, whilst the group who enter motor vehicle mechanics in a technical school are aligned only towards the formal private and public sector.

TRAINING IN THE BUILDING TRADES IN THE RURAL AREA

The main building trades in Githiga are different again in certain important respects from the situation we have described for car repair or blacksmith work. For one thing, there are really quite large numbers involved, the majority to be found in the fields of masonry and carpentry. Electricity has only very recently arrived in the village, and there has not yet developed sufficient work in the immediate area, although a Githiga electrical contractor has established himself nearby in Kiambu. There is a similar picture for plumbing, since the village is still without piped water. As a consequence the handful of plumbers from the village work on the nearby white estates, the City Council of Nairobi and in subcontracting in other parts of the country. Painting, too, is still primarily used outside the demands of the village itself. We shall concentrate therefore first on the group of some fifty masons and carpenters from whom we have detailed information, and conclude by examining a building firm which is owned by Githiga people and has a significant number of its skilled workers at any time drawn from the village.

The nature of the building process affects the training system very conspicuously. For instance, there is not the same possibility of a building-school emerging as there is with mechanics. While a customer's car is in a backyard, any number of people can in turn strip and reassemble a component without undue risk to the vehicle or waste of materials. This can be done outside hours also. Work with concrete, stone-shaping, roof trusses and wooden window frames is simply not amenable to *practising* on the job. Skill is transferred rather more slowly by the *fundi* or *mistri* letting his better helpers take more and more of the work on. Although there is not the same scope for the commercialisation of the training function, this is not to say that apprenticeship or informal learning need be protracted. Usually payment is less common than selecting out the better casual labourers, but it does still apply in more specialist activity such as furniture making.

The historical origin of the building trades is not itself very different from that we sketched for car mechanics. In fact, it is probably true that the first permanent stone buildings—the shops round the market— began to be constructed in the middle 1940s, at about the time that cars and pickups also made their appearance. These early masons and carpenters (Samuel Gachuiri, Samuel Kiboro, Waweru Kahoro—to mention only a few) had gained their skills in the white estates or from Indians in the Rift Valley and Nairobi. It is interesting, from a historical perspective, to note that the beginnings of this Africanisation of building skill were going on at almost the same time as we noted for candlemaking. The first generation of largely unschooled Africans had begun to set up on their own in a whole range of small activities by the

1940s, and, as with lamp-making, they were prepared to pass on their new knowledge to others. Several of the earliest masonry trainees paid 120 shillings in 1949-50 to be accepted. And it is known that one of the earliest carpentry trainees had to pay 200 shillings and 'one fat sheep'. These rather large amounts if accurate, suggest that building skill was indeed a much sought-after commodity in this period just before the Emergency.

It is incidentally worth making this point about the market demand for technical skills in the colonial period. It might otherwise be thought from a reading of standard works on the history of African education that technical and trade schools kept collapsing because of African hostility to acquiring skill. Since basic skills were not being gained through the formal school system, there is not much to be learnt about African attitudes in the colonial period by analysing the fate of formal vocational education. Amongst the group of fifty Githiga builders before us, there is in fact only one who attended a formal trade school.

This group of skilled men can in the modern period be used to show something of the same network of employment opportunities as was constructed for car mechanics. There has, for instance, been a clustering of Githiga carpenters in some of the large firms of lorry and bus body-builders in Nairobi. In addition, there is a great deal of movement in and out of self-employment. Conditions in some of the large-scale foreign-owned construction companies are by no means as attractive as some other parts of formal sector employment, particularly as labour subcontracting which we described earlier has tended to make the rewards from working on large Nairobi sites not so very different from doing a small contract in the village.

Skill models and skill profiles

In view of the importance of the building trade in rural areas, it may be worth discussing briefly the fields which preliminary research might suggest are worth examining in some more detail. One of these is the question of whether rural building skills are in some way qualitatively different from those associated with formal sector firms in Nairobi. The reason for attempting this is that the NIVTCs in Nairobi and Kisumu do currently offer skill upgrading courses to some of the building trades. Such skill improvement courses—like official apprenticeships—are at present only of interest to a small number of large bodies, such as the Water Department or the various city council employees, and successful course completion is often linked to a salary increase. If, on the other hand, the technical education services of the government desired to offer relevant upgrading to fully experienced *fundis* who have been working on their own or for a small African contractor, the question would soon arise as to what precisely they should be offered. And this in

turn would relate to a fundamental ignorance about the skill profile of a rural plumber, electrician, mason or carpenter.

1. *The stages or timespan of training.* It is quite possible for any of these building trades to construct a skill profile, demonstrating how soon a trainee plumber, for instance, learns the use of certain tools or makes certain fixtures. It would be found that learning plumbing on the job deviates very markedly from the methodical progress through the various materials of a formal training course.

2. *Improvisations in tools and techniques.* It would also be found that a rural plumber, lacking the range of die-machines and other tools available to a city firm, makes a number of standard improvisations. Certain components, such as reducers or nipples, are improvised more or less satisfactorily, pipes are bent without bending machines, and a limited range of pipewrenches only are used. The asbestos waste pipes are tested for leaks without the usual equipment.

3. *The provenance of the tools.* These too could be readily listed, and again it would be useful to note which are imported and which made locally. Broad and narrow chisels used by plumbers are exclusively the local handmade variety. If more were known about the barriers to the possession of certain 'standard' plumbing tools, it might be possible realistically to examine the potential of local manufacture.

The value of this sort of exercise would by no means be theoretical. If done sufficiently rigorously across a whole range of trades, it would begin to produce information on skill formation and rural technology which would be of great advantage to those formal institutions such as the village polytechnics and rural industrial development centres. Equally, it must be said that the exercise might very well be of more value to the NIVTCs and technical schools of the formal sector than the other way round. There is admittedly in a country like Kenya a need for a certain amount of very sophisticated plumbing (although most of this is not executed by technical school graduates). But there would seem to be a greater obligation upon the formal sector to understand and analyse the methods of the rural sector, and of the Indian firms from which the rural artisans have derived their craft. For instance, the almost total lack of interest by Indian plumbing firms in formal apprenticeship and in the NIVTC courses must to some extent be balanced by there having been no attempt at all by the formal sector to consider the process of Indian skill formation in Kenya.

There is then the question of policy towards the village skill models or *mistris*. Some of these have over a period of twenty to thirty years played a key role in transferring skill to younger men, and in at least one case in Githiga, the quality of their work is of a very high standard indeed. There are, however, a number of ways in which their value to their community and the building trade might be enhanced.

1. Many such men have a minimum of formal education, like the Indian *mistris* they learnt from, but they could nevertheless benefit from short post-experience courses on interpreting basic drawings, and filling in tender forms. These could be run at district centres in the same way as traders' courses have been for many years, and would doubtless attract considerable interest. Some such extension role might be attached to the NIVTC and would allow it to implement in a small way its desire to relate more closely to rural skill formation.

2. Some of these *mistris* could also play a useful part in the village polytechnic and other institutions, once they were no longer working full-time in their trade. Already many local craftsmen do participate in polytechnic teaching, but the majority are government trade tested artisans. If it were felt necessary to employ people who had got some form of national accreditation, it would be worth investigating whether trade tests could also be awarded on the basis of quality of work done in the rural areas. Naturally the costs of decentralising trade testing and giving it such a practical focus would be expensive, but then it could be argued that the present highly centralised system, with a very marked *academic* content for the higher grades of trade test also has its costs. It effectively isolates many rural skilled men from national recognition, and is open to some abuse, since it depends on one-off success in an examination. If NIVTC extension personnel were to visit Githiga and examine the blacksmith work of Mutang'ang'i, the masonry of Samuel Gachuiri, or the garage-school, they might well decide that one at least of these men was working at the level of government trade test, grade one. If this were done gradually in different parts of the country, it would not by any means encourage a drift into the big companies of those graded. It could very well bring them more custom locally, and, in the case of an institution offering inferior instruction at an inflated price, it could help to protect the primary school leaver and the community from an over-commercialisation of training.

This would be the sort of way that the central government could relate positively to the informal sector, incorporating it gradually into a national system, but without diminishing its dynamism. It would also be a welcome example of those types of educational reform that we mentioned in Chapter I — awarding accreditation for standard of work rather than performance on a partly academic test.

TRAINING IN A MORE CAPITALISED RURAL CONSTRUCTION COMPANY

The barriers to some of the village *mistris* expanding their scale are not only those we have mentioned, such as the rudiments of tendering for a

formal contract, but also access to credit. This is not an absolute obstacle in Kenya, and there have been two main ways in which it has been overcome.

1. Many of the growing number of African builders have compensated for lack of capital by taking labour subcontracts, in which, as we showed in Chapter III, all the materials are provided by the main contractor. Very often such men or groups of men are given labour contracts after working with Indian or European contractors long enough for their work skill and organisation to be respected, and they now span a variety of building operations — especially steel fixing, shuttering, plasterwork and painting. By judicious organisation of the labour force, capital can be acquired without the lengthy process of negotiating a loan. The system is not much help, however, to *mistris* in the rural areas, for the large firms are seldom involved in rural building — except in the sphere of civil engineering.

2. The other way that the capital constraint has been eased has been through the operation of the National Construction Corporation (NCC), a joint venture of the Kenyan and Norwegian governments which is designed to foster indigenous African contractors. The main technique for doing this has been the effective reservation to NCC of all government contracts beneath 400 000 shillings. NCC has then been in a position to allocate these to its list of clients, either by competitive tender or by negotiation.[7] The Corporation has also granted quite a significant number of direct loans to its clients, and has deployed extension staff to oversee and advise on the site. The interest in becoming a successful client of the Corporation is amply demonstrated by the figure of approximately 900 names on its lists in 1972. Typically, clients who do get awarded a contract will be engaged on the construction of local administrative offices, extensions to secondary schools and other public sector building.

Analytically, therefore, there are really three sorts of smaller African building contractor: (a) the labour subcontractor to large urban companies; (b) the clients of the National Construction Corporation; (c) the independent rural (and urban) builder. The first and the third really have more in common than the second, since they are forced to be more or less self-reliant, and have to operate without any of the protection afforded by NCC. Of course there is no reason why local *mistris* should not register themselves as a company and tender along with all the others, for NCC contracts, but in practice many of them will not. We thus have a situation in which local contractors who at the moment build very substantial primary schools, *Harambee* schools, churches and a scattering of local stone houses with very slender profit margins, since every cent is collected from village people, find themselves effectively cut out of the next level of building operation. In

THE TECHNICAL FORM OF A KENYAN VILLAGE

due course such local builders may come into their own if investment in the rural areas accelerates, and more people convert from semi-permanent to permanent buildings. At the moment, however, it must seem to local builders that in Kenya as in other countries it is the government contracts that afford a really significant return. Again, therefore, we find as with so much else in the informal sector that what might appear its obvious path of development is often blocked by some mechanism of the formal sector.

Having said this much in general about the varieties of smaller contractor, it may be worth glancing at the recruitment and training facilities in a single firm that has received a number of NCC contracts in the last two years. The work force during the summer of 1974 in this firm was fluctuating around 30 people, and it was managed by a man whose previous education and employment may well not be unique amongst NCC clients. He had the considerable advantage of just having finished his secondary education at Independence, and had attended a technical high school. Despite the name, the school was oriented to science subjects and did not involve a practical or prevocational curriculum. He was then recruited into the Ministry of Works and acquired some field experience from checking the progress of various contracts. Shortly he was able to offer advice to his older brother who had come up to contracting by a quite different route. The latter had gained his experience working for Indian firms in Naivasha and the Rift Valley, had gone on to do labour subcontracting from Indian firms in Nairobi during the early 1960s, and had only come to obtain the occasional NCC contract after this long apprenticeship in the building industry. Within a year or two the younger man had decided to quit formal sector employment in favour of a joint enterprise with his brother. Finally the son of the old contractor also joined the team; interestingly enough he had attended an ordinary government technical school, and had, not untypically, gone on to work for one of the large corporations, before he too agreed to leave. For a year and a little more this unusual combination of practical experience and formal sector training held together, before the younger two split off to form their own construction company. This very brief outline of this family's movement may seem to contradict suggestions made elsewhere in this study that those educated up to secondary school seldom find it easy to contemplate self-employment. In fact, the youngest of the three people is not strictly self-employed, but receives a salary for the clerical work he does, while the man who resigned from the Ministry has not, of course, entered the kind of informal sector self-employment which has been uppermost in previous chapters. His self-employment, although enterprising, maintains very strong links with formal sector institutions, such as the National Construction Corporation.

The young man who attended technical school is almost the only one

of the thirty employees who has had any full formal technical training. And as we have already mentioned, he does not need to use it anyway in his clerical work. One of the others joined a technical school for a time, and one more attended briefly a tinsmith course in Githiga's youth centre. But the others have acquired their skill either on the job or in some type of informal training. The plumber, for instance, had learnt from his uncle in the Rift Valley, and has appeared earlier in this book, during the time that he was making bicycle carriers in Nairobi. Several of the others had worked at one time or another for Mutang'ang'i or Gachuiri, and one had even gone through the full garage training in Githunguri. The older men tended to have worked in the Rift Valley or Nairobi with Indian builders or on white estates. And the same system of learning on the job was now operating in this firm; the better workers amongst the casual labourers were applying themselves as plumber's help, mason's help or carpenter's mate, and were thus hoping to move up and out of the casual wage of six shillings a day.

Like the candlemakers of Nairobi the workforce was by no means unschooled. Almost half (14) had completed Standard VII, three more had proceeded to some years in secondary. On the other hand, ten were unschooled, and three had little schooling to speak of. It should not be assumed that the unschooled and those with minimal schooling are necessarily the old workers, because, in fact, eight of the thirteen in this category were young boys. These had often been picked up on the site as the company had moved round from Nairobi to Murang'a and to other parts of Central and Rift Valley Province. As a consequence only a portion of the workforce was local to Githiga; others were drawn from Nyeri, Kabete, Naivasha; the three non-Kikuyu were originally from Western Province.

Predictably, a number of those picked up as casuals on the various sites are from very poor families indeed. In terms of previous experience there is the usual round of petty jobs taken by the poor or parentless as they wait to grow older: cooking maize and beans in Nairobi at ten years old; domestic service; milkman and cowherd; turnboy; tea and coffee picking. For such boys, a training has got to be acquired on the job, and the building trade offers the advantage of living rent free in the *muscans* or workers' quarters as they move from site to site. A stove and a camp bed can be bought through the contractor by deductions from salary, and gradually tools can be acquired.

Very accurate data on wages are hard to come by, but the position in 1974 was not very different from the following: just over two-thirds of the workforce (21) were receiving *daily* wages of between 8 and 6 shillings, with the largest number (11) getting the rate of 6 shillings. The remaining nine workers were spaced out at intervals of up to 25 shillings: 10; 13; 16 (2); 17; 20 (3); 25. The wages offered have some relevance to the skill profiles that were discussed earlier. For instance,

the range between a skilled and an unskilled painter is 6 shillings for the casual learner and 8 shillings for the skilled man. By contrast in masonry and carpentry a man with considerable experience and his own tools can reach three to four times the wage of a casual learner.

The system clearly does allow people to move upwards and acquire skill as rapidly as they have the ability to. As was mentioned in Chapter II, the workforce have no interest in being graded by the government trade test system, since a test result cannot affect their wages. They realise also that if they stay in the firm, they cannot expect their wages to advance very much beyond present levels. Consequently, the secondary school boys in particular are very much on the lookout for their next move. They are aware of the salaries that can be gained in the formal sector, since they keep track of classmates from Standard VII, Form II or Form IV. Each time they meet and compare progress, they will hear that another of their peers has slipped across into a 'real' job, that so and so has just got a Peugeot 504, and that somebody else has got a loan. It should not perhaps be surprising therefore that two of the three secondary school boys are already deep in negotiations for a loan, one of them for a maize mill, the other on the security of his land. It is especially galling possibly in what were traditionally *age-graded* social and political structures for boys and girls to notice the very uneven rates of development amongst their age-mates. This feeling is expressed very acutely by the third of the secondary school workers in this company, despite the fact that he has been working almost continuously in the informal sector for four years: it comes from a recent letter to the author.

> Anyway, I will come to my point; young boys are becoming very rich due to nepotism, loans and connections. The only thing I want from you is only a loan of about four to five thousand shillings, since I have seen that without a loan or robbery, you can't improve. With robbery I have never attempted yet. But with a loan, I will be able to master it till I get what I want — 'up from the slavery of poverty'. There are very young people of my age who have got the loans and all these were my classmates, and since they found some sponsors to push them forward they have cleared their loans and are bosses nowadays. 1. One is a friend who got a loan of 20 000/-. And he is now a boss. 2. Another is my classmate. He is also among the bosses now with his 404 Peugeot and he has already paid his debt. 3. A third is in the city council and he has also paid and he is now a boss. NB. They are all of my age.

The aspirations of this and many other young people to succeed by what they conceive as the standard method of business success in Kenya must make us very hesitant about regarding the informal sector as having shaken down into a separate, self-sufficient style of employment. Possibly in a large part of the informal sector, this particular loan and credit aspect of the formal sector does not impinge so forcibly, but the

employees in some of these new building firms are at the centre of one of the contradictions between the formal and informal sectors. They embody one element in that process whereby the formal sector *subcontracts* to the informal. Such men are recruited informally, train informally, are housed informally and are paid at informal rates, but the larger operation, which they serve, is part of the formal sector's strategy for producing modern African contractors.

1. Joyce Moock, 'Pragmatism and the primary school', in D. Court and D. Ghai (editors), *Education, Society and Development* (Oxford, 1974), 109-10.
2. For detailed discussion of the adjustment of secondary school leavers to Kenya's labour market, see K. King, *Jobless in Kenya, op. cit.* Also, K. Kinyanjui, 'Education, training and the employment of secondary school leavers in Kenya', in Court and Ghai, *op. cit.*
3. The Jeanes teacher in colonial Kenya embodied many of the current aims of non-formal educators. See Roy Prosser, The Development and Organisation of Adult Education in Kenya with special reference to African Rural Development (Ph.D. thesis, Edinburgh University, 1971); and King, Ch. VI, 'The Jeanes School' in *Pan-Africanism and Education.*
4. D. Court, 'Dilemmas of development: the village polytechnic movement as a shadow system of education in Kenya' in Court and Ghai, *op. cit.*, 237.
5. Coombs, *Attacking Rural Poverty,* 12.
6. T. Wallace, 'Working in rural Buganda: a study of the occupational activities of young people in rural villages', *African Review* (Dar es Salaam) 3, No. 1, 1973.
7. B. Dinwiddy, *Promoting African Enterprise* (ODI, London, 1974), 73-4.

CHAPTER VII

Conclusions on Local Policy, Research and the Informal Sector

Previous chapters have offered an analysis of how the informal sector is perceived by some of those who have to operate in it. The intention has been to begin to uncover the very complex ways in which skills and technology are acquired and used in Kenya. Since this typology of informal sector operations is still at a very elementary stage of analysis, it would clearly be premature to try to extract from it a series of policy implications. We shall instead just touch on a number of the more fundamental gaps in our knowledge of the informal sector, upon which research might concentrate to good effect. Incidentally, some of these research areas do raise questions for policy.

INVENTORY OF INFORMAL SECTOR TRAINING OPPORTUNITIES

It would be of value to a large number of agencies, both public and private, to have detailed accounts of the facilities for informal training in different parts of Kenya. We have given some impression of the diversity of these for Nairobi's informal sector and for a part of Kiambu District. But it would be a high priority to establish whether the pattern that emerges there has its counterpart in most other regions of Kenya. The main elements worth cataloguing would be those below.

1. More or less commercialised types of informal training, such as garage-schools. These are rather far removed from man-boy or master-apprentice relations, since the number of trainees is not necessarily related to the productive capacity of the garage or workshop. Nevertheless, we observed that the graduates of this fee-paying system seemed equipped either to move directly into rural self-employment or, if they had the contacts, to practise in the large-scale modern sector.

2. Informal technical 'colleges': strictly speaking this training seems to be more on the formal side of training opportunities. It has to be remembered, however, that the informal-formal division is really a continuum, so that although some of these 'colleges' are registered with the Ministry of Education, and have a good deal more of the appearance of a formal institution (higher fees, syllabus, some classrooms, etc.), on closer inspection it will be found that students are gaining their practical experience in an ordinary garage business, like their counterparts in (1) above.

3. On-the-job learning (with and without the payment of fees): this takes in a multiplicity of operations. In some, the notion of the training as a 'course' is explicit, in others, skill will be acquired regardless of any intent on the part of the owner of the small industry.

In cataloguing the range of provision under these heads, a number of issues on which there is still fundamental ignorance will be aired. There is, for example, the question of whether we have in Kenya, and possibly in neighbouring countries, a distinctive style of artisan training. We have suggested that to use the term informal apprenticeship for much of this activity seems almost a contradiction in terms, since, at the moment, many parts of the system are characterised by extremely open access *and* departure. On the other hand, many of the men who have made outstanding contributions to skill transfer in their particular trades can reel off the names, dates and present locations of their former trainees in much the way that would be expected of a local plumber or carpenter in Scotland. More work, however, would need to be done in this area before we could be certain in which direction the apparently open-access system is moving.

We have also suggested that some such inventory of local level training could be of value to some of the slightly more formal institutions actually working in rural areas, or considering moving to a particular locality. This could be of importance in any move dramatically to expand the number of village polytechnics or rural industrial development centres. It should be noted that a local analysis of skill openings could suggest what a polytechnic might offer, but it would just as likely destroy the notion that village skill openings are restricted to the immediate village area. As we have shown on several occasions in these chapters village communities have already built up urban networks of village mates, and traditions have grown up of migrating to exploit these urban connections for skill and possible employment. At the moment there seems some limited evidence that these established rural-urban patterns do not only act one way—to siphon off the most talented rural youth to seek urban employment. They also appear to work in reverse, and fertilise the village with new skills acquired in the urban areas. If the latter is at all widespread, then

it would be important for agencies concerned in rural development not to concentrate entirely on the problem of holding young people in the countryside and providing skills for them there, but to study the existing flow back to the rural areas of certain categories of skilled worker.

A wider knowledge of present informal opportunities could also be usefully related to educational planning for the upper primary school. We have already mentioned the value of some career and training guide for the primary school leaver which went beyond a discussion of the various secondary schools. Equally, it could be of benefit to the community if some elements in informal training were gradually brought within official recognition. At the moment, the fairly widespread system of exchanging skill for money is strictly speaking quite outside the provisions of Kenya's official industrial training legislation. On the other hand, if the same thing is done with much higher fees within the educational setting of some informal 'college', it is permitted. Some of these anomalies could at least be rationalised once the government were provided with adequate information on the scope and quality of these kinds of training.

Finally, on this subject, a more precise understanding of informal provision could make it easier to see relevant alternatives to the present rather pernicious influence of the Certificate of Primary Education. A number of suggestions have been offered both by the ILO Mission to Kenya and by local authorities on how the primary school might be extended to provide nine years of basic education, with the last two oriented towards employment. However, any such major programme to revocationalise the upper end of Kenya's primary schools would do well to note that the local priorities of many communities are for post-secondary rather than post-primary technical and vocational training. In the face of this preference, it would be very difficult for the formal school system to offer basic skill training at a much lower level, and almost impossible for it to replicate the improvisation, technology and working conditions of that sector which already does produce the bulk of Kenya's intermediate skilled manpower.

CONSTRUCTION OF SKILL PROFILES

From a variety of angles, it would seem appropriate to combine any inventory of institutions with *skill analysis*. At the moment there is a good deal of interest amongst personnel in central government in seeing whether organisations, such as the NIVTCs, which currently only service the upgrading and skill-improvement needs of large-scale companies and the technical ministries, could be used to reach a wider range of Kenya's skilled workers. It is relatively easy to work with the large-scale sector, since, in practice, attendance at short courses tends

to be linked to improvement in wages. There is therefore a predictable demand. By contrast, very little is currently known about potential demand amongst the majority of Kenyans who do not work in such large companies. Similarly, almost nothing is known about the 'course-content' when a skill is picked up in a garage-school, a tinsmith yard, or from a rural builder. What are the main emphases? In what order are competencies acquired? Is the often quite remarkable speed of skill acquisition compatible with certain basic standards? What are the main improvisations in tools and procedures and what implications do these have for the government's own trade test procedures? We have suggested in the previous chapter that some such skill analysis carried out for the basic trades would indicate what sorts of problems local *fundis* face. It would then at least be possible to see if there was any role for the NIVTC and other bodies in course provision.

POLICY TOWARDS SKILL MODELS

We have noticed throughout this account the very considerable training function that attaches to certain individuals in the rural and urban areas. Often five or six key craftsmen in any village are responsible for the quality of work done in various trades. Given the current interest in many fields in 'training the trainers', it would make sense to link such men into any integrated plans for skill improvement in the rural areas. In some cases, they are already put to good use by local bodies such as youth centres or polytechnics, but this is sometimes difficult as they tend to be completely outside the government's national system of trade testing. Nevertheless, as many of these men are skilled in practice to a level of grade two, if not more, there might be a case for granting them official recognition on the basis of work carried out in rural areas. As was pointed out earlier, some such innovative adaptation of trade testing to the smaller scale enterprises outside Nairobi could benefit rural craft as well as altering the current view that trade tests are merely a way of earning increments for those working in large companies.

PRODUCT DEVELOPMENT AND TECHNOLOGY IN THE INFORMAL SECTOR

Several agencies operating in developing countries are very closely involved with the development of new products at a technological level appropriate to the local craftsmen. We have said earlier that such activity if pursued in isolated centres by largely expatriate experts is not likely to make much impact. In addition, some of the search for an appropriate or intermediate technology is carried on out of context.

General assumptions are sometimes made about the stagnation of rural craft and as a consequence little serious attention has been given to the subject of local technological innovation in Africa. There is, for instance, an almost virgin field for studies in the history and development of technology and of craft practice. And this is of particular importance for many areas in East and Central Africa where highly specialised craft communities were not a prominent feature of the precolonial period. In this sphere, it would be a useful contribution if the Rural Industrial Development Project in Kenya, and its counterparts in other countries could undertake a detailed account of informal sector products, particularly those which appeared to have a very wide market demand, and which had significant backward linkages in terms of their use of scrap or local materials. An instance at the rather petty level would by Kenya's development of low cost light which is not similar at all in Zambia for example, and at the more sophisticated level there is the range of informally assembled machines such as we examined for the manufacture of bicycle carriers, foreguards and bicycle stands in Nairobi. Equally important would be the classification of locally made equipment and tools being used in the building industry and in agriculture. It will be found that a much wider range of informal sector tools and building components are actually in use than is often imagined. Obviously in this area there is some scope for judicious attempts to borrow from the experience of neighbouring countries. And not least from India and Pakistan whose technology has already made a substantial impact in Kenya, Uganda and Tanzania.

FORMAL TECHNICAL EDUCATION PROVISION

We are aware that quite frequently throughout this book the technical schools and some of their graduates may appear not to have developed in quite the way anticipated for them. In this area too, however, there is a notable shortage of reliable information, despite the current interest in the industrial training levy and formal apprenticeship. For example, soon quite a lot of information will be available from the apprentice files being built up at the NIVTC, but these only refer to the 40 to 50 per cent of technical school leavers that succeed in getting signed on as an apprentice in the formal sector. Nothing at all is known of the remainder, and yet this is an important group, for it looks almost certain that the category of boys with prevocational training but no formal apprenticeship is bound to expand. From 1975 they will be joined by the first groups of graduates from the *Harambee* institutes of technology, and these will tend to have had four years of academic secondary school with a further two years of technical training. Doubtless the terms on which they can get access to certain kinds of

skilled jobs will change from year to year; doubtless also some of the first groups of *Harambee* leavers will be traced to analyse the sort of employment or self-employment they have entered. It is to be hoped for any such tracer study that the particular skills generated by the *Harambee* institutes will not be followed up on their own, but will be seen as fitting into and possibly interacting with a very complex range of craft and skill that Kenya has acquired in the last few decades.

FORMAL VERSUS INFORMAL

The last really major area of research brings us back full circle to the issues with which we started in Chapter I. There we noted that a great deal of the most current advisory literature on African development has urged that the spotlight should move away from the formal school and the formal sector of the economy and focus instead on the creative potential of informal training and informal enterprise. In a small way these last six chapters have explored something of these two informal sectors, and have certainly quite often been able to contrast the style of the informal modes with that of official education and official industrial enterprise. Nevertheless, we found it consistently difficult to prise the informal side very far apart from its official counterpart. In some cases the informal structures were not truly alternatives, but were determined by a policy that had concentrated the major resources in the formal sector. In others what might appear as an extremely dynamic mode of informal production turned out to be parasitic upon developments in the large-scale sector, or upon subcontracts from it. Similarly with education, a good deal of what is loosely referred to as non-formal seems on closer inspection to be intimately connected with the certification and employment aspirations of the formal sector. There are admittedly areas of skill acquisition and of petty production that operate apparently unaffected by the official systems, but it is precisely those elements which would be the hardest to generalise across the nation as some kind of alternative policy objective; their resourcefulness, rapidity of training, technology and low costs are not so much chosen as dictated by necessity.

There is therefore a danger of polarisation in the thinking of some agencies in this area; over against the allegedly critical state of the schools, a search is being mounted for indigenous learning systems in rather the same way that enthusiasts for indirect rule sought to revive and strengthen tribal forms of African authority during the middle colonial period. There certainly is a fundamental ignorance about the variety of possible avenues towards work and skill outside the official modes, and some of this diversity may be traced to older local systems that predate the western school and the western factory. Research

consequently would do well to document the whole range of unofficial learning, both traditional and modern, as well as the ways in which it is to a greater or lesser degree incorporated into the formal mode. Any such study is likely to reveal that the rather static stereotypes of formal and informal learning take inadequate account of popular pressures which are constantly adapting both systems to changing local needs and aspirations. The inclusion of this wider dimension would, however, give more coherence to the emerging discipline of educational planning. And as far as the estimation of skilled manpower in Kenya and other nations is concerned, an awareness of unofficial modes of artisan training would make enumeration vastly more complicated, but hopefully would also produce a rather more accurate reflection of a country's talents and resources.

As this study proceeded, we have found ourselves constantly facing the question: how peculiar to Kenya is the skill and training situation we have described in these few chapters? How does the concept of the informal sector stand up in other countries of the Third World where perhaps the mix of skills, technology and products looks rather different? In an attempt to answer these sorts of questions, we seek now in the last chapter to locate more precisely the Kenya blend within a wider international context.

CHAPTER VIII

Informal Sector Skills in International Perspective

It can be argued that the recent interest in informal sector skills was partly the result of a much wider western disenchantment with high cost institutions in developing countries, whether these were expensive teaching hospitals, national university campuses or miniature industrial estates. However, it is probably no accident that it was the urban informal sector in Kenya that first came to achieve a measure of international attention. The white settlement areas of East and Central Africa had in colonial times encouraged a series of discontinuities between occupations, between races, between town and country, between white farmer and black 'reserves'. Salisbury, Nairobi and Lusaka were developed as predominantly white cities, with organised little industrial estates, and special zones for the African or, in the case of Nairobi, Indian workers.

Markets and beerhalls did have to be specially sited for the African population, but there was no need to allocate land for an *African commercial* area in the way that was done for the Indians of Nairobi and of other Kenyan towns. There was, after all, no very striking commodity production to be identified with the various African communities of the time. This meant that as urban Africans acquired competencies in production in some of these European colonial towns there was really nowhere for them to practise their trade. *The very conspicuousness of the informal sector in Nairobi today, therefore, is the result of a town planning constraint from the colonial period which did not anticipate the rise of the African petty producer.* For this reason petty commodity production initially grew out of the few designated market places such as Burmah and Kariokor in Nairobi, or Luburma in Lusaka. The official scope for expansion was so small in the case of Nairobi that production spilled out along the river banks and on to any waste ground which might be temporarily available. Admittedly after Independence the fortunate few were able to buy over permanent

workshop premises from the departing Indians in all the major towns, and continue, often on a basis of multiple occupancy, a similar line of production to that of the Indian *fundis*. But this option was simply not available to the majority of Africans, who had to improvise premises where they could get a foothold.

'TRADITIONAL' VERSUS MODERN SKILLS

The very term 'informal sector' suggests, then, that African petty producers were not really expected to emerge in large numbers in these parts of East and Central Africa. And it also underlines the gap expected between formal sector technology and that practised in the informal sector. It is in fact precisely the lack of what can be called a 'technological continuum' between the firms in the official industrial areas and these small producers that has led people to talk of the informal sector. We have mentioned elsewhere that, even so, it is difficult satisfactorily to segregate formal from informal.[1] And yet compared to countries such as India where there is an extremely diversified technological hierarchy from village skill to the large-scale sector, the East and Central African countries do offer a very stark contrast between the activities of the small man and those of the factory. It may help therefore to locate more exactly the specificity of informal sector skills and technology in Kenya if we examine them in relation to the traditional craft sector on the one hand and the development of modern industry on the other.

Kenya's informal sector vis-à-vis traditional skills

An added factor in making Kenya's informal sector rather conspicuous was that it did not blend imperceptibly into a base of traditional craft skills, as these did not exist in East and Central Africa even on a scale comparable with, say, West Africa, let alone with countries in Asia. Village-based crafts concerned with handspun cloth, paper, lacquer, wood, brass, precious metals and many others were either non-existent or extremely rare in East Africa, Zambia and Rhodesia, apart from sections of the Coastal Strip and apart from certain skills such as blacksmithing.[2] Africans in Kenya, therefore, have mostly not come to the informal sector from established village or urban industries, but have most often been the *first* in their families to work with wood, leather or tin.

Although instead the first generation of modern African artisans learnt largely from Indian craft workers, Kenya Colony, as it then was, only received a truncated version of the body of craft skills from the subcontinent; and the African successor artisans only practised in turn

a fraction of the wood, metal and tin crafts present in the Indian workshops. This doubly restricted repertoire of the African artisans is not to do with their craft capacity but is a function of the limited market for craft goods in East Africa. Traditional handskills in India, for example, face two ways—to the poor and to the rich. Accordingly, handskill products span the whole range of quality from the exquisite, intricate pieces for the discerning and better off, to the very simple design of ordinary village products.

By contrast, the African tinsmiths or woodworkers have only taken over a few excerpts from the Indain repertory, and they make their goods for a market that has no middle or top. We have noted that this truncated market may not affect the informal repairman to the same extent, for the backstreet mechanic may mend a minister's car. But it is true of many of the commodities made in Nairobi's informal workplaces. We shall examine part of the reason for this situation in a moment, but one of its most obvious effects is that most products of the informal sector are not *quality* goods. They lack finish. They are being sold into villages and towns whose people have not had a craft tradition in these particular lines, and who are principally concerned that the goods be cheap and serviceable. If the goods are rough and ready—whether stoves, lamps, buckets, tables or chairs—this has obvious consequences for the levels of competence required in their manufacture. Indeed, this lack of a craft tradition and of a sophisticated upper end of the craft market may help to explain the exceedingly short training periods we have encountered in East Africa, and the ease with which a man may drop one 'trade' and take up another.[3]

Training in the informal sector is often product-specific. When a boy learns to make tin lamps or tyre-sandals, he does not learn the whole spectrum of skills associated with the craft of the tinsmith or the woodworker, but a number of discrete operations. From this perspective, therefore, the informal sector operator is not really a skilled craftsman at all, although we have ourselves used the words 'skill' or 'craft' loosely in discussing him; for he does not turn out a product where the quality of the hand-finishing is crucial to the article. *Rather he is a rough and ready improviser with a limited range of materials.* On any skill spectrum, in fact, he is probably nearer to the semi-skilled worker in a small factory or workshop than he is to the traditional craftsman.

Kenya's informal operator vis-à-vis the modern industrial estate

If most of Kenya's present informal sector workers are technically far removed from the traditional craft skills of the Middle East or Asia, they are equally remote from much of modern industry in East Africa. The

technological gap is enormous, and is demonstrably much more marked than in Asia where slight gradations of scale and of technique mean that the workshop sector shades off into the small factory, and the small factory into the large. Part of the reason for the apparent remoteness in East Africa is that much of the industrial plant is very recent, and, as it is frequently foreign owned, tended merely to reflect contemporary trends in western technology at the time of the transplant. The exceptions to this tendency were some Indian and local European firms in East Africa which grew into factories from being on a much smaller scale earlier. However, the nature of the modern industrial sector needs to be examined a little more closely if we are to understand the discontinuities between informal sector skills and products on the one hand and those associated with the industrial area.

The first critical factor is that industrial activity in Nairobi or Lusaka is really also a truncated version of what would be found in any major European city. It is dominated by *process* industries, and has very little in the way of manufacturing. The actual processing sector may be loosely divided into those concerned with agricultural (or mining) products — tea, coffee, sugar, flour, rope, pyrethrum, fruit, etc., and those making in East Africa various commodities identical to those in the West, such as toothpaste, soft drinks, beer, paint, tyres, metal boxes, aspirin, detergents, etc. In historical terms the category of agricultural processing was earlier established, whilst a good deal of second group has been set up more recently under the drive for import substitution. Both of these sectors are concerned with a *quality* product, particularly when an internationally known brand of some commodity is being locally processed in Kenya or Zambia. Consequently the actual process machinery is increasingly characterised by instrumentation and control, affecting both the contents and the packaging.

The growth of this instrumentation and process control in the industrial areas of these countries has important implications for the requirement of skilled labour. Principally, this whole processing sector needs only *operative* skills on the production lines, with a handful of plant maintenance mechanics or technicians; and even this latter skilled category can be reduced as the actual plant becomes more sophisticated. *As far as skills alone are concerned this means that a major sector of industrial activity offers no continuity with the employment and products of the very small-scale sector, nor any base where workers who have gained some rough and ready competence in the informal arena can hope to deploy their skill at a higher level.*

Equally significant, however, is that many of the products currently made with the latest technology in the import substitution sector were not locally available already in the small-scale workshop area of the economy. So that although we stressed that many of the informal sector products are sold to a market that has no middle or top, it is also true

that many commodities in the industrial area are made with a technology that has no middle or lower levels. There are, for instance, few, if any, local alternatives to the quality consumer goods made by the internationally known companies, and even where the Indian workshop has provided a kind of local alternative in East Africa, all the evidence points to the 'quality' product progressively undermining these more indigenous initiatives.

This has meant that in the case of many commodities, the African housewife or consumer has little real choice. If she is poor, her handful of household objects will be locally made and of very indifferent quality, for, as we have explained, none of these really basic goods grow out of a longstanding craft tradition. Then there will be another group of items such as cooking oil or detergent which will have been factory produced to a very high quality indeed. If she is better off, then there is an abrupt transition from the rough household utensils of the informal and workshop sector to the imported quality goods of the industrialised nations or of local factories.

It is not easy, however, to generalise about the range of cheap, informally produced local goods in East and Central Africa. In Kenya, at any rate, the range and geographical spread of local *fundi* goods has been dramatic in the last decade, as has been the growth of relatively cheap goods produced in local factories. Thus, in a small unpretentious hardware store in Nairobi there is still a great deal of movement between the goods of the three sectors: products of local *fundis* operating with or without workshop; products of local factories; and products of foreign factories, especially China. This is the kind of store that shows to best advantage the growth of the two local sectors, since the owner may not have the capital to become more specialised. Rough and ready hardware is, as we have said, the area in which the informal sector is most likely to be competitive, since many of its materials are recycled, and there is now very little profit margin amongst the increasing numbers of petty producers. But it is rather a different story if the three categories are examined in other contexts. Stalls selling bric-à-brac, from zips to penknives to toys, are likely to be much more dominated by mass production in the industrialised nations, as are the specialised hardware stores selling the whole range of handyman tools. In the latter, the products of the local informal sector will simply not be represented at all.

Despite this, the picture in Kenya is far from static, and it is constantly necessary to remember that in colonial times the African informal sector was almost non-existent if we are to appreciate properly the present diversification of the local economy.

In Zambia, by contrast, the three product categories are in a very different relationship to each other. Largely due to the absence of an Indian intermediate sector, the growth of a local class of petty

producers has been much less marked. Because of local traditions of order and disciplined development, the Zambian equivalent of the informal sector is also much less informal, and thus not so noticeable. It has not spilled out of the earlier trading centre and markets in the way it did in East Africa. In fact petty producers are very likely to have an officially registered plot, and perhaps because of the much longer exposure to urban living and its associated consumer goods, the use of scrap and second-hand materials is not so characteristic as it is in the towns of East Africa. Thus in the urban markets of Lusaka, the tinsmiths will typically be making their small range of baths, braziers and water buckets out of new galvanised sheet, and decorating them with quality paint.

Equally in Zambia the local factory production of cheap basic goods has not yet developed to anything approaching that in Kenya, and as a consequence the market stalls have a very high preponderance of mass-produced goods from foreign countries, especially China. In 1975, most stalls in Luburma market in Lusaka would typically have some 20 to 30 foreign lines compared with only two to four local Zambian products.

However, the discussion of various product types from various sectors does not by itself reveal very much about the ongoing interactions that there are between the different forms of production. And if we desire to understand the policy options available in skill acquisition and industrialisation, it is precisely the interactions and discontinuities amongst these levels that must be examined.

Towards a model of skill levels and productive sectors in Africa

By putting forward even a provisional model to explain product and skill levels in Africa, it is hoped not only to reaffirm the particularity of the skill resources of different countries, but also to point up the dangers of talking about Africa's needs for 'basic skills' or 'high level skilled manpower' as if these were self-evident categories.

Production Category	Skill Level
1. Traditional craft sector	High degree of manual skill
2. Informal-cum-workshop sector: cheap hardware, furniture, food and clothing items	Rough and ready manual skills, very rapidly acquired
3. Precision workshop or small factory sector: engineering, toolmaking, casting, machining, spare part manufacture, small-scale processing, basic tools and machinery production	Very high degree of manual skill

Production Category	*Skill Level*
4. Medium and large scale process and assembly plant: primary agricultural processing, assembly from knock-down kits, food and drink processing	Low level of manual skill but varying with degree of instrumentation and control technology
5. Heavy engineering: capital goods machine tools, production machinery	High level of manual skill

1. The Craft Sector

Although these categories have been assembled with Kenya in mind, they are intended as much to show what does *not* exist in Kenya as what does. Thus, we have already said that in Kenya a widespread craft sector is now non-existent, with the exception of some basket-weaving, carving skills and ornaments. Some exclusively Indian craft workers in gold and silver are still to be found in the main cities of Nairobi and Mombasa, with some small pockets of Arab and Swahili craft workers on the Coast. But the present day scarcity of craft workers throughout large belts of East and Central Africa must make for a rather different cluster of policies towards, say, rural industrialisation than it might do in some of the North and West African economies.

At the moment, for instance, there are several attempts to develop craft work currently in Kenya, in the areas of pottery and handloom weaving. The intention of such experiments is often to encourage the spread of craft work for employment generation. Inevitably, however, the weavers or potters are coming from Western countries whose ordinary craft base has long been completely eroded by industrial development, and who have themselves no experience of craft work as the *ordinary* job of a mass of poor people. The handmade article in Europe or America is viewed with respect and admiration by many people whose ordinary daily objects are factory-finished. There is therefore only a tiny craft élite in the industrialised world who produce for the upper end of the market.

The transfer of this outlook to East or Central Africa has meant that the little pockets of experimentation have done the same thing in Africa as in Europe — made articles for the upper end of the market; which tends to be the international tourist community or the expatriate residents in the country. Craft development, therefore, is a fundamentally different process in a country such as Ethiopia, for example, where the bulk of the inhabitants wear varieties of handspun cloth than it is in Kenya where nobody does. In the former category, policy for an existing widespread craft can include design, marketing and materials provision, and institutional backing from government or local organisations. In the countries where the few craft items have all

been rapidly integrated into the international tourist market, there are very real difficulties in developing from scratch an alternative local demand on a scale sufficient to generate employment.

The other problem for countries not having an existing craft base in the rural areas is that such skills can really only be learnt on the job through long periods of family or apprenticeship learning; they cannot be picked up on a large scale through formal teaching in institutions, apart from the sort of craft and design work now associated with Art Colleges in the West. Thus, any attempt such as Tanzania's at present to communicate rural skills through primary schools is likely to transfer only a very rudimentary level of expertise. Which brings us to the informal sector.

2. *Informal-cum-workshop Sector*

Lacking a mass craft base, the informal-cum-workshop sector is really the bottom end of Kenya's technological pyramid. There is no qualitative distinction between those who have premises and those who work outside. In terms of technique and skill deployed they form a single grouping, and make a common list of products. The addition of hand-operated and power machinery in a number of the workshops has not so far made a significant difference to product type. Typically, across both rural and urban areas, the sector depends on hand-tools, but as neither the tools nor the trade emerge from a family tradition of craft practice, the range of skills is limited, and therefore easily acquired by those who want to. Unlike the craft sector, there are understandably no traditional caste or clan objections to entering or leaving a particular line of business.

In countries which have a massive continuing craft base, the term 'informal sector' is simply inapplicable. Existing craft workers have gradually taken on more modern lines, but there is really no satisfactory way that, say, radio, watch and automobile repair can be prised apart, along with other non-traditional activities, into a separate sector. The new lines blend imperceptibly into the widespread craft world, and are often organised by a single community or grouping in rather the same way as the older skills. In terms of skill level, such new lines are not necessarily less demanding, for they are incorporated into the existing patterns of high manual skill.

It is not surprising, therefore, that the notion of the informal sector was not first applied to India or to countries with a thriving bazaar sector in most of their small towns. And in Africa itself there are obviously regions (principally in the North and West) where new activities such as gas or electric welding have been organisationally affected by the norms of the existing craft practice. In East and Central Africa, by contrast, the new informal sector has developed largely outside the influence of any traditional craft constraints, and has,

particularly in Kenya, been affected by other kinds of local factors, such as the Indian and European settler presence.

These have combined to produce the rapid transfer system of relatively low level skills, and the particular dynamism associated with the newness of many enterprises in the urban and rural areas. There is still a good deal of movement and development in the system as it is, in a sense, meeting some of the needs covered by the craft sector in other countries. We noted that traditional craft skills are not really susceptible to institutional training; they have to be learnt on the job. With the lower levels of skill in the informal sector, it is conceivable that they could be taught, at a cost, through a basic skills programme attached to the primary schools, but inevitably many more children would be taught than would practise. Additionally, the school setting—however community oriented—is always at a considerable remove from the realities of trade practice. It is almost impossible to anticipate in a formal school atmosphere the need to improvise with poor materials, tools and premises.

But the replication of the *existing* level of skills is not the problem of informal sector development. There is no shortage of these rough and ready skills, although obvious scope for geographical expansion still remains in many countries or regions. This type of *horizontal* spread of low level skills is proceeding of its own accord in most countries of East and Central Africa. Its progress may be much more rapid in Kenya than Zambia where the official view prefers petty producers to work in proper licensed areas or not at all, and to receive a really thorough training or not to practise at all. But even given these regional variations, the further horizontal spread of this level of skill is likely to continue for quite some time to come. *The real problem for the informal sectors of the East African region, however, is their lack of vertical integration into the next technological level.*

We have noted elsewhere various types of integration into the formal sector in the case of the building industry and automobile repair. But this does not constitute links to a more advanced technology.[4] It has often meant merely that the larger employers or individual clients were using the informal sector worker to do more cheaply the *same* task that they would have had to pay more for in the formal sector. Here, by contrast, we are concerned with the integration of the informal sector into our third category of production—the precision workshop or small factory sector.

3. *Precision workshop-cum-factory*
This is another of our production categories that, like the craft sector, is conspicuous by its absence from many parts of the East and Central African region. And it is this virtual absence which so complicates policy on rural industrialisation, and produces that discontinuity in

technology we mentioned earlier. Of course, there were in the major cities and smaller towns a handful of precision engineering workshops which tended to be Indian-owned in East Africa, and were run by Europeans in Central Africa. But despite the relatively rapid growth of the larger scale import substitution industries, this sector has not really expanded significantly since Independence. Indeed, with the departure of the Indians from East Africa at different rates, the sector as a whole has probably contracted.

There has been a tendency moreover in approaching the area beyond the ordinary informal sector skills to fail to see the precision sphere as a totality. Instead, policy on the promotion of small industries has veered from one fashion to the next. At one stage in many African countries, small industrial development loans were awarded much more in commerce or trade rather than industry, as it was politically necessary to encourage African entrepreneurship in the face of non-local control. More recently, on the analogy of agricultural extension, rural industrial promotion has been associated with official demonstration centres, where instead of new high-yield seeds, fertilisers, and improved farm practice, there can be found sophisticated machinery, bulk materials, and experts in prototype development. Various kinds of short courses have been mounted to aid in the upgrading of existing artisans, and attendance at these has often helped in the procuring of credit facilities. Kenya's Rural Industrial Development Centres, for instance, operate within this general perspective, and they share with similar ventures in other parts of Africa a constant concern that their strategy is not really producing the necessary changes in the rural areas.[5]

The issue, however, is not really whether the provision of upgrading opportunities for rural artisans is a good thing or not, or whether credit should be made more widely available to petty entrepreneurs. Rather it is a question of whether a country without a widespread precision-workshop-cum-factory sector should embark on the creation of this level of technology. The answer is not necessarily yes, because the skill requirements of such a sector are of a really different order from those present amongst Kenya's informal operators today. Countries which do have a very diversified workshop production capacity demonstrate this high skill quality quite clearly. Their manufacture in petty workshops of simple hand-operated machines or agricultural implements such as water pumps looks straightforward, but depends on small foundry and casting knowledge and all the associated skills of moulding, pattern-making, and, later, machining. Similarly, with plastic products, the widespread ownership of the small injection moulding machines in countries like India requires access to skilled die makers. And again at the marketing stage of many products, there are obvious advantages in having cheap local printing and packaging facilities. Even on the repair and maintenance side, the manufacture of spare parts or one-off orders

for other firms needs very highly developed diagnostic and machining skills.

For countries that do not have an existing integrated network of these production skills, it is difficult and dangerous often to proceed piecemeal. Loans for new machinery can easily be put at risk by plant lying idle for lack of machine maintenance skills or lack of readily obtained spare parts. It is not just a question therefore of getting the informal sector more mechanised; often when the new machinery is all imported, reliance on foreign spare parts is as irksome as the older reliance on inadequate hand-tools.\On the other hand, any co-ordinated approach to the development of this small engineering sector does not only involve thorough techno-economic surveys at the regional and national levels, but inevitably involves larger questions of protection for the infant precision sector.

In fact, protection policies are rather closely connected to the development of the sector we have been discussing. Although it is not possible to generalise for Africa, a good deal of the working of current import substitution policies has not helped the emergence of this sector at all. Protection has frequently been given for a particular product, e.g. tyres, and has been awarded to a single 'local' manufacturer.[6] This may seem logical given the rather small size of the present domestic market, but its result has been to favour the transplant of a single *large-scale* factory with national capacity. This can and does often produce a local monopoly situation where previously there was choice amongst the competing products of the industrialised nations, but, more important for our present perspective, it substitutes one technologically remote process for another equally remote local process. Present unintegrated protection policies certainly do not seem to have the effect of spreading technical capacity downwards locally. It is, of course, questionable whether a more comprehensive ban on imported goods could, if linked to a sensitive credit policy, begin to reproduce a small-scale manufacturing sector which had more backward linkages into the informal sector. Few independent African nations at any rate have encouraged local manufacturing capacity through comprehensive controls on anything like the scale India imposed on herself shortly after her Independence, or Rhodesia had imposed on her involuntarily during her decade of UDI.

Leaving aside the larger economic strategies on protection, the training needs of this precision sector are what concern us principally. The skills required here cannot be picked up at anything like the speed that is common amongst Kenya's present informal sector. They need a long exposure to workshop practice, and are ideally learnt on the job. However, Kenya's official apprenticeship system has very largely failed to place trainees in the few remaining precision workshops belonging to the Indians, and, as was pointed out elsewhere,[7] is much more

successful in locating boys in the large international companies whose technological development, in fact, makes the requirement of the traditional apprenticeship much less essential.

In the absence of sufficient facilities to train young people on the job, institutional alternatives should be considered. Of Kenya's present spectrum—polytechnics, technical schools, youth service, village polytechnics and the new institutes of technology—most make no provision for the skills required in this precision sector: the village polytechnics and youth service do not in practice turn out young people at a skill level much beyond that already available in the informal sector's own system of skill acquisition. The technical schools are in the anomalous position of still offering basic building trades, metal work and auto repair courses to an academic élite who are at the moment unlikely to remain as artisans. And the polytechnics are principally concerned with students sponsored on day or block release from their firms. But in Kenya as in the United Kingdom, the small workshop employer seldom takes advantage of release facilities for his workers. The emerging institutes of technology affirm the importance of technical self-employment in their objectives, but however rigorous the standard of their instruction, their graduates will find it difficult without some associated credit programme effectively to embrace levels of technology that are much above those required in the small building contractor.

This section on the intermediate engineering sector has been put rather forcefully since it highlights the particularity of the informal sector in a number of African countries, and points up the specific nature of the discontinuities between that informal sector and the larger scale process plants. It reinforces also the argument we have made elsewhere, that skill level, technology and training must be examined concurrently if the weaknesses in the present piecemeal approach are to be overcome.

4. *Medium and large-scale process, manufacture, and assembly plant*
We have already discussed the product and technology contrast between this rather recent, expanding sector and the world of the informal operator. Here we would merely argue, in addition, that this will probably continue to be the preferred growth area for many countries. In contrast to the complications of developing a local precision workshop sector, the attraction of import substitution of individual items is that a whole modern package is transferred, and, given the availability (at a price) of highly automated production machinery, local manufacture can be under way very rapidly indeed. One day all cutlery or tyres are being imported; in six months time, they are being made locally. As the latest production systems do not even require a bulk of skilled operators, there are no particular training hurdles to be

THE AFRICAN ARTISAN

overcome. In many countries there is still a very wide range of consumer goods whose production can be localised in this way. The method is quick, clean and efficient. It is often socially popular also, because it produces a quality good with the advantage of the most modern technology. There is a further attraction in the sense that this replication of modern industrial plant in Africa appears to leapfrog over the slow stages of growth that many western nations experienced. This type of approach, therefore, is not open to the charge that Africa is being held back by having to accept much older, 'intermediate' methods of production than those current in the West.

And yet, attractive as this form of import substitution may appear to the national élite and to the participating local and international firms, it can have all the drawbacks suggested earlier. It provides few positive backward linkages to the skills and products of the informal sector, apart from generating a certain amount of scrap. Arguably also the skill and technology gap between modern process machinery and the competency of the informal operator is widening; at least with the older, largely mechanical, systems of processing for agricultural products it was possible for the ordinary maintenance man to spot faults relatively easily. But with the introduction of new pneumatic, hydraulic and electronic systems into the production process, the older type of machine operator has been progressively removed from an understanding of the machine he controls. Indeed, as the standards of quality control continue to rise in the developed nations, local firms and subsidiaries in the Third World come under pressure to apply similar standards to their products. The resulting increase in instrumentation and control engineering in the production process may well mean that maintenance and spare parts contracts can no longer go to the little local engineering shop, but will tend to go overseas. Increasingly also as components are made to be replaced rather than repaired in the developed world, it will no longer necessarily be as simple to replace a whole sub-assembly through putting out to a local precision engineering firm. Even therefore, if the precision engineering base in East Africa were not being eroded by the withdrawal of the Indians, the very design of much modern production equipment could still entail increased dependence on overseas suppliers.

For these kind of reasons it looks as if the development of a vigorous small-scale engineering and service sector, ancillary to the larger production units, will not be by any means straightforward. Quite apart from the production technology of the process and assembly sector, ancillary workshops in Kenya lack the incentive that would come from the presence of really large-scale manufacturing industry in the country. But the latter is yet another of our original five production categories that is conspicuous by its absence in Kenya, as in many other African countries. At the moment there is nothing approaching the obvious first

step of many would-be petty producers in India — to begin making spare parts for the textile mills or other large-scale enterprises.

STRATEGY FOR SKILLS AND INDUSTRY IN KENYA

After this rather brief analysis of the major production categories in Kenya, and the levels of skill and technology associated with them, it is perhaps easier to review some of the frequent calls for 'more skilled men', or 'more prevocational training in schools', or 'basic skills for self-employment'. Too often phrases such as 'skills training for self-employment' have not been thought through. They have the right political sound, since they stress the absence of formal sector wage employment, but they do not ask 'What level of *skills*?' 'What type of *training*?' and 'To make through self-employment, what kind of *products*?'

The answers to these questions cannot be generalised from Kenya to other countries (though there will perhaps be a common core), for the mix of the skills training, and production categories will differ from one country to the next; but we can, by now, say a number of things about the *specificity* of the Kenya situation.

The present impact of historical factors

The 'homelessness' of the informal sector in Kenya today is quite largely the result of the Africans being judged unskilled and unproductive at the beginning of the colonial period. European towns in Kenya grew up around this assumption that the local population did not practise any crafts worth speaking of, and, as a consequence, needed no particular physical provision. When eventually the African artisan began to emerge from the racial and occupational segregation of the colonial period, it was still difficult to acknowledge that anything needed to be done. Indeed it could be argued even today that not much really needs to be done beyond according petty producers some of the same security and services offered to the Indian in the colonial period. Petty Industrial Areas need to be demarcated in most of the cities and towns, so that, with security of site, the ordinary mechanisms of credit can become operable. In this sense it could be said that providing the minimum infrastructure to the present informal sector must take precedence over skill upgrading or product development.[8] Without the first, the other two will be largely ineffective. This does not imply the provision of standard workshop accommodation by the government, but perhaps schemes could be tried such as those associated with Zambia's squatter upgrading where the tradition of self-help building

has been combined with straightforward credit policies to produce dramatically improved housing and workshop provision.

Horizontal spread versus vertical integration

It is easier to see what is happening to the informal-cum-workshop sector in Kenya, if we bear in mind the other sectors that have been briefly described. Clearly in Kenya what is perhaps too loosely called the informal sector is rapidly fanning out horizontally over the country, and is beginning to undertake in its own way many of the activities that would elsewhere be done in the traditional craft world of the village and town. Unlike the traditional craft worker, however, with his restrictions on access to skill and long periods of apprenticeship, the informal sector in Kenya has an 'anybody-can-try-anything' feel about it. There is no special group feeling about being a plumber, a shoemaker or a tinsmith, though it is likely that certain regional specialisms will eventually emerge.

Also unlike the traditional craft worker, the skill level of the informal workshop is rather low for the reasons we have described earlier. There is, by contrast, a good deal of initiative and improvisation, but often no very obvious arena in which they can be applied. Because of the limitations of consumer demand, the bulk of producers make a small range of basic household and farm items from sheetmetal, wood and cloth. Competition within these lines is accordingly quite keen, and product diversification appears to be slow, even though progress has really been dramatic in the fifteen years of Independence.

For one thing, there is very little vertical integration into a more skill-intensive or capital-intensive mode of production. Admittedly, here and there someone will have acquired hand-operated or power machinery, and will be using this to make a product such as rainwater tanks. But access to relevant machine tools is not easy, nor is product identification in a situation where the really basic needs of poor people are already being met by the informal sector, and where the well-to-do are catered for by established local or foreign companies. Consequently, wider ownership of machine tools is not a sufficient policy objective, though it may seem so to many forced to improvise with inadequate hand-tools. Rather, an analysis is needed of present trends in the small precision engineering sector, so that credit and promotion policies towards the informal entrepreneurs can be seen in the wider context of industrial development.

Important to this analysis would be the recognition that although there seems little technological connection between the present informal sector and more specialised modes of production, Kenya has had the experience of vertically integrated modes of production through the activities of the Indians. In many parts of the country, even down to the

level of the very small town, there were little general engineering workshops which faced two ways—to the small Indian craft sector and to the maintenance of farm machinery and any other equipment in the area. We have stressed that this kind of activity is highly skill-intensive, and unlike the rather narrow specialisation of much of the informal sector, depends upon a wide range of competencies and services towards differing clients. For this reason, it is likely to prove one of the most difficult areas to Africanise. So far, local entrepreneurs, with a few exceptions, have been much more interested in product-specific workshops concerned with one line of goods, such as steel trunks, steel window frames and gates, or rainwater tanks. Or they have gone in for contracting or motor vehicle maintenance. With the latter two categories there is of course a considerable measure of integration between the skills of the informal building contractor or the wayside repairman, on the one hand, and the skills present in the large-scale contractors and car agencies on the other. This is certainly not yet the case for the few remaining Indian machine shops in the main Kenya cities. And it therefore remains to be seen whether the skill intensity of this sector can be replicated before its numbers dwindle very much further.

In the present state of our knowledge, it is not possible to be dogmatic about the need for a technological continuum in a country like Kenya. If a range of engineering services is no longer available locally, industry will adapt to the situation, and insure that its equipment becomes independent of local inputs or local spare parts. Indeed, we have suggested that regardless of these special factors in Kenya, modern production equipment imported from the West is itself now designed to be self-sufficient. Recent rapid changes in production systems may be absorbed or resisted more easily in countries of the Third World where there is an established and dynamic layer of ancillary firms linked to large-scale industry. But in Kenya, the rough and ready skills of the informal sector only began to develop at a time when these major changes in production technology were under way. It is possible therefore that this simple historical coincidence could have a marked effect upon the development potential of the present informal sector, and even reduce the scope for vertical integration of these different levels.

Training and industry

Reflecting this technical polarisation we have described, there is the training system. The largest quantity of formal technical training in Kenya is directed towards the process, service and assembly firms, and to the Ministry of Works. Leaving aside the last, it can be said that the majority of the best known international firms in Kenya take on an

element of male apprentices who will already have been exposed to four years of technical school. By the time they have finished a further three years of in-plant and off-the-job training, they are arguably overtrained to be skilled tradesmen. This is particularly the case with the process industries where much of the manual skill has long since been eroded by advances in production equipment; but it is increasingly true also of the building industry and the automotive sector.

We have a situation, then, in which the major element of formal technical training is directed towards the apex of Kenya's industrial activity. This apex, however, is much narrower, as we have said, than the spread of manufacturing in most medium-sized European cities, and has a concentration of process plants that would not normally be thought of as requiring formally skilled labour in the European context. It is not surprising, therefore, that many Kenyan apprentices seek to escape upwards into technician or supervisory status.

At the other end of the scale, there is really no formal training at all associated with the rough and ready skills of the petty entrepreneurs. Through the various informal arrangements that hold for most African countries, competence is picked up on the job.

Paradoxically, if the labour required by modern process industries and by the informal sector is contrasted, it can be seen that really neither mode of production needs highly skilled manpower; and yet the modern sector has a whole seven years of expensive prevocational and initial training surrounding it, while the informal workshops have a few months of learning on the job.

Quite separate from the reality of training requirements, it must be accepted that in Kenya there is a very strong popular conviction that technological education of some sort *must* hold the key to the problems of local development and educated unemployment. To this end, unprecedentedly large sums of money have been collected on a self-help basis to found colleges and institutes of technology.

At a time when the first of these college graduates are entering the labour market, and other institutions are trying to design the most relevant technical courses, it might be an appropriate moment to make the whole subject of 'Training and Industry' the subject of a commission of inquiry. Ideally, any such commission would not concern itself with forecasting needs for skilled manpower (which is certain to be as perilous an exercise in Kenya as it has been in UK) but would map out the exceedingly complex existing patterns of vocational training for young people, and seek to relate these to the structures of work and technology in the factory, the workshop and the roadside.

REFERENCES

1. See Chs. 2 and 3 above.
2. For an example of precolonial craft, see J. van der Hulst and F. Steffens, *Small Industries in West Lake Region, Tanzania* (Eindhoven, University of Technology, Netherlands, August 1975), 44 ff.
3. See further, K. J. King, 'Skill Acquisition in the Informal Sector', *Journal of Development Studies,* XI, January 1975 (2), 113. On the importance of a sophisticated market for weaving in West Africa, see the influence of the Asantehene and his court upon the development of narrow strip cloth, in Venice Lamb, *West African Weaving* (Duckworth, 1975), 160.
4. See Ch. 3 above.
5. See passim, Per Kongstad, *Extension Services to Rural Industries: A Partial Assessment of RIDP* (IDR Project Paper D 75.1), Institute for Development Research, Copenhagen, 1975, mimeo.
6. On the failings of import substitution policies, see ILO, *Employment, Incomes and Equality: A Strategy for Increasing Productive Employment in Kenya* (Geneva, 1972), Ch. XI, 180-82.
7. See Ch. 3 above.
8. See further, Jens Muller, *Regional Planning for Small Industries in Tanzania* (IDR Project Paper A 76.2, Institute for Development Research, Copenhagen, 1976, mimeo).

A Research Note

The field work research underlying this study was conducted in three consecutive years, for periods of two months at a time. The notion behind this was that it would be difficult to survey the informal sector using methods that had been developed for the formal. Because of the anticipated mobility in petty production, also, it was thought wise to avoid the use of a single one-off survey, and instead employ case study methods, in which particular enterprises could be visited more than once, at yearly intervals. It was not thought so necessary to employ this technique in Nairobi's industrial area, where some 50 Indian and European firms were interviewed during the summer of 1972. But with the other industries sampled here, such as candlemaking and machine-making, it has been possible to maintain contact over a three-year period.

Although the detailed illustrations of informal sector activity have usually been drawn from the building trades, metal work and tinsmithing, and often from artisans working in Nairobi or Githiga, a great deal of supportive material was collected from other areas of Kenya — particularly the Rift Valley, Karatina, Thika and Machakos. Similarly, corroborative data were gathered from a wide spectrum of informal industries in Nairobi, even though the specific reference in these chapters has tended to be to tinsmith and metal work. This has all helped to place the case studies within the broader context of informal enterprise.

A NOTE ON TERMINOLOGY

The term Indian has been used throughout to refer to those from the Indian sub-continent, many of whom came to Kenya when India and Pakistan were still India. This seems preferable to the alternative word 'Asian' which is, however, quite widely used by English speakers in East Africa. Swahili speakers still refer to the group as 'Wahindi'.

A Short Guide to the Literature on the Informal Sector and Out-of-School Education in Kenya

Instead of appending an exhaustive bibliography, it may be more useful to students of the rather interdisciplinary field of the informal sector, to have some of the principal areas of reading outlined.

ANALYSIS AND CASE STUDIES OF THE INFORMAL SECTOR

It is not possible to restrict this to Kenya, since only a small amount of work has so far been published. However, Chapter 13 of the ILO's *Employment, Incomes and Equality in Kenya* is the most useful starting point, since a number of the other articles available are affirmations or rejections of the ILO's analysis. See further: Colin Leys, on 'the informal sector' in his *Underdevelopment in Kenya* (Heinemann, 1975); John Weeks in *The Informal Sector and Marginal Groups* (Bulletin of Institute of Development Studies, Sussex, 5, nos. 2/3, October 1973, pp. 76-82); Chris Gerry and Olivier le Brun, 'A theoretical prelude to the class analysis of petty producers in Senegal', *Review of African Political Economy,* i, no. 3. Also, Keith Hart, 'Informal income opportunities and urban employment in Ghana', *Journal of Modern African Studies,* ii, no. 1, 1973.

THE CONCEPTUAL FRAMEWORK OF NON-FORMAL EDUCATION, AND OUT-OF-SCHOOL LEARNING

This is a rapidly expanding field of study, and a great deal of literature has already been generated during the 1970s. The best indicators of the scope of these concepts are Philip Coombs and Manzur Ahmed's two books: *New Paths to Learning for Rural Children and Youth* (International Council for Educational Development, New York, 1973) and *Attacking Rural Poverty, How Non-formal Education Can Help* (John Hopkins, Baltimore, 1974). This should be connected however to

217

a vision of life-long learning and recurrent education that does not only apply to Third World countries. For this, see UNESCO, *Learning to Be: the World of Education Today and Tomorrow* (UNESCO, Paris, 1972). Illustrations of the scope of non-formal education specifically drawn from Africa are concisely drawn together in James Sheffield and Victor Diejomaoh, *Non-formal Education in African Development* (The African-American Institute, New York, 1972). Outside Kenya, the most provocative account of the difficulty of moving from formal to non-formal is probably, Patrick van Rensberg, *Report from Swaneng Hill* (Dag Hammarskjöld Foundation, Uppsala, 1974).

CASE STUDIES OF NON-FORMAL EDUCATION PROVISION IN KENYA

To gain a preliminary impression of the spread of non-formal education in Kenya, the best source is D. Thomas, *Who Pays for Adult Education in Kenya?* (Board of Adult Education, Republic of Kenya, November 1971). Interest however has focused primarily on the village polytechnic movement, as exemplifying an innovative step towards non-formal education. See J. Anderson, 'The village polytechnic movement', *Evaluation Report* no. 1, Institute for Development Studies, University of Nairobi, 1970; and David Court, 'Dilemmas of development: the village polytechnic movement as a shadow system of education in Kenya' in *Developmental Trends in Kenya* (Centre of African Studies, Edinburgh University, 1972).

SMALL-SCALE ENTERPRISE AND PETTY PRODUCTION IN KENYA

The best known publications still refer to the *larger* of the small-scale businesses, and the classic work here is R. Marris and Tony Somerset, *African Businessmen* (East African Publishing House, 1971). Similarly, the Kenya government institutions for encouraging African entrepreneurs at this higher level are very usefully brought together (along with material from Malawi, Swaziland and Ghana) in Bruce Dinwiddy, *Promoting African Enterprise* (ODI, London, 1974).

At the much more small-scale level, however, some valuable data have been produced by the Institute for Development Studies and by the Danish-based Institute for Development Research, some of whose personnel have been intimately concerned with the Rural Industrial Development Centres. See, *Small Scale Enterprise,* Occasional Paper no. 6 (Institute for Development Studies, University of Nairobi, 1973); and progress reports and papers on rural industrial development,

available from Institute for Development Research, 104 Vester Volgade, DK-1552 Copenhagen V. Some detailed case study material is contained in Kenya Industrial Estate's survey: Rural Industries Development Programme: Techno-Economic Survey Report of Selected Centres (mimeo, Nairobi, no date, but *circa* 1970). Further at the IDS, Nairobi University, papers by Philip Mbithi, I. Inukai and J. Okello are all critical to understanding the condition and obstacles to petty entrepreneurship in Kenya.

KENYA'S FORMAL TECHNICAL EDUCATION SERVICES

There are a number of local documents in the organisation of Kenya's formal apprenticeship programmes. These are *The Industrial Training Act* (Cap. 237); *The National Industrial Training Scheme for the Training of Craft Apprentices* (Directorate of Industrial Training, Ministry of Labour, 1973), and *Questions and Answers on Craft Apprenticeship Training in Kenya* (Ministry of Labour, 1973). The Employment Promotion Division of the Ministry of Labour has also circulated 'Towards a Long Term Plan for Industrial Training' in August 1974. The annual reports of the Confederation of Kenya Employers are also an important source of information on the training side.

THE WIDER BACKGROUND OF EDUCATION IN KENYA

The best general survey of Kenyan education is probably John Anderson, *The Struggle for the School* (Longman, 1970), but some of the most recent post-independence writing on the sociological and political aspects of Kenya's education system are brought together in David Court and Dharam Ghai (editors), *Education, Society and Development. New Perspectives from Kenya* (Oxford University Press, Nairobi, 1974) — see articles especially by Mutiso and Godfrey, Moock, Kinyanjui and Somerset. On the politics of artisan education in the colonial period see K. King, *Pan-Africanism and Education* (Clarendon, 1971).

THE WIDER BACKGROUND OF SOCIETY AND POLITICS IN KENYA

Perhaps the most instructive combination is to begin with two books almost exactly fifty years apart: Norman Leys, *Kenya* (London, 1924) and Colin Leys, *Underdevelopment in Kenya* (London, 1975). The

single most valuable source of data on a very wide range of development issues is the ILO's Mission to Kenya, *Employment, Incomes and Equality in Kenya* (Geneva, 1972). A fascinating variety of historical and contemporary research is produced through the Historical Association of Kenya, its journal, and its annually published conference proceedings. On the social sciences, the widest spread of research is contained in the annual social science conference papers.

Index

Advisory Committee on Education in Colonies, 8

African, African: historiography of education, 3-14; impact of India on education in, 8-9; Africanisation in Kenya, 27, 62-3, 67; building contractors, 74-6; entrepreneurs, 92 ff.; production of low cost household goods, 98, 145-6

Agriculture: changing priorities in, 1-2; colonial education for, 29-30; developments contrasted with industry and education, 94; grade cattle and social differentiation, 135

Aid agencies: critical of African education, 1-2, 6; Carnegie Corporation, 10; attitudes to skill training, 21; Danish and Norwegian, 96; village development as a priority, 161

Apprenticeship: in Kenya's colonial period, 22 ff.; Kenyatta's, 23; in colonial Kenya versus UK model, 24, 28-9, 38-9; Kenya's informal system of, 49-56; fees charged for, 50; parallels with W. Africa, 51; open access to, 52; interethnic training, 55; UK model for independent Kenya, 68-9; in Kenya versus UK, 83; wage differentials in, 84

Artisan: Kenyan, 22, 23; as skill source, 48; and self-employment, 55; historical development of African petty producers, 102 ff.; first generation of in Kenya, 104; jobless, 129; village versus urban, 158, 177-8; origin of in Kenyan village, 175-6

Asquith Commission, 10

Ashby, Sir Eric, 12

Assembly plant: in relation to Kenyan industry, 209-10

Assimilation: of education in Third World, 12-13

Automotive industry: comparative developments in Kenya, 79-80; repair versus replacement, 79-80

Bicycle carriers: case study of informal sector production, 97 ff.; produced in urban informal sector, 111

Blacksmithing, 48, 52, 55, 103

Building Construction, 48; training on the job in, 74; African labour subcontracting in, 74 ff.; development of in rural areas, 182 ff.; Africanisation of, 182; informal training for, 183; National Construction Corporation, 186-7

Burmah Market (Nairobi): site of urban informal production, 113, 119, 138, 198; site clearance, 123

Car Industry: spin-off from to informal sector, 57; vehicle-related skills in Kenyan village, 178-9

Careers: advice for primary schools, 192-3

Casual Labour (kibarua): and skill acquisition, 27; upgrading of, 49; opportunities for in rural areas, 106, 122; in rural building industry, 188-9

Certification: antipathy to in small industry, 56-7; of rural skilled men, 184-5

Colonial Office: policy on Indian and African education, 8-9, 10

Community: and school participation, 5; education of in Africa, 9-10

Coombs, P. H., 14; on world educational crisis, 13, 170

Craft, Craftsman: Africanisation of Indian, 89; historical background of in Kenya, 199; Indian versus East and Central African traditions of, 199-200; encouragement of in E. Africa, 204-5